The Art of Caring
A Look at Life through Photography

The Art of Caring
A Look at Life through Photography

Essay by Cynthia Goodman

Published by Ruder Finn Press, New York
in association with the New Orleans Museum of Art

RUDER FINN PRESS

**New Orleans
Museum of Art**

Editorial Director: Susan Slack
Creative Director: Lisa Gabbay
Senior Art Director: Salvatore Catania
Art Director/Designer: Jeeyoon Rhee
Production Director: Valerie Thompson
Digital Imaging Specialist: Steve Moss
Production Artists: Jeff Gillam and Rubén D. Mercado

ISBN 10: 1-932646-50-7
ISBN 13: 978-1-932646-50-4

Printed in China.

Table of Contents

In memory of my father, Sander Goodman, M.D., a beloved and revered physician, who was a pioneer in geriatric medicine and taught me and my sisters from a very young age how caring is an art that can make an incalculable difference in people's lives. And to my mother, Eleanor Goodman, who supported his ability to maintain the high professional standards that he set for himself and from which both his family and his many patients benefited.

C.G.

Foreword

The Art of Caring: A Look at Life through Photography is an emotional and thought-provoking examination of many of the transforming moments in human life. This exhibition was inspired by an earlier, equally provocative exhibition, *Hospice: A Photographic Inquiry*, organized by The Corcoran Gallery of Art in 1996. Both were initially and generously supported by the National Hospice Foundation.

In the continuing effort to fully recover from the devastation of Hurricane Katrina, the New Orleans Museum of Art strongly felt that this exhibition could serve as an important reminder of the essential elements of the human experience and how they need to be nurtured and sustained. Now three years after Katrina, our country, in fact the entire world, is experiencing an equally overwhelming disaster, this time manmade: the worst economic crisis since the Great Depression. This financial meltdown, like Katrina, will demonstrate yet again that the arts are not luxuries but necessities in troubled times — a source of solace, comfort, and rejuvenation. It is the hope of its organizers that *The Art of Caring: A Look at Life through Photography* will serve this purpose by inspiring visitors with optimism and instilling them with hope. It will be further enhanced by special educational programming developed in collaboration with the Children's Defense Fund, the American Heart Association, the American Medical Association, the American Red Cross, Habitat for Humanity, AARP, and the National Hospice Foundation.

Many dedicated individuals have played decisive roles in making this complex exhibition a reality. From the beginning, the National Hospice Foundation has played the lead role. More than three years ago the Founding Chairman of the Foundation, Zachary Morfogen, with his passionate enthusiasm for both the arts and Hospice, was the catalyst in bringing together a number of museum curators and directors to plan a worthy successor to the earlier exhibition, *Hospice: A Photographic Inquiry.* The resulting NHF Art Committee, first chaired by then Corcoran Gallery director, David Levy, and subsequently by James R. Borynack, who is the current Chair of the Foundation's Board of Governors, developed the first exhibition concept and engaged as guest curator, the distinguished contemporary art historian and museum director, Dr. Cynthia Goodman. Initial funding for the project was provided by the Exhibition Founding Fund from the Honorary Founders of the National Hospice Foundation: Marion Roberts, Steven Wood, June Ebensteiner, Henry Kimelman, Audrey Harris Hilliard, Jay Mahoney, and Zachary Morfogen. We are also grateful for the funding provided by the Steere family. Additional generous support was received from Wally Findlay Galleries International, courtesy of James R. Borynack.

Cynthia Goodman has played an active role in all aspects of the creation of the exhibition and the accompanying catalogue. She has tirelessly devoted herself to conceptualizing the exhibition, to traveling the country to visit artists, private collectors, galleries, museums and photo archives, to narrowing down thousands of compelling images to a sensitively selected group of more than 220 photographs that illustrate the exhibition's seven thematic categories, and finally to writing the perceptive catalogue text. She was aided in this job by a

number of able research assistants and volunteers and on her behalf I am happy to acknowledge the invaluable contributions of Katie Landrigan, Chessia Kelley, Ivey Ford, Jaime Thompson, Jo-Ann Mueller, and Betsy Frank.

In organizing the exhibition, Cynthia also benefited from the generous assistance of many institutions. On her behalf our thanks go to our museum colleagues: Julian Cox, The High Museum of Art; Dennis Kiel and James Crump, the Cincinnati Art Museum; Charles Stainback, the Norton Museum of Art; Karen Irvine and Kristin Freeman, the Museum of Contemporary Photography, Chicago; Erin Barnett, the International Center for Photography, New York; Virginia Heckert, the J. Paul Getty Museum; Katherine Hinds, the Margulies Collection; Jonathan Newman, the Canadian Museum of Contemporary Photography; and Trinity Parker, the Center for Creative Photography, University of Arizona; also to Barbara Hitchcock, The Polaroid Collection; Andy Blau, Time Inc.; Regina Fuller, LIFE Gallery of Photography; Bonnie Hathaway, Time Warner Cable; Suzanne Pinto, HBO; and the collectors Doug and Dale Anderson. This beautiful catalogue is the result of the professional talents at Ruder Finn Press in New York. Special thanks there go to David Finn, President; Susan Slack, Vice President and editor; Salvatore Catania, Senior Art Director; Jeeyoon Rhee, Art Director, Jeff Gillam and Rubén D. Mercado, Production Artists. On the staff of the New Orleans Museum of Art, I want to thank especially Alice Dickinson, Associate Collection Manager, who spent many, many hours securing reproduction rights from artists, publishers and lenders, among other duties. She was aided by Monika Cantin, also Associate Collection Manager; Wanda O'Shello, recently retired Director of Publications; Jennifer Ickes, Registrar; Tao-nha Hoang, Chief Preparator; and Paul Tarver; Chief Registrar.

Special thanks must also go to Annie Leibovitz and her assistant, Jesse Blatt, for all the extra effort they made in selecting and printing the perfect group of images for the exhibition's visual introduction.

Finally, and most significantly, the exhibition would not have been possible without the incredibly talented artists who created these sometimes funny, often moving, occasionally sad, but always passionate and compelling photographs. To them and the many private and public lenders to the exhibition, our deepest appreciation for their generous support.

It is our intention to circulate this exhibition to museums across America after its inaugural, five-month presentation at the New Orleans Museum of Art from May 16 to October 11, 2009. As we go to press with this catalogue the Art Museum of South Texas in Corpus Christi has committed to presenting *The Art of Caring: A Look at Life through Photography.* I thank Joseph B. Schenk, Director, Deborah Fullerton, Curator of Exhibitions and Adult Education, and Toby Shor, Trustee, for being the first to join us on this exciting journey. I also thank Irvin Lippman, Executive Director, Museum of Art Fort Lauderdale/ Nova Southeastern University as well as Douglass McDonald, President & CEO, and Sandra Shipley, Chief of Staff and Vice President Exhibits, Cincinnati Museum Center at Union Terminal for joining the tour.

E. John Bullard
The Montine McDaniel Freeman Director
The New Orleans Museum of Art

Essay
by Cynthia Goodman

The Art of Caring: A Look at Life through Photography is comprised of seven thematic components: Children & Family, Love, Wellness, Caregiving & Healing, Aging, Disaster, and Remembering. Through photography and film, this exhibition provides a visual discourse on how key life events are celebrated and honored, and how pivotal life decisions are made by a number of different cultures. Each stage of life is depicted by simple everyday situations experienced in moments of joy and gratification as well as by poignant events of passage. The unfathomable scale of devastation inflicted upon humanity and our environment by both manmade and natural disasters is also intrinsic to this life story.

The selection of the more than two hundred photographs in this exhibition took shape like a complex and carefully composed mosaic in which the distinct fragments represent mothers, fathers, children, caregivers, first responders, and others from around the globe. For the viewer, encountering these photos on the walls of this exhibit is somewhat like taking a walk on a busy street in any one of a number of major metropolitan cities. Who or what you see is often a surprise impossible to plan for or predict, much like the cycle of our own lives.

Replete with the minutiae of everyday existence, viewers will glimpse inevitable life cycle occurrences in these photographs as well as events they pray will never exact a toll on them, their loved ones or society. By sharing joyful moments as well as sad and tragic ones, it is my hope that not only will the photographs in *The Art of Caring: A Look at Life through Photography* be enjoyed in themselves but also that key life lessons will be gleaned from the contents of this exhibition.

According to Ansel Adams' much-quoted expression: "You don't take a photograph, you make it." The photographers who have "made" the pictures in this exhibition come from divergent backgrounds and cultures. They have crafted their photos motivated by varied emotions and life situations. Some capture an intimate family exchange. Others record a disaster of unfathomable scale. Still others show the drama between strangers who, because of unforeseeable occurrences, have come into intimate contact with one another in a possibly life-dependent relationship, such as an emergency room exchange between a trauma victim and a doctor or nurse. This exhibition does not purport to demonstrate that man is inherently good and caring. However, it does allege that through unpredictable life circumstances, during both major and minor events, caring people around the world made incredible differences in the lives of others who were often previously unknown to them.

In Cornell Capa's introduction to his *Concerned Photographer Series* he explains the inspiration behind many photographers in this exhibition to make pictures, "whose contents possess the magic power of remembrance or demoralization," that is, to make images that have the lingering impact of certain scents of perfume:

…They stay near you like a little tune that annoys you because you whistle it all the time. You can't disentangle yourself from them…We must always remember that a picture is also made up of the person who looks at it. Maybe that is the reason behind these photos that haunt me…It is about that walk that one takes with the picture when experiencing it.[1] Beginning at the conclusion of World War II, the slightly more than sixty-year time span encompassed by the photographs in this exhibition allows the viewer to witness the great events that shaped the last half-century as well as those that are shaping the next. Photographers have captured these occurrences — no matter how remote or dangerous the locale — and brought them home to our newsstands, living rooms, and classrooms. The broad chronology covered traverses enormous transformational developments in our society as well as in the field of photography, including changes in subject matter, technology and presentation.

The stage was set for photography to take on the unprecedented role as chronicler, consciousness raiser and educator during World War II. Throughout the war, new magazines like LIFE in the United States, as well as *Vu* in France and the *Picture Post* in Britain, were credited for turning "…documentary photographers into photojournalists and photojournalists like Robert Capa, Margaret Bourke-White, and W. Eugene Smith into heroes…"[2]

Some of the images that changed the lives and reputations of these photographers and others have become symbolic of the era. These include the ineffable horrors witnessed in the concentration camps after liberation at the end of World War II so memorably captured in the photographs of George Rodger and Margaret Bourke-White. In contrast, Alfred Eisenstaedt's photo *V-J Day, Times Square, New York City* (1945) captures an exuberant expression of joy as a sailor impulsively embraces and kisses a total stranger as if she were a long lost sweetheart.

After World War II, "…photo-essays by photographers like W. Eugene Smith and Gordon Parks were credited with helping to stoke the 'can-do' energy of the times."[3] By the 1970s, however, many of the same established photojournalists, whose images had stirred the nation and the world in the lavishly illustrated pages and photo essays that appeared regularly in LIFE, *Look* and other magazines, saw their careers change with the demise of these publications and others. At the same time, the advent of color photography, and its acceptance as a legitimate artistic medium, closed the gap between fine art and commercial work in new ways. William Eggleston's one-man exhibition at The Museum of Modern Art in 1976 is recognized as the watershed event that legitimized color photography. Use of color film became widespread immediately afterwards. Yet it is still hard to imagine that the staggering breadth and level of accomplishment by so many photographers is the product of something considered a legitimate medium for barely forty years.

Also in the 1970s, commercial art galleries began to have an increasing interest in exhibiting and selling documentary photography. Throughout the history of this medium, there has often been a strict delineation between documentary and fine art photography. I have chosen not to make this distinction. Placing images usually categorized as "photojournalistic" side by side with others considered "fine art photography" seemed the only valid approach, particularly since the lines between the two are frequently blurred, and the photographers themselves often prefer not to make this differentiation.

Mary Ellen Mark, for example, like many other photographers of her generation, acknowledges how inspirational the great photo essays she saw in her youth were on her development as a photographer. Mark, whose large body of distinctive work has primarily been characterized as photojournalistic, has written: "The best documentary images, like all great photographs, have always had a place in the world of fine art. This is very important, especially now when we no longer have the opportunity to see these pictures in magazines."[4] Making strong distinctions between the two kinds of photography does a disservice to the photographers, the photographs and the photography-viewing public alike.

A number of artists have dedicated a great part of their careers to documenting and exploring the themes in this exhibition. For others, although interest in these subjects may have been fleeting, the relevant work they produced is so powerful that Robert Doisneau's description of the influence of unforgettable photographs on him is comparable to the lingering and unshakable impact the selected works had on me. In his words, memorable photographs: "…radiate a unique atmosphere of their own, one that stays with you and that leaves an important imprint on your mind."[5] The story each told made an inextricable contribution to the exhibition's themes, and this indelible allure was paramount in my selection process.

The Art of Caring: A Look at Life through Photography has been compared to the epic *The Family of Man* exhibition, which Edward Steichen organized for The Museum of Modern Art, in 1955. Despite the undeniable similarities, it is important to note that our curatorial goals were as different as the times in which the exhibitions were organized. Both shows purport to present a photographic overview of humankind through life cycle events. *The Family of Man* sought to do so exclusively through the works of photojournalists, many selected from the LIFE Photo Archive.

Although the LIFE Photo Archive was also a resource for my selections, the major contributions came from the collections of a number of museums, private collections, corporate collections and art galleries specializing in photography, and include some of the most prominent photojournalists and fine art photographers who have worked since the end of World War II. *The Family of Man* illustrated many different daily activities, including work and religion. *The Art of Caring: A Look at Life through Photography* narrowed its themes. Most photographs in this exhibition show interactions between two or more people distinguished by a clear bond and a demonstration

of caring. In some cases, however, the scenes are not populated, and concern is demonstrated through the very act of documentation. Steichen's over-arching theme was sameness, or as he described the philosophy that motivated his research and eventual selections: "It was conceived as a mirror of the universal elements and emotions in the everydayness of life — as a mirror of the essential oneness of mankind throughout the world…"[6]

Rather than sameness, *The Art of Caring: A Look at Life through Photography* celebrates diversity.

This diversity is a by-product of great upheavals in the political, sociological and technological underpinnings of our society. Even the concept of what constitutes a family has been transformed. The nuclear family structure of the 1950s, which traditionally consisted of a mother, father and child or children, was replaced by a multiplicity of societal norms. The recognition and acceptance of alternative lifestyles increased, as well as the number of same sex marital unions. The ethnic mix in America also changed. The U.S Census Bureau reported in August 2008 that it anticipates minorities will make up the majority of the U.S. population by 2042.[7]

Finally, in today's interconnected world, photography has become more a part of our everyday lives than ever before. Only a few years ago, bringing a camera with you was a conscious decision and often involved fastidious planning and the transport of cumbersome equipment that made documentation far from spontaneous. Today, most of the skyrocketing number of cell phone users have a camera with them at all times. Taking a photo of anyone or anything and transmitting it effortlessly via email to one person or many has become second nature. Walking, talking, shooting and transmitting photos are now virtually synonymous.

The very omnipresence of photography, and the advances in digital technology that impart a new meaning to "immediacy," have had a major impact on audience expectations and on the relevance of documentary photography. The shocking photographs from the Abu Ghraib prison outside Baghdad taken in early May 2004, and the speed at which these scathing images appeared almost instantaneously on the front pages of newspapers and on television screens around the world, circumvented all long-established protocols for military reporting through traditional media outlets. Later displayed in an exhibition called *Inconvenient Evidence* at the International Center of Photography in New York, photography critic Andy Grundberg commented that what made this exhibit truly remarkable was not the casual manner of the installation or the way in which the imagery was acquired, but " the museum's recognition that its implicit subject, photojournalism, had been irrevocably altered."[8]

Organized by the New Orleans Museum of Art (NOMA), *The Art of Caring: A Look at Life through Photography* is a powerful testimony to how art is a transcendent force that unifies diverse peoples and provides incalculable comfort and moments of respite even in the most difficult times. NOMA,

under its longtime director, E. John Bullard, has ingeniously survived the aftermath of Hurricane Katrina even though the rebuilding of devastated neighborhoods has been slow, and infrastructure repairs are ongoing. For NOMA, *The Art of Caring: A Look at Life through Photography*, the largest exhibition to be organized by the institution since Katrina, is truly symbolic of life after the storm.

The people of New Orleans are critically aware of how a timely, caring hand, a comforting gesture or an offer of assistance can determine one's very survival. Appropriately, in organizing this exhibition we have reached out and invited a number of the relief, humanitarian, and educational organizations that played, and continue to play, a role not only in the recovery of New Orleans after Katrina, but also New York after September 11, 2001, Indonesia after the tsunami in 2004, in the Sudan today, as well as in innumerable other disasters around the globe, to participate as our community partners. The crisis in daily healthcare was also instrumental in our selection of partners.

The following national and local organizations have been paired with the seven exhibition themes:

Children & Family: Children's Defense Fund and Head Start
Love: American Heart Association and Louisiana SPCA
Wellness: East Jefferson General Hospital Wellness Center
Caregiving & Healing: Ochsner Medical Center and Covenant House
Aging: AARP
Disaster: American Red Cross and Habitat for Humanity
Remembering: National Hospice Foundation

These community partners not only reflect the thematic components of the exhibition in their daily activities but also have the potential to contribute to the lives of visitors and other community members in each location where the exhibition will travel, through education and other critical outreach efforts. As curator of this exhibition, I have been motivated by the potential that *The Art of Caring: A Look at Life through Photography* has to be an agent of change by inspiring viewers to act in a more socially responsive manner. Indeed, this is the only viable message with relevance to our times. HBO has tackled many of the same tough themes through film and is providing a film program to accompany this exhibition.

In 1996, the Corcoran Gallery of Art mounted the courageous exhibition *Hospice: A Photographic Inquiry*. For that exhibition, organized by then director David Levy and curated by Philip Brookman, Corcoran curator of photography and media and guest co-curators, Jane Livingston and Dena Andre, five photographers were commissioned to go into various hospice situations to witness and record the end of life care that their subjects received. Subsequently circulated around the country to a dozen museums and accompanied by the award-winning HBO documentary *Letting Go: A Hospice Journey*, the exhibition taught important lessons about caring,

and piqued the curiosity of a number of museum directors, corporate and philanthropic leaders, who launched this project, about how caring is manifest not just at the end but at all stages of life. The vision and guidance of Hospice Founding Chairman Emeritus Zachary Morfogen were instrumental in the realization of both *Hospice: A Photographic Inquiry* and *The Art of Caring: A Look at Life through Photography*. The enthusiasm and heartfelt passion about this subject demonstrated by James Borynack, chairman of the Art of Caring Committee and Chairman of the Board of the Hospice Foundation has also been invaluable. Profound thanks are due to Susan Slack, vice president, Ruder Finn Press, who has provided crucial guidance not only in her careful and insightful editing of this text, but also in her perceptive oversight and contributions to all aspects of this publication. Thanks to Susan's direction and the exquisite designs of Jeeyoon Rhee and Salvatore Catania, the essence of this exhibition is sensitively conveyed in the pages of this publication. Finally, and most significantly, the knowledge and dedication of E. John Bullard, as well as that of his talented staff at the New Orleans Museum of Art, coupled with NOMA's impressive photography collection, with its outstanding and in-depth holdings, made the realization and presentation of *The Art of Caring: A Look at Life through Photography* truly possible.

A Visual Introduction

Although I have divided *The Art of Caring: A Look at Life through Photography* into distinct sections, the photographs were not always easy to categorize. In fact, many could have been placed in more than one section. All seven themes define complex processes both difficult to document and assess.

The vast and accomplished oeuvre of Annie Leibovitz includes significant works that could have been included in each section. Instead, in collaboration with the artist, ten photographs were selected to serve as a visual introduction. Some reveal how this great photographer recorded very personal family scenes, while others are from photo assignments covering celebrities and current events around the world. These often challenging assignments did not always allow Leibovitz to follow her own advice to young photographers, which is, "to stay close to home."[9] *Thanksgiving, Clifton Point, New York* (2003), in which Leibovitz smiles, holds her daughter Sarah in the back row and poses along with her large extended family for a classic holiday photo, is one of these. In contrast, *Living room of my parents' house, Silver Spring, Maryland* (2003), is a somber photo that shows her father pensively sitting beside the hospital bed that was moved to their living room when his health was deteriorating. These photos are of particular significance now for Leibovitz, who has lost both her parents since they were taken. Through her camera, Leibovitz not only shares her life with viewers but also inevitably engenders reflections about our own celebrated events as well as painful losses and transitions.

In the preface to her own book, *A Photographer's Life 1990 – 2005*, Leibovitz expressed her awareness of how "[t]aking intimate pictures of family members and people to whom you are close is a privilege, and it brings a certain responsibility."[10] She had developed such a closeness with Demi Moore while taking photographs of the actress on numerous occasions, including her wedding to fellow actor Bruce Willis. Leibovitz had expressed an interest in photographing a pregnant woman to Moore, who remembered this remark and called Leibovitz when she was pregnant with their first child. In *Bruce Willis and Demi Moore, Pregnant with Rumer Glenn Willis, Paducah, Kentucky, 1988*, neither actor's face is shown. Rather than concentrating on their celebrity, the focus is on maternity and the impending birth of their child. Both monumental and intimate, Willis' large hands encircle Moore and rest on her protruding belly; her own hands are clasped below his. Through her exquisite compositional skills, Leibovitz respectfully shares her privileged entrée into their private, loving, family circle.

Traces of the Massacre of Tutsi School Children and Villagers on a Bathroom Wall. Shangi Mission School, Rwanda (1994) was the product of a quite different assignment. Although since the birth of her own children Leibovitz has not ventured into war zones, she acknowledges the intoxication for photojournalists who work regularly on dangerous assignments, "where everything is stripped down to simple life and death."[11] With bloodstained walls the only horrific remnant left to tell the tragic and brutal story, this haunting photograph engenders pity for these innocent young victims of genocide as well as an incendiary hatred for the perpetrators.

Leibovitz's photographs of three women, *Rebecca Denison, founder of WORLD (Women Organized to Respond to Life-Threatening Diseases), San Francisco* (1993), *Kerie Campbell, member of WORLD (Women Organized to Respond to Life-Threatening Diseases), San Francisco* (1993), and *Glenda Thornton, member of WORLD (Women Organized to Respond to Life-Threatening Diseases), San Francisco* (1993), pay tribute to another kind of fight. Each has a life-threatening illness yet resiliently and stalwartly refuses to succumb to the disease. The words painted in white on Denison's otherwise black body with the exception of two red hands clenched on her heart, both pay homage to friends who have been lost to AIDS and offer hope and inspiration to others in their own fights, whatever the illness. Some of these words "Courage, Never Give Up Hope" are apt for Denison's own story. Although HIV positive, Denison refused to let the disease stand in her way of having a family, and she has given birth to two healthy children.

Just as *Mikhail Baryshnikov and Rob Besserer, Cumberland Island, Georgia* (1990) in a striking pose and silhouetted against an ocean-front shoreline reveal not only their ballet skills but also their superbly conditioned bodies, Leibovitz's portraits of the elderly author *William S. Burroughs* (1995), taken two years before his death, clearly portray the effects of age on the visage of even the most indomitable spirit. Neither the profile nor the frontal view

bear much resemblance to the formerly irascible author of the provocative novel, *The Naked Lunch* (1959), banned in many regions of the United States because of its flagrant use of obscenity. With this remarkable group of photographs, Leibovitz introduces the exhibition's themes, not through words but through sheer visual impact.

Children & Family

A myriad of images replete with the minutiae of our everyday lives fill a multitude of cherished family photo albums lovingly stored for easy retrieval and perusal. Today many photos are also readily available on web sites, where relatives, friends and long lost acquaintances are invited to view and learn more than anyone except a doting family member with inordinate amounts of free time wants to see or know. The incessant, almost obsessive picture taking prevalent among families in our contemporary society has elicited the comment from writer Susan Sontag, who has brilliantly and inimitably chronicled numerous issues relevant to the history of photography, that the parent who doesn't take pictures of their children is today tantamount to "a sign of parental indifference, just as not turning up for one's graduation picture is a symbol of adolescent rebellion."[12]

Many of the photographers in this section seem to revel in deceptively casual family subjects captured in their most intimate moments. The snapshot presentation of some of these compositions belies the extensive study and analysis that contributed to their picture taking over many years. Through these photographs we not only come to learn cherished details about the lives and relationships of these artists but also about our own. Although families differ widely in their social and socioeconomic status, structure, world views and religions, there are nonetheless, basic rituals and passages such as births, birthdays, life milestones, holidays and deaths, that are marked in some way by everyone. There is a certain inescapable universality about a family portrait no matter whose family it is.

In light of this inundation with images from our private lives, it is noteworthy that in 1991, when Peter Galassi organized the exhibition *Pleasures and Terrors of Domestic Comfort* for The Museum of Modern Art, New York, he commented in his catalog essay that the photographs he selected were representative of a new development in American photography since 1980, when photographers "turned with enthusiasm to the *terra incognita* of the domestic scene."[13] Yet Galassi's exhibition focused on the middle and upper class milieu. His statement excludes, as he was well aware, the iconic images of domestic life from earlier decades captured by photographer Walker Evans and the equally memorable photographs of former slaves taken by participants in the Federal Writers' Project of the Works Project Administration from 1936 –38. These chroniclers traveled the country in an attempt to record as much as possible about this era in American history, before the last survivors were gone, through photography, audio recordings

and transcribed interviews, that were compiled in seventeen volumes as *The Slave Narratives: A Folk History of Slavery in the United States from Interviews with Former Slaves*.[14] In the classic publication, *Now Let Us Praise Famous Men* (1940), James Agee told the story of the tenant families that he and Walker Evans similarly documented at approximately the same time.

Evans' and Agee's objective, against which much of subsequent American documentary photography was measured, was to observe and record in words and pictures the daily lives and living conditions of cotton tenant farmers in the United States. They did so by living with three families, who were strangers to them before they began this project, in the summer of 1936. Agee acknowledged that their assignment seemed to him "rather a curious piece of work," in which the "photographs are not illustrative. They, and the text, are coequal, mutually dependent and fully collaborative."[15] Nevertheless, he also expressed recognition of this volume's importance for the future of photography.

Whereas some photographers travel to remote locations in search of their subjects, others take their most memorable photos at home. A number of the artists in this exhibition including Elinor Carucci, Tina Barney, Jessica Todd Harper, Melissa Ann Pinney, Larry Sultan, Harry Callahan, and Lee Friedlander, have repeatedly photographed highly personal moments in the lives of their family members, close friends, and themselves, with varying degrees of complicity and cooperation. Often photographers turn to these subjects because they have more access within their own families and social milieu than in others, and the only risk they take is the chance of incurring emotional rebuttal. Yet the cinéma-vérité-like-fashion in which many of these intimate photos were taken is in some ways akin to the harrowing realism of battlefield photojournalism. Whether at home or on the frontlines, each photographer was immersed in the subject matter and was often simply and serendipitously there when the shot appeared.

Yet family photos, no matter whose family, capture but one millisecond of an entire life with its inherent highs and nadirs, shrill-pitched dramas and intolerable boredom, indolent pleasures, insufferable vicissitudes and hard won rewards. When a camera is focused on a family, or any subject for that matter, what happened in the minute, second or years before the photo was taken goes mostly unrecorded. Whether the subjects are willing or forced, gleeful accomplices or deeply resentful ones, they are captured for posterity exactly as she or he appeared at the instant that the portrait was taken, no matter how inconsistent with their typical demeanor or sentiments. With characteristic eloquence, Roland Barthes discussed the polarities inherent in such photographs in his epic essay *Camera Lucida: Reflections on Photography*:

> The portrait photograph is a closed field of forces. Four image repertoires intersect here, oppose and distort each other. In front of the lens, I am at the same time: the one I think I am, the one I want others to think I

am, the one the photographer thinks I am, and the one he makes use of in his exhibit.[16]

Despite the heightened level of artifice, the pleasure and solace that family photos engender upon later reflection is a significant component of every family's personal history.

Both Harry Callahan and Alfred Stieglitz before him endlessly photographed their respective wives and muses, Eleanor Callahan and Georgia O'Keefe. These portraits, however, are anything but traditional. With their memorable physiognomies and classic poses these women assume a stature in the history of photography that far transcends the typical home snapshot.

Callahan's beloved wife, Eleanor, was his most frequent subject for more than twenty years (1941–63). His former student and lifelong admirer, Emmet Gowin, has perceptively written about what Eleanor meant to him both personally and artistically. According to Gowin, Callahan's portraits of Eleanor, " inspire and open us to what is both visible and invisible… Of course, there is watchfulness, almost or nearly a worshipful awe of her as the center of the mystery of life; there is also a constancy of real and enduring beauty."[17]

After the birth of their daughter, Barbara, the child was often in the photographs as well. Many photographs of the two were taken on trips and in public settings, whereas others like *Eleanor and Barbara, Chicago* (1954) were much more intimate. No amount of staging could ever capture the bond of closeness and trust between mother and child more successfully than Callahan's photo of his wife and small daughter bound in slumber. Callahan was often inspired by the quality of light or an impulse to capture a certain compositional opportunity afforded by the family as they went through their everyday activities. In this shot, taken from behind his unaware and sleeping subjects, light from the window behind the bed gently illuminates the upper portions of their nude bodies. According to Eleanor, the camera was very much a part of their lives, and as was true of many photographers and their families, Callahan's picture taking was like any other daily family ritual.[18]

Emmet Gowin has instilled the same "sublime tenderness" for which he praised Callahan's work in his own photograph of his wife and son, *Edith and Elijah, Danville, Virginia* (1968). With her downward gaze averted away from the photographer, the nude young mother clutches their unclothed son with one arm firmly across his chest and the other between his legs as she stands unabashedly in a doorway of their home.

Lee Friedlander is another who often turned his camera on his own family, beginning with his first portraits of his wife, Maria, after they were married nearly fifty years ago. Friedlander also began taking photos of their son and daughter as soon as the children were born, then of their children's spouses, and then of each of their children with their own children, Lee and Maria's grandchildren.

In *Eri and Ava* (1998), Friedlander took a photograph of his son-in-law, granddaughter, and the family dog nestled on a couch sound asleep. With Eri's long arms providing warmth and solace for infant and pet alike, Friedlander has captured a moment of family intimacy that no amount of prodding and staging could have achieved. The illumination on the fabric of the couch that envelops them intensifies the impression of their cocoon-like enclosure. This nestled threesome emanates with a sense of the tenderness and sweetness of the baby as much as that of the curled, fuzzy pooch, fully secure in his family role.

In *Kristin and Ryan, 18 Days* (2007), Dona Schwartz also acknowledges the role of pets as full-fledged family members, capturing the family dog standing on his hind legs, joyfully wagging his tail as an expression of the delight he shares with the expectant parents. Nestled with her brood on an oversize yellow armchair, Ava, the female Weimeraner in William Wegman's *Mother's Day* (1989) blissfully celebrates the intimate bond between mother and nursing offspring through the artist's unique ability to endow these dogs with human characteristics.

Marion Penner Bancroft's triptych *2:50 a.m. Mission Memorial Hospital… six hours into labour…Judy and Tennyson…dance a slow one* (1982) portrays a couple in the delivery room six hours before the woman gives birth to their child on the hospital bed behind them. Their dance is as pregnant as the soon-to-be-mother with the knowledge of both the responsibility and joy that lie ahead of them, and the two cling together tenderly in anticipation and fear before the birth of their child. Also palpable in the pregnant woman's movement, which progresses from upright and calm to bent over as she sways increasingly more intensely, is their recognition that their once relatively simple union is about to be expanded in a way that will make sharing such private moments of solace and interpersonal communication increasingly difficult.

Claire Yaffa turns her gaze onto the most everyday objects and occurrences and endows them with a transcendent quality. *Mother and Child* (2002) tenderly depicts a shirt-clad mother and small child whose torso, naked buttocks and small feet are shown. In this tightly focused shot, mother and infant merge in a symbolic gesture of their eternal bond, captured in this classic embrace.

David Hockney is a versatile artist, renowned for his paintings, works on paper, stage sets, prints and photographs. Despite all the bravura and flamboyance of his public persona and life style, Hockney also masterfully depicted intimate moments in his own life, including his lovers, his parents and his dear friends, which show quite a different side of the artist. Before his father's death in 1978, his parents often posed together. His closeness to his parents as well as their respect for him as a son and artist is readily apparent in these exchanges. Until the end of her life some twenty years later, his "Mum" who was supportive of Hockney's career as an artist from the time he began his art studies, continued to be a willing sitter for portraits.

In many of these her gaze is forthright, but in the composite large format Polaroid *My Mother, Bolton Abbey, Yorkshire, November 1982*, in which she is seated in the yard of Bolton Abbey, her eyes are directed toward something unknown in the distance. Alone, in this imposing and somewhat bleak landscape, she appears both frail and vulnerable. This particular portrait not only depicts the artist's mother but is also a melancholic portrayal of old age fraught with loss and reflection. The artist's emotional proximity to her is reinforced by his own physical presence. Yet the brown toes of Hockney's shoes in the foreground are only recognizable to someone who knows to look for them.[19]

Much of Milton Rogovin's work as a social documentary photographer has concentrated on the lives of those suffering from economic hardships. This work eventually took him beyond our country and around the world to record the lives of steel workers and coal miners. His first photographs, however, were taken as a means of expressing the social and political injustices he witnessed close to his home in Buffalo, New York. In 1972, Rogovin began walking the streets of the city's working class neighborhood accompanied by his wife Anne, who asked various people they encountered if her husband could take their photographs. Initially wary of his motivations, he quickly gained their trust, since his keen interest and empathy were apparent. He also made a point of soon returning to the neighborhood with copies of the photographs he had taken as gifts for his subjects.

Encouraged by his wife, Rogovin revisited the same neighborhood ten and then twenty years later to record the same groups of people. *Lower West Side Quartet* (*Grandparents — Baptism Boy*) (1974, 1985, 1992, 2001) was Rogovin's unique attempt to photograph his subjects a fourth time. The youth in these four portraits, Joey, was also someone with whom the Rogovins had established a particularly close relationship. The first photograph in the quartet was taken when he was baptized, and his proud grandparents stand holding the infant in his flowing white gown. Rogovin next photographed Joey, now a teenager, twelve years later, accompanied by only his grandmother, a tacit reference to the loss of the grandfather. The grandmother still stands erect, clasping the youth by the arm as both gaze forthrightly at the camera. The third photograph captures both the grandmother's physical decline as well as the grandson's growth to an impressive stature and size as he towers over and dwarfs her. Visibly frail, she leans both on her grandson and a piece of furniture for support. Joey has fondly recalled both the taking of these pictures and his grandmother:

> My grandmother always used to come stay here with us and babysit. She used to get up in the morning, make the bread, and cook food all the time. She was a good cook, but she got older and more or less stopped.
>
> In the second picture I was eight, nine years old. That picture was taken right here in our living room. I was still in grammar school, I believe. I was dressed up just for that picture. We looked forward to it.

> In the third one I was eighteen, just finishing high school. My grandmother was ninety-one, living in a nursing home.[20]

In the final photograph, Joey stands alone, a potent acknowledgment of the demise of both cherished grandparents.

Mary Frey's photograph, *My Mother, My Son* (2004) portrays another tender exchange between a grandson and a grandmother. In this work, the transformation and role reversal are even more extreme. Frey's son carries her frail mother, his grandmother, who is evidently too weak to walk, to her bed. The young man pauses at the doorway to the room, both to pose for the camera and perhaps to ponder this sad rite of passage. Reflected in the mirrored closet door are a number of ties, an indication that the concerned grandson has vacated his own room so that his grandmother can stay there. Pinned on the mirror are both a number of cards from well-wishers and photographs of the family from a presumably happier, healthier time. This photograph is from the *Family, Friends and Strangers Series* that the artist took between 2002–06. Precipitated by passing a significant birthday, Frey "began to consider how [her] life and work have been inextricably bound together for those many years."[21] In recording her own mother's illness and metamorphosis from a vital, independent person to a frail, dependent one, Frey poignantly confronts and half-heartedly accepts her own probable destiny.

U.S Census Bureau records reflect not only how attitudes but also the very structure of American family life have changed over the course of time. In 1960, 19.4% of children did not live with their parents. In the 1990s, this number rose to 42.3%. In 1950, 78.2% of households were headed by married couples in comparison to 61% in 1980 and 53% in 1998. In the late 1990s, of those couples that wed, only 60-65% had even one child. As these statistics make clear, the demise of the nuclear family is generally accepted in the 21st-century world. Nevertheless, a number of photographers who began their work in the final decades of the 1980s still found relevance in the topic both inside and outside their own family circles.

Nuclear Ceramic Family (1994) by Phil Bergerson is one of a series of photographs published in his monograph *Shards of America*. This series presents the fabric of American life in the tradition of Walker Evans, Joel Sternfeld and Lee Friedlander, whom he admittedly follows. Many of Bergerson's square images were shot at close range through a windowpane. In this particular composition, rather than images accompanied by the words, street signs or handwritten messages that frequently mark his compositions, the artist seems to acknowledge that within the nuclear family exists all the complexity of the human condition. This ceramic figurine threesome depicts a mother in a long embroidered dress holding an infant in her upraised arms for her business-suit-clad husband to admire. The father looks attentively at the child but holds his arm at a distance, seemingly fearful of physical interaction, and reinforcing the historically assumed division of labor between the sexes by his stance. Whereas *Nuclear Ceramic Family* appears to accept,

if not nostalgically yearn for, the family of days past, Judith Black, Dona Schwartz, Susan McEachern and Julie Blackmon all tackle contemporary family issues head-on with the blunt confrontational style characteristic of succeeding generations.

Dona Schwartz's *On the Nest Series* from 2007 looks at life before baby for a number of different couples in their anticipated babies' rooms. *Kristin and Ryan, 18 Days* proudly flaunt Kristin's swollen belly, while *Jason and Kevin, 7 Days*, is a photograph of the Mickey Mouse-themed nursery into which these two men will bring home a new baby, happily challenging societal norms in doing so.

When Judith Black completed her MFA in photography, she was young, divorced and raising four sons on her own. Her family became her primary subject matter as she struggled to practice her profession and raise them alone. Her portrait of her four sons before going off to spend time with their father, *Self with Children (Before Vacation with Their Father), July 14, 1984* is a frequently repeated contemporary scene. In her distinctive fashion, Susan Sontag made a trenchant comment with relevance both to Black's photography and the status of her broken family. She writes, "Photography becomes a rite of family life just when, in the industrializing countries of Europe and America, the very institution of the family starts undergoing radical surgery."[22]

Debate on the impact of feminism on our society and its future were rampant in the 1970s. A product of this milieu, Susan McEachern has identified "gender and domestic labor"[23] as major themes in her scenes of everyday life. When she began *The Family in the Context of Child-Rearing (1983-84) Series*, she not only realized that she was interested in having a family but also became aware of how biased our culture was about the traditional family configuration. In this twelve-panel work, eight are photos and the other four are statements about families from different viewpoints: psychological, historical, social, and the voice of the artist. The quotes by Henry Maine (1861), Sigmund Freud (1900) and James H.S Bossand (1953) espouse patriarchal dominance and other entrenched family values. McEachern's text provides a contradictory feminist voice, "My grandparents' generation was the first generation of my family to consider romantic love as a primary consideration in the choice of a marriage partner." From potty training to preparing dinner with a child watching, the photos in this installation portray proverbial child-rearing activities. The only inkling that the artist is questioning the legitimacy of traditional marital roles is in her words.

Elinor Carucci's photographs of her own family are notable for their candor and tenderness. Her mother, father and husband grant her and us access to the intimate moments of their lives often rejected as uninteresting subject matter in the context of the complexity of contemporary life. Yet Carucci adeptly and unobtrusively captures the kind of tender exchange between mother and grown daughter that in most families disappears long before adulthood. As a consequence, the unabashed closeness and genuine affection in *My Mother and I* (1996) becomes as much the object of our curiosity as does the drama in other family scenes. Carucci has commented on her "obsessive" picture taking of her mother, what it indicates about their relationship, and the life lessons her mother instilled in her. She has also reflected on the limitations of her medium to stop the inevitable: "I once thought that to take pictures of my mom would help me overcome the fear of time passing, but the photography only shows me the cruelty of time and even the pictures of faces without wrinkles do not comfort me."[24]

Nic Nicosia has also made his family and others like his the subject of much of his work. Yet he is one of a group of artists including Sandy Skoglund, Cindy Sherman, and Isaac Peter Witkin, who inventively interweave reality and fiction in elaborately staged tableaux that contrast starkly with Carucci's straightforward manner of presentation. Nicosia is known for his reconstructions of daily family life based on his own existence in suburban Dallas, Texas. His schooling in film and television is abundantly clear in the way that he approaches each photograph as a stage set on which his themes will play. *Domestic Drama #1* (1982) elicits an appreciative smile from any parent who has struggled to juggle family responsibilities, professional obligations, and forays into the world outside the home for either amusement or recreation. In this instance, both parents are so involved with their own grooming needs that they either do not notice, or do not care, that the child, whose toys are strewn on the floor, is scribbling on their bedroom wall. The child's unraveling of the roll of toilet paper from the father's bathroom becomes an apt metaphor for the disorder and pandemonium that child-rearing can create in a once tidy domestic interior.

Diane Arbus began her career as a commercial photographer, but it was an exhibition of her photographs alongside those of Gary Winogrand and Lee Friedlander in 1967 at The Museum of Modern Art that won her wider public recognition as an artist. In 1970 she produced *A Box of Ten Photographs* with family themes. All ten are in the collection of the New Orleans Museum of Art. Two of these photographs, which were boxed together with a clear plastic top, are in *The Art of Caring: A Look at Life through Photography*. Along with each photograph, Arbus has provided a handwritten caption. *Family in Brooklyn* (1970) is accompanied by the following inscription: "A young family in Brooklyn going for a Sunday outing. Their baby is named Dawn. Their son is retarded." Her blunt description of this family's tragedy contributed to her hallmark style.

Although known for her work in highly saturated color, New Orleans photographer Judy Cooper acknowledges her debt to Diane Arbus, Emmet Gowin and Mary Ellen Mark. Her portrait of two grown men with dogs on their laps, yet still called *Mrs. Robertson's Boys (1989),* is both indicative of how they were regarded in the community, and their inordinate dependence on their mother as adults. Through the accumulation of objects visible in

the predominately yellow tinged interior setting Cooper selected for this portrait of her neighbors, including their dresser top, crowded with bottles of medicine as well as religious images of Jesus, sculptures of Mary, a cross and a Navy banner hanging prominently on the wall behind them, the viewer can reconstruct important chapters of the two mens' lives.

Laura Gilpin's first photographs of the Navajo people date from 1930 to 1933, when a friend of hers, Elizabeth Forster, was a field nurse on the New Mexico portion of the Navajo reservation called Red Rock. The photograph in the New Orleans Museum of Art Collection, *Francis Nakai and Family* (1950), dates from Gilpin's second period of photography of the Navajo from 1950–1968, when her book, *The Enduring Navajo* was published. Just as Margaret Bourke-White has been criticized for her ideal-ized portrayal of America's tenant farmers, Gilpin's photographs have been criticized for presenting an idyllic view of the Navajo devoid of the rampant social injustices, abject poverty, abuse of spirits, and other problems that existed on this and other reservations.[25] Nevertheless, her photographs serve as an important record of how the Navajo changed over the course of the 20th century, since she determinedly photographed as many of the same subjects on her later visits as she could.

Mrs. Francis Nakai was also the subject of an earlier Gilpin photograph dating from 1932 called *Mrs. Francis Nakai and Son,* in which the mother is wearing traditional dress including a magnificent striped blanket. Her young son is dressed in western style clothing. In the later photograph, the considerably older and somber-faced mother, still in traditional garb, but now seated in a rocking chair, is shown with her husband and grandchildren. Remarkably absent is the young man, who was killed in World War II. The American flag, which creates a strong yet sobering backdrop, was given to the family in recognition of his service and sacrifice. Although the gazes of the mother and grandchildren are forthright, the father's look is oblique, perhaps a tacit reference to the pain his family has endured and also his resentment at being part of Gilpin's photograph.

Following in the tradition of Laura Gilpin, James Barker spent fourteen years documenting the lives of the Yup'ik Eskimo in southwest Alaska. His fastidious and insightful documentation resulted in his book, *Always Getting Ready: Upterrlainarluta Yup'ik Subsistence in Southwest Alaska.* Barker's photograph, *Grooming in Angelina Ulroan's home in Chevak, Alaska* (1977), is from this project. The title of the book and the way of life of this indigenous people in sub-arctic Alaska are synonymous. With an urgent need to hunt when the moment is propitious as well as to be constantly wary of potential danger, preparedness has a greater sense of urgency to the Yup'ik than to those who live in less challenging environ-ments. As Agnes Kelly Rostrum described to Barker: "All through the winter we are getting ready, getting ready for fishing, for berry picking, for potlatches, getting ready for winter. We are always ready to go somewhere to get foods. And because we are so religious, you know, we are always getting ready for the next life."[26]

Although much of Barker's study involved hunting and skinning seals, hauling water from a snow melt, ice fishing, guarding salmon from predators, picking berries and edible greens, and celebratory singing and dancing, in *Grooming in Angelina Ulroan's home in Chevak, Alaska,* the preparedness is of a more commonplace nature: the young children are simply being groomed for their daily activities. According to Barker, the whole scene "unfolded from one child fixing another's [hair] and then others joining in."[27]

There could not be a more stark contrast than that between the meager subsistence of the Yup'ik and the upper middle class comfort captured by Tina Barney and Jessica Todd Harper. Barney has unabashedly proclaimed, "The settings are my life."[28] Both Barney and Harper embrace the subjects and stylistic devices of the Old Masters, and in a review of Tina Barney's exhibition at The Museum of Modern Art in New York in 1990, *New York Times* art critic Michael Brenson spoke specifically of Manet as her artistic precedent, as well as how photography in general had taken on the role of depicting the "social tableau of modern life that essentially was brought into art by Manet and Degas."[29]

In Jessica Todd Harper's *Christmas Eve Dinner (2006)*, the viewer is given the opportunity to share and revel in each detail of the festive occasion, from the elaborately staged feast replete with Christmas tree-decorated plates in the foreground, to the family's own ornate tree in the background and the cards hanging on the dining room doors. Not only is the manner in which the table and rooms are decorated remarkable but also how they are illuminated either by candle, floor lamp, chandelier, or the star-like blaze of light that draws the viewer's eye to the rear of the photograph, beckoning like the star in the sky that led Joseph to Bethlehem. Even the table settings sparkle in this scene, which is also suffused by a glow from family members gathered together, drinking wine and enjoying a holiday meal. Although somewhat quizzical to an observer outside Harper's family circle, each guest has donned a crown, which must be a beloved and time-honored family ritual acknowledged by both adults and children.

Family traditions can be transmitted and preserved through sound, touch, and movement, as well as special celebrations. Chicago photog-rapher Cecil McDonald's portrait of his two daughters, *1200 Meditations, Things My Mother Gave Me (2005),* acknowledges a love for and knowl-edge of music passed from generation to generation in his family. Each detail has been selected to pay tribute to "the gift of music" that the artist's mother gave to him. He is conscientiously passing on to this heritage to his daughters in the form of vinyl records now as obsolete as the model 1200 "turntable that changed the landscape of music."[30] McDonald reinforces his allegory by placing the outmoded turntable on a classical pedestal.

The photographs *Hugo and Dylan 2* (2006) by Loretta Lux, *Kiss Goodnight* (1988) by Sally Mann, and Nicholas Nixon's portrait of *The Brown Sisters* (1980), each portray tender exchanges between siblings. In Lux's photo, one of a series of double portraits, in which the subjects project simultaneous feelings of intimacy and alienation, the older brother helps the younger brother button his shirt. In Mann's photograph, the siblings' goodnight kiss appears both affectionate and provocative, typical of the artist's portrayal of her children. The Nixon portrait is one of many the photographer took of his wife Bebe and her three sisters, who were his subjects one day each year since 1975. With the second *Nicholas Nixon Brown Sisters* monograph in 2007, The Museum of Modern Art acknowledged the popularity and the power of this annual picture-taking tradition. The four women evidence their affection for each other and gracefully age before our eyes. As one turns page after page and stares at their transformation in both physiognomy and stance, the viewer eerily glimpses his or her own inevitable aging process and mortality.

Raking leaves, playing in the yard, swimming in a neighbor's pool, Christmas caroling, grilling, sharing a meal, watching TV, Bill Owens' photographic essay and book, *Suburbia (1973)*, aptly chronicled the middle-class migration away from metropolitan settings. His subject was Livermore, California, where he lived. Livermore was also symbolic of innumerable such suburbs across the United States that were burgeoning at the time. A news photographer, Owens took one day off from his job each week to take the photos in his book, which documents the euphoria of many first time homeowners.

Despite the inscription that accompanies Owens' photograph, *We're really happy our kids are healthy, we eat good food, and we have a really nice home*, all is not perfect in suburbia. Visible through their sliding door and window is an electrical plant indicative of how housing developments such as theirs would exact an increasingly devastating toll on the formerly virgin landscape. It is also important to place this photo and the others that Owens took for his study within the political context of the time. President Richard Nixon had won a second term in office, and the Vietnam War raged on. Another photograph in Owens' book shows a woman in rollers holding her baby in the kitchen. She expresses the seething emotions of the era by exclaiming: "How can I worry about the damned dishes when there are children dying in Vietnam."

Also a product of the seventies, Eugene Richards' *Family Album, Dorchester, Massachusetts* (1976) is another familial kitchen scene. In this case, the subject is the deteriorating working class neighborhood in which Richards grew up. Although a traditional family album is being shown off in the foreground, the young boy's posture and the close cropped shot alert the viewer to the fact that the composition may have been contrived and that the scene, once again, may not be as complacent as it appears.

For Carrie Mae Weems, the kitchen is also often the focus of familial drama. To someone unfamiliar with the complex motivations behind Weems'

works, the triptych *Untitled #2450* (1990) might look like a fairly typical mother-daughter scene. Yet, rather than simply fraught with the after school drama and tension that a mother's normal supervision of a child's homework often provokes, Weems' composition speaks to more than the mother's responsibility. She is also displaying the resentment that having an unwanted child with an absent father creates in the context of what she saw as the distinctive African American experience of the time.

There is a strange similarity between compositions like Weems', which have been purposefully constructed, and presumably more spontaneous records of family occasions. As has been amply illustrated, even in the midst of the seemingly happiest family there is often a yearning for something more — more money, more understanding, more camaraderie, more time together. Whatever a family as a whole, or individual members feel is lacking, the obligatory family portrait - when each member of the group is told to smile, not move, and comply with the photographer's wishes — often captures a feigned moment in everyone's lives that conceals the drama that seethes beneath the surface.

The focus in the previous photographs has been on family life in America. John Hinde, recognized as a major innovator in color photography in Britain and Ireland, provided a fascinating look at family vacations in these countries beginning in the late 1960s and continuing through the 1970s. Hinde's studio in Dublin produced a series of postcards that were sold at Butlin's popular resorts in England and Ireland. What began as a modest enterprise, evolved into the most successful postcard publishing business in the world with annual sales of 50 million postcards. At Butlin's, every moment of the vacationer's day was skillfully planned with such astounding success, that these resorts became synonymous with the ultimate in carefree family vacationing. By the time they closed in 1972, more than ten million people had taken a vacation at one of Butlin's nine resorts.

What began as postcards may well have remained as postcards, if these striking images had not caught the eye of photographer Martin Paar, who had once been employed as a photographer at this British resort. Hinde's color photography held a certain allure for Paar at a time when color was not yet taken seriously. Paar began to collect Hinde's work, until bringing the enigmatic photographs to the public became a personal mission. He convinced the Museum of Modern Art in Dublin to mount an exhibition. And, in 2002 the first version of a publication of Hinde's work appeared with an essay by Paar that took as its title Butlin's slogan for his parks, *Our True Intent is All For Your Delight*. In this publication, Paar recalled his amazement when he first saw Hinde's work and thought that his own attempts to capture the camp paled in comparison: "The impact…was intense and they have haunted me ever since. Each image offers everything a good photo should. They are entertaining, acutely observed, and have great historical value." [31]

These beguiling photos recall British family life in the 1970s. The colorful photograph of a *Corner of the Children's Playroom* (c.1970), taken with a 4 x 5 camera on Ektachrome film, was attributed to John Hinde, but was actually taken by his staff photographer, Elmar Ludwig, following Hinde's stylistic direction. The red, yellow and blue of the linoleum tiles on the floor is a color theme that is echoed throughout the cheerful playroom replete with a small carrousel, boats and other fanciful carnival figures and toys for the amusement of the young vacationers. Immaculately clad blue and white uniformed nurses attentively care for the children while their parents enjoy their own adult activities elsewhere at the resort.

Life events often irreparably change photographic subject matter for better or worse. Before her own daughter, Emma, was born, Melissa Ann Pinney's subjects were often adult women. After Emma's birth, the artist became happily preoccupied with capturing her child at home, at play and in daily interchanges with other family members and friends. In *Disney World, Orlando* (1998), Pinney has focused on a little celebrated yet essential aspect of parenting. In this amusement park facility, the corner of the room designated as a changing area for diaper-clad children and the mothers who are changing them is so crowded that one mother, only partially visible at the far left, stands holding her child waiting for her turn at the changing table. Several children old enough not to wear diapers but not old enough to be trusted to stay safely outside wait for their mothers to finish caring for a younger sibling. Pinney has skillfully captured the frenzy and bustle of these mothers as they juggle their various child-rearing responsibilities, and has imbued this most mundane scene with a sense of appreciation for mothers who endure challenging situations to care for their young.

In my selection of photographs for each section of this exhibition, I tried to balance both world views and circumstances. Consequently, in *Children & Family*, I did not shy away from showing tough or painful as well as non-traditional situations. In contrast to the photographs of Tina Barney, Jessica Todd Harper and John Hinde, as well as numerous others who document their families and others enjoying fortunate lives, the abandoned babies in Sebastião Salgado's memorable photograph *São Paulo, Brazil: Abandoned babies playing on the roof of FEBEM (Foundation for Child Welfare) Center* (1996) were not. Salgado's belief that provoking and participating in debate is a critical function of the documentary photographer echoes sentiments similar to my own. He has explained:

> I believe that there is no person in the world that must be protected from pictures. Everything that happens in the world must be shown and people around the world must have an idea of what's happening to the other people around the world. I believe this is the function of the vector that the documentary photographer must have, to show one person's existence to another.[32]

Salgado's photo documents an incomprehensible act, that is, the abandonment of so many babies by an inconceivable number of mothers and fathers. Also remarkable is the critical role that the caregivers at FEBEM play in literally saving the lives of these abandoned infants. Salgado sees these children as victims of the "sudden migration to a large city [which causes] the disintegration of families".[33] When he took this photograph, 430 babies lived at the Center. Thirty-five percent of them had been left on the street, while the others were brought to the Center by parents no longer able to take care of them. The staggering number of forsaken infants is a testament to the rest of the world of the enormity of the poverty that exists in Brazil. Silhouetted against the *São Paulo* skyline, the lone infant in a high chair is an indelible metaphor for the instability in the lives of these babies, any of whom could have slipped off the face of the earth as easily as off the roof were it not for the care provided by this facility.

Salgado is known for his in-depth studies of the subjects he chooses, and he often travels the world for many years to complete his research. In a similar fashion and also akin to the way in which Walker Evans and James Agee successfully captured the migrant workers' story in their epic study, Misty Keasler immerses herself in the lives of those she photographs. A documentary photographer of a younger generation, who is gaining considerable renown, Keasler is dedicated to taking pictures with strong social content, and to portraying her subjects whether living in orphanages, love hotels or garbage dumps with respect and dignity. Keasler's *Orphanage Series*, which began as a trip to photograph orphanages in Guatemala, turned into a series of photographs taken at orphanages all over the world. In *Afternoon Bathtime, Mi Hogar Zacapa, Guatemala* (*Orphanage Series*) (2003) Keasler photographed three women tending to a group of boys ranging in age from a small child on the changing table to several older youths in various stages of undress whose frenetic energy as they hurry to their baths is captured in blurry motion. Beyond the activity, Keasler exacts great care to capture her orphan subjects in settings that, despite peeling paint and sparse surroundings, will engender respect rather than pity for those in unfortunate situations who approach their plight with admirable resignation and carve out a life no matter how deplorable the circumstances.

Documentary photographer Fazal Sheikh was born in New York City in 1965 to an American mother and a Kenyan father. After studying photography with Emmet Gowin at Princeton, he began traveling to capture the world's displaced peoples through portraiture. His memorable subjects have included communities in Ethiopia, Mozambique, Sudan, Somalia, refugee camps in Kenya, survivors of the Soviet occupation of Afghanistan, and the indigenous people of Brazil. Rather than focusing on the sensational, *Gabbra tribal matriarch with Gabbra women and children, Ethiopian refugee camp, Walda, Kenya* (1993), reveals Sheikh's uncanny knack for capturing family rituals and structures.

Sheikh established his unique documentary style on his first assignment, when he and other journalists were authorized by the United Nations High Commission for Refugees to visit the Sudanese refugee camp in Kakuma. He recalls that the other photographers seemed to know exactly what shots they wanted and began to take them immediately upon arrival at the camp, however, he was unable to do so. He quickly realized that he needed to stay on in order to gather his impressions and decide how he would accomplish his photographic mission. After several days in the camp, he approached the community elder, Deng Dau and asked his permission to work in his village. This simple courtesy, which had not been extended by anyone else in his documentary group, won him the trust of the elder as well as that of the entire village, beginning a two-year collaborative documentation.

Sheikh's description of how his process of taking formal portraits of these displaced peoples became both a village event and an opportunity for dialogue is fascinating:

I use a simple Polaroid camera that yields both a positive and a negative. The slow process dictates the pace of the work. We construct the image together. Many of the people have never been photographed before, and the Polaroid provides a point of reference for the discussions that follow in which the residents of the community offer their opinions on how the documentation may unfold. [34]

Gabbra tribal matriarch with Gabbra women and children, Ethiopian refugee camp, Walda, Kenya attests to the remarkable fact that Gabbran family structure, and the bond between generations including respect for the elder, is maintained even in this displacement camp. Striking also is the way Sheikh's subjects stare directly at the camera, and hence at the viewer, in a manner that reveals the complete trust that the photographer has earned. They welcome the opportunity to tell their story to those who will listen. Clearly, Sheikh is one who will. Not only has Fazal Sheikh taken on these peoples as his subject matter, but he has also played a role in promoting awareness of the international human rights issues that he has witnessed through the distribution of thousands of his books and multimedia publications free of charge. Once again, a concerned photographer's lens and commitment have made available to the world not only an irreplaceable observation but also an understanding of circumstances and traditions otherwise too distant and imponderable.

Love

Twenty-first century love and relationships have been transformed by digital media and technology just like the rest of our lives. Online dating and chatting opportunities abound. A plethora of information about a potential companion is readily accessible on a number of online sites that provide comprehensive dating services and large member databases, and the allure of clicking through statistics and photographs of potential mates provides the same comforting familiarity and ease that an introduction through family and friends once did. Meeting a person — in person — for the first time is almost a novel concept today.

Yet despite the new dating rituals, the unprecedented acceptance of non-traditional unions, and statistics that prove marriages often do not last a lifetime, the almost universal quest to find one's ideal match — as the images in this section attest - endures. Intimacy and companionship are still both valued and sought after. Furthermore, as the wedding pictures included illustrate, both the ceremony and the photographs that capture it for the bride, groom, family and friends often do not remotely resemble those of previous generations.

Once again, a number of memorable photographs published first in LIFE magazine portrayed the exuberance of the post-war era as well as the changing nature and attitudes of our society. Alfred Eisenstaedt's *V-J Day, Times Square, New York City (*1945) portrays a sailor's elation at the end of World War II in the Pacific Theatre, to the obvious delight of a number of coincidental onlookers. The euphoria infused into this era by the defeat of the reviled dictators in Europe and the consequent newfound freedom from repression of ideas and religions, lifted a veil of primal uncertainly from the daily lives of millions of imperiled people who had lived in fear not only of repression but also for their very existence. And the new mood and optimism were pervasive.

The publication of the Kinsey Report on human sexuality in 1948 and Masters and Johnson's studies on *Human Sexuality* published in the late fifties, opened the door to further freedoms, and lifted the taboos on an open discussion of sexual practices. A photograph that John Dominis took of *Steve McQueen and his Wife Neile* (1963) demonstrates that even lust became acceptable subject matter for family magazines. Both Bill Ray's *Co-ed dorm, Oberlin College, Oberlin, Ohio* (1970) and Grey Villet's *Wedding cake adorned with homosexual couples to be used by activists to protest New York City clerk's refusal to issue wedding licenses to homosexuals* (1971) attest to the changing attitudes and norms of the 1960s and early 1970s. In this era, anti-Vietnam War protests raged in the streets and on college campuses. Parents became resigned to the fact that their children would be living in co-ed dorms and sharing co-ed bathrooms, and the intoxicating chant of "sex, drugs and rock 'n' roll" blared on the radio, at school dances and virtually everywhere that young people gathered.

Rights for homosexuals were also openly debated. The layering and frosted roses on the wedding cake featured in Villet's photograph resemble the decorations on traditional wedding cakes, however, the top layer is adorned with two same sex couples: two women in wedding dresses on one side and two men in groom's attire on the other separated by the Lambda symbol. Provoked by the New York City clerk's refusal to issue wedding licenses to homosexual couples, the heart on this atypical wedding cake proclaims: "Gay Power to Gay Love."

Protests like that featured in Villet's photo have contributed to the steadily growing acceptance of homosexuality over the past four decades. According to a study published by the Kaiser Family Foundation, in 1983 only 24% of the general population in America knew someone who is gay, lesbian or bisexual; this number rose in 1993 to 43 %; to 55 % in 1998; and to 62% in 2000. Based on these statistics, Nicholas Nixon's *J.F., D.C., Boston* (2000), a photograph of two men kissing in public, was still a relatively uncommon image at the time it was taken.

Sometimes, seemingly oblivious to the world around them, certain photographers have had the ability to create timeless images that reflect their own lives unaffected by time and place. Harry Callahan and Lee Friedlander are two such photographers. Their repeated photography of their spouses reveals how their wives were not only frequent subjects but also the objects of an intense lifelong love that was both inspirational and inextricable from their art.

In Harry Callahan's *Eleanor, Chicago* (1948), his wife's figure is located to the far right of the composition and dwarfed in scale by a large window near the center of the image. Since she stands with her back toward the viewer, the triangular panel of light emanating from the window illuminates only the edges of her face, arms and right buttock. Although proportionately small within the frame of the photograph, her figure dominates the composition in the same way that her presence was a unifying and sustaining force throughout Callahan's oeuvre.

For Lee Friedlander, another hotel room serves as the setting for *Las Vegas* (1970). The artist's partially clad wife is captured in a brilliant frame of light on the wall behind her in a dramatic composition, despite the unmade bed with rumpled sheets visible in the foreground. Almost magically, the photographer's shadow is superimposed upon her. Insinuating his presence into a composition via his reflection in a window was a compositional strategy that Friedlander had used on other occasions, when the subject was unknown to him. In this instance, however, it reinforces his emotional proximity to his wife, Maria. This intimacy is crucial to the success of the photo.

In the preface to Friedlander's monograph, *Family*, Maria Friedlander recalls how art critic Richard B. Woodward described *Las Vegas* "as…a portrait of a marriage in which [Lee's] photography has overshadowed both [our] lives." Maria admitted to the partial veracity of this writer's comments and even extended his observation to include "all four of our lives,"[35] that is, both theirs and their children's. More than anything else, I see this image as representative of a union in which two lives are so perfectly blended that they are indistinguishable one from the other. Photography proffered the perfect medium through which to express this relationship. Lee's incessant picture-taking of their family, documenting their love for posterity, is an integral part of what has kept these two individuals together in a mutually gratifying union for more than forty years.

During the Great Depression, Dorothea Lange photographed the lives of the poverty-stricken people of San Francisco, in soup kitchens, on strike, or living homeless on the streets. In later years, and during more prosperous times, she returned to San Francisco, but her subjects, like the times had changed. Partially attributable to her own deteriorating health, she now seemed to find joy in expressing some of life's simpler pleasures and themes. The elderly man pushing his wheelchair-bound-wife in *Love in Berkley: University Avenue* (1955) attests to an enduring affection that has evolved into a caregiving role that continues to evidence their love.

A similar manifestation of lifelong affection is apparent in Keith Carter's *Wedding Ring* (1981) in which the wife tenderly places her wrinkled and age-spotted left hand on the head of her husband, who is covered by blankets and lying in an elevated bed. His face is turned away from the viewer so that only wisps of his white hair, forehead and prominent nose are visible. A closer look reveals that his wife wears both his wedding band and her own, either for safekeeping during hospitalization or in anticipation of his death. The tight cropping of this photograph, common to Keith Carter's work, accentuates the intimacy of the exchange, shields the viewer from a potentially uncomfortable proximity, and disguises the identity of the couple.

In contrast to Lange's and Carter's photographs, the broadly smiling faces of the elderly couple in Ed Kashi's *Florida (2001)* convey their delight in having found a loving relationship, despite the odds, when both wed in their eighties Their good fortune was shared in a ceremony attended by several hundred equally elated family members and friends. Similarly, the affection between George Cecil Winsor and Lettice Edwards Winsor, his wife of many years, the subjects of one of Chester Higgins' memorable portraits published in his monograph *Elder Grace,* is obvious in their happy faces and warm embrace. Despite new ways of meeting and acceptance, there are still some tried and true secrets to deeper understanding and a more harmonious relationship. As George Cecil Winsor advises the viewer: "The key to a happy marriage is having a keen understanding of your spouse. Even if you disagree, listen."[36]

Jessica Todd Harper's *Self-Portrait with Christopher and My Future In-Laws (2001)*, is a contemporary love scene, although some of the pictorial conceits hark back to Renaissance painting. Harper stands somewhat self-consciously in a strapless black sheath directly across from her fiancé, Christopher, and between his parents, seemingly so each can get a good view of her. In what is thinly guised as a meeting but appears to the casual observer as much more of an inspection, her future mother-in-law looks rather grim in her stiff black hat and dress. Her future father-in-law, in contrast, sits more casually in a folding chair with his hands clasped, as if cognizant of the tension inherent in this meeting but somewhat removed from it. A vertical mirror behind Harper shows her reflection from behind, and also reveals the face of her fiancé, who is attentively and supportively returning her gaze.

In her use of a mirror as an artistic conceit, Jessica Todd Harper follows a tradition established in some of the greatest paintings of all time, most notably: Jan Van Eyck's *Arnolfini Portrait*, Diego Velazquez's *Las Meninas* and Edouard Manet's *A Bar at the Folies-Bergère*. The comparison between Harper's photographs and paintings by European masters is not simply a coincidence. The artist admits that copying paintings as a child on museum visits with her mother and sister, guided her in choosing to major in art history in college where she "fell in love with Vermeer, Memling, Pieter de Hooch and other Northern European artists, who at first glance seem to make paintings about nothing everyday-ness, but whose charged, quiet domestic scenes haunted me afterwards." These artists as well as Sally Mann and Andrew Wyeth, continue to inform her own work, which she describes as "about identity, familial relationships and the unspoken things that make up the stories of our lives." [37] The eye contact between Harper and her fiancé reflected in the mirror adroitly illustrates the kind of non-verbal exchange that she seeks.

The bride and groom in Tina Barney's *The Wedding Portrait* (1993) are embarking on their wedded lives with the traditional pomp and splendor of elaborate gowns and formal portraits. In Barney's photo, members of the wedding party, who are obediently following instructions for this shot, surround the bride and focus their attention on the placement of her gown. The setting, replete with an American Impressionist painting above the fireplace, as well as their formal attire and jewelry, reflects their privileged social milieu.

Barney's wedding scene is in strong contrast to the festivities portrayed in the wedding portrait of Chris Verene's bride and groom in *My Cousin Candi's Wedding* (1994). In Verene's photo, the newlyweds are joined by the bride's "two favorite customers from her job at the Sirloin Stockade." With a large American flag as the backdrop, Candi and her husband cheerfully pose with these customers, who are dressed in their best cowboy outfits and hats. Lavish floral displays have been replaced by simple arrangements decorated with red and black balloons.

Nick Wapplington's *Wedding Party (1996)* clearly portrays a second marriage for both bride and groom. As they exit from the ceremony, the couple is surrounded by a bevy of children, presumably from prior marriages, who will now be blended into one household. The viewer wonders if the dour expression on this bride's face, as well as the reticence of some of the children accurately reflects their sentiments or is just an unintentional wedding day moment captured and preserved by a photographer who did not give the bride the chance to edit her photo album before sharing it.

This photograph exemplifies the growing acceptance and incidence of interracial marriages in America., This trend is particularly remarkable because only a little more than forty years ago, it took a Supreme Court ruling (*Loving v. Virginia*, June 12, 1967) to overturn a ban on whites marrying non-whites in Virginia and fifteen other states. Less than 2% of those married in 1970 were interracial couples; however, in 2005 the number rose to more than 7% of the 59 million married couples in America. The increase in interracial marriages was so great, in fact, that since 2000 the federal government has allowed Americans to check one more than one race on census forms. As a consequence, 2.4% of the population or about 6.8 million people designate themselves as multi-racial.

Wedding photos are often the product of an emotionally charged atmosphere replete with expectations, raw nerves, family hostilities, sibling rivalries, jealousies and pangs of possible regret, even fear. Steps must be taken so that neither one side of the family nor one set of friends feels slighted. Family dynamics are often balanced behind the carefully orchestrated photographs.

Although the psychodynamics of such marital preparations seem momentous to all the participants at the time, the story behind *Marine Wedding* (2006) by Nina Berman is a drama that not only transcends the occasion but also touches everyone who views it. The 24-year-old groom in this photo is Ty Ziegel, a former Marine sergeant, who served in Iraq and was decorated with the numerous combat medals, including a Purple Heart, that adorn his dress uniform. His expressionless face is a result of nineteen surgical procedures to restore as much of the skin as possible that was melted away when he was trapped in a truck fire triggered by a suicide bomber. His childhood sweetheart, Renee Kline, 21, stands stoically by his side. Berman's portrait is a moving testimony to the commitment and bravery of this couple, whose wedding plans were not deterred by his horrific wounds. It is also a reminder to us all of the extraordinary sacrifices made by those who protect us and our country, and the extent to which we are indebted to them for our security both in the United States and abroad.

Flights into the imaginary have been acceptable subject matter for painting and sculpture for centuries. Photography, a much newer medium, had always relied on what the photographer could see in order to photograph it, and was the last art form to integrate the staging of subject matter into its artistic process. Once fantasy was introduced into the photographer's domain, artists began creating ever more complex settings for their subjects.

Arthur Tress was an early innovator in this genre. Over the course of his nearly fifty-year career, Tress' works have ranged from photojournalistic to surrealistic. Both of his photographs in this exhibition fall into the latter category. [38]

In *Stephen Brecht, Bride and Groom (1970),* Arthur Tress composed a memorable wedding portrait in which the couple is joined together as one figure that is half-bride half-groom. The pair stands upon a pile of shattered pews strewn across the floor of the desolate and decaying church replete with water stained, crumbling walls that form a backdrop for this foreboding composition. Tress, who was blatantly homosexual, seems to be commenting on the sanctity of marriage vows and the significance of heterosexual "union." The female part of this couple demurely holds the skirt

of her multi-layered-lace-wedding gown in anticipation of wedded bliss. In contrast, with his eyes closed, his mouth downturned, and his hand held up as if taking an oath, the male part of the couple is assuming neither the traditional expression nor the comportment of an expectant groom. The fact that no one else has come to witness this marriage makes the scene even more ominous. Despite all the glaring warning signals, the pair moves forward unmindful of the ruin around them and determined to wed.

In the 1980s, Sandy Skoglund became known for the elaborate sets she began constructing for her photographs, with improbably populated scenes in which large numbers of radioactive cats and red foxes take center stage. With color established as a legitimate medium, Skoglund utilized a palette so fully saturated that a blazing heat seems to emanate from her predominately red *The Wedding* (1994). Even the bride and groom are both clothed in red, and an ornate deep red four-tiered wedding cake dominates the foreground of this bizarre scene. Skoglund has decorated both the walls and floors with three hundred ceramic roses that she fabricated, which adhere to the sticky surfaces composed of strawberry jam on the walls and orange marmalade on the floor. Is Skoglund intimating that marriage is a "stickier business" than most newlyweds imagine? Or was red selected to portray the heated passion of the much-anticipated wedding night? Known for her highly original, complex and labor-intensive compositions, Skoglund's record of this unusual wedding is a memorable and welcome antithesis to the traditional wedding portrait.

Among those who built upon the heritage established by Tress in photos such as *Stephen Brecht, Bride and Groom*, Duane Michals stands out as among the most inventive. To this day, his both fanciful and familiar compositions accompanied by words cause us to pause and reevaluate many aspects of our lives including love, death and life beyond death. The couple entwined and peacefully sleeping on a tatami mat in *Lovers Sleep as One* (2005) with its accompanying inscription, "Lovers Sleep as One. Each dreaming of the other," provokes the viewer to accept, question and analyze his interpretation in quick succession.

In stark contrast to some of the previous photographs, no elaborate sets were necessary when Norwegian photographer Karl O. Orud took his picture of *The Brides of Sofiiska* (2006). On this busy wedding day in the Bulgarian capitol, more than sixty brides were married by the priest in a lovely church adorned by onion-shaped gold-plated domes and mural paintings.

Artist Robert Indiana first exhibited his *LOVE Series* of paintings and sculpture in New York in 1966. This iconic artwork was adapted for a multiplicity of uses including t-shirts, coffee mugs, and stationery in an era when free love abounded, and the Beatles proclaimed "All You Need Is Love," to a Vietnam War weary world. More than forty years later, Indiana's classic artwork once again shows its timeless appeal to a new generation in Silas Shabelawska's *Love Series* that playfully pays homage to it.

Rather than spelled out in paint, steel or another material, Shabelawska has formed Indiana's noteworthy design out of human beings both clothed and unclothed and then photographed them.

Wellness

From the everyday exuberance of carefree children on a playground or families in their backyards, to those who overcome enormous disabilities to participate in sports, or others whose lives revolve around preparation for competition at the highest level, the photographs in this section attest to the enormous benefits of making physical fitness and wellness a part of our daily routines. The value of wellness extends beyond our personal lives. With obesity and its coincident diseases in epidemic proportions in America, our health care system is challenged both financially and in terms of the ability of our trained health care professionals to care for all those who need their assistance. According to the U.S. Department of Health and Human Services Centers for Disease Control and Prevention, in 2009 more than one-third of the adults in the United States — more than 72 million people — are obese, 16% of American children are obese, and 24 million adults are considered morbidly obese - weighing more than 100 pounds above ideal body weight. [39] A report released by the U.S. Census Bureau in August 2008 revealed that 45.7 million Americans were still without health insurance coverage in 2007, and many were forced to care for themselves and their loved ones even though they were not qualified to do so. The incidence of substance abuse also showed an increase, with abusers less able to seek care due to the bleak financial situation in our country and the world. In these times, when critical medical decisions and basic care are often complicated or compromised by financial exigencies, our newfound focus on becoming a fit and healthy nation is far more than a matter of vanity, it is a matter of survival.

The startling increase in childhood obesity has touched our communal conscience and shifted our national interest towards healthy eating and healthy living, beginning with the infant in utero. School classrooms and cafeterias have assumed the role of educational forums for the distribution of information about nutrition; school lunch menus have become more health conscious; soft drink and candy machines have been removed from public and private school cafeterias or other areas accessible to students during the school day. Insurance companies monitor the medical test results of their participants and suggest alternative, healthier lifestyle practices. There is a bottom line: poor health is costly to the American economy, particularly at a moment when it cannot bear any more strain.

The other sections of this exhibition focus on how caring is most often demonstrated by an exchange between family members, friends, trained professionals and those in their charge. This section focuses on how the subjects take care of themselves through physical activity, even though they are sometimes unaware of the physical benefit these activities provide. The

importance of adhering to an exercise routine and maintaining a healthy weight is amply substantiated. Yet among adults, 30% do not participate in any physical activity, and 50% of those who start an exercise program will stop within six months. The World Health Organization estimated that in 2000, this inactivity cost the United States $75 billion.[40] Although trainers may demonstrate routines, families and friends may be encouraging and supportive, and schools may enforce certain guidelines, physical health and the amount of energy and dedication with which any individual pursues his or her daily or weekly regime, is largely dependent on the individual's own willingness and mental attitude.

These images also reflect the changing times. Peter Stackpole's photograph of children engaged in various schoolyard activities, including holding hands in a circle and swinging during school recess, appeared in LIFE magazine in 1945. The young children in the photo, captioned *Black and white children playing in school playground,* are unaware of any deeper significance. Yet it would be almost another decade before schools in the South were forcibly integrated by a landmark Supreme Court decision (*Brown v. Board of Education*, 1954).

A similarly action-packed playground scene was captured by Philippe Halsman, who was often commissioned by the motion picture studios to take photographs of celebrities such as Greta Garbo, Johnny Weissmuller and Hedy Lamarr, to document public lives in a manner consistent with their celebrity and much sought after mystique. *Danny Kaye* (1960) did not need to stage his photograph on a playground surrounded by adoring children who cling to him. Kaye was the original UNICEF celebrity and served as a Goodwill Ambassador from 1954 until he died in 1987. As Halsman's photo makes clear, Kaye enjoyed this interchange every bit as much as the children and expressed with heartfelt emotion what motivated his tireless efforts for children around the world:

> I believe deeply that children are more powerful than oil, more beautiful than rivers, more precious than any other natural resource a country can have …I feel that the most rewarding thing I have ever done in my life is to be associated with UNICEF.[41]

Harold Edgerton was a much beloved professor at Massachusetts Institute of Technology, where he began teaching electrical engineering in 1934. Although firmly grounded in scientific principles, the photographs for which Edgerton achieved worldwide renown represented the penultimate intersection of science and art. In this interest, he was the artistic heir to 19th century photographer Eadweard Muybridge, who was obsessed with visualizing movement in a manner that made it comprehensible in ways previously impossible for the human eye to view and grasp. Whereas it took Muybridge up to fifty cameras to capture the movement of a horse on a track, Edgerton developed an electronic stroboscope and masterfully used this technology to capture numerous athletes as they demonstrated their prowess, including fencers, dancers, pole-vaulters, golfers, archers, ping-pong players, and circus performers in the midst of acrobatic feats.

Both Edgerton's *Diver* (1955) and *Moving Skipping Rope* (ca. 1960) incomparably depict the movement and exertion expended by those engaged in these two activities. In *Moving Skipping Rope* a simple everyday repetitive action has been elevated to a complex choreography of line and motion. The pleasure the girl is deriving from this common childhood pastime, as well as the intricate curvilinear patterns created by the rope and the even more sumptuous movement of her plaid skirt, have been captured by Edgerton's stroboscope, a multi-flash system fired thirty times per second. Similarly, in *Diver*, Charles Batterman, a coach at the university, is captured in four different poses in midair as he dives into the MIT pool. Despite all the recent advances in visualization of the previously invisible through sophisticated computer graphics techniques, Edgerton's photographs still intrigue, delight and inform.

The gravity-defying leap of Aaron Siskind's solitary figure in *Pleasures and Terrors of Levitation #99* (1961) from his *Pleasures and Terrors of Levitation Series* exerts a similarly enigmatic fascination upon the viewer, who is puzzled by his manner of elevation. In fact, the photographer captured these divers as they leapt through the air while positioned with his camera beneath them.

In the early to mid-60s, at the moment when surfing was becoming a culture as well as a lifestyle, LeRoy Grannis participated in the scene as well as documented it. Surfing was a way of life for him beginning in his youth in California in the 1930s, when he became one of the best surfers in the state. Grannis' skill enabled him to take his photos while on a surfboard himself, endowing them with an immediacy, excitement and thrill impossible to capture from a static location on shore. Grannis even devised a rubber-lined box for his camera so that unlike other surfer-photographers he didn't have to go back to land to reload his film. Steve Barlotti has commented in his book, *LeRoy Grannis: Surf Photography of the 1960s and 1970s* that especially between 1960 and 1965 Grannis's photos "captured the real thing, providing a bridge between the world of Beach Boy lyrics and the reality of the Southern California beach scene. Surf language, surf music, surf art, surf media, surf fashion, Grannis was one of the few surf photographers to swing his camera off the wave action and record it all."[42] It was also during this period of time that Grannis helped start the popular magazine *Surfing Illustrated*.

LeRoy Grannis has taken photographs of many amazing surfers of the '50s and '60s. *John Boozer, Pipeline No. 65* (1966) is remarkable not only for how it portrays the surfer's daring but also for the dramatic abstract composition. The solitary surfer is silhouetted against azure and deep purple waves so mountainous that were it not for his consummate skill they would submerge him. A tall white froth of water cuts a swathe across the middle of the composition and accentuates this surfing drama.

Photographer Neal Slavin is well known for his unique ability to capture the essence of a group of people, gathered together either because of their profession, avocation, family or other common interests. In so doing, these portraits comment on not only the activities of the gathered groups but also on the different societies of which they are a product. Both *The Channel Swimmers Association* (1986) and *Great Britain Paraplegic Weight Lifting Team* (July 2,1984) are part of a series of large Polaroid photographs shot over the course of a several year journey, during which Slavin traveled throughout Great Britain in search of selected subjects and others to be published in his book, *Britons*. Rather than casual photographic records, these remarkable portraits required the complex choreography of Slavin and a team of three others, who coordinated every shoot as if on a cinematic set.

Each of the seven athletes posed in the *Channel Swimmers Association* maintained a rigorous training schedule in order to accomplish this impressive swim; however, for one member of this group, Bill Steen, who is standing second from the right, this feat was even more significant. Paralyzed on the right side of his face following surgery for a brain tumor, Steen was the first disabled swimmer from Great Britain, and only the third disabled person in the world, to complete this swim. The achievements of the girl and boy seated in the front are also remarkable, as they are the youngest male and female swimmers to finish the swim. The three subjects in *Great Britain Paraplegic Weight Lifting Team*, each of whom is paralyzed from the waist down, are superbly conditioned and able to compete successfully in weight lifting contests with a sense of pride and accomplishment. Both the *Channel Swimmers Association* and the *Great Britain Paraplegic Weight Lifting Team* attest to the power of the human spirit and body to overcome seemingly insurmountable challenges. For both groups of athletes, achieving wellness to the greatest extent possible despite their physical challenges is a valuable component of their ability to maintain self worth and acceptance of their limitations.

Just as American photographer Neal Slavin found his subject matter in Great Britain, Peter Granser, who was born in Hanover, Germany, in 1971, is one of a group of emerging European artists fascinated with American society. Since his *Sun City Series* of 50 photographs debuted in 2001, his work has been garnering increasing international recognition. Sun City was built in 1960 by developer Del Webb outside Phoenix, Arizona, for senior citizens age 55 and upward as the first seniors-only retirement community in America. Both the photographer's fascination with, and admiration for, the residents of Sun City is obvious. Although an outsider in both age and nationality, Granser clearly won the trust and acceptance of those he documented. Granser has written that his interest in this population was motivated by watching his own "grandparents (who died in the last three years) getting old." Observing them initiated his own reflections on the aging process and "our aging society and the problems that this increase in age

brings." Sun City afforded him the opportunity to "look at aging with a little amusing touch."[43]

Although arguably Granser's photographs could have been placed in the section on Aging, the 35,000 residents of Sun City admirably exemplify how an aging population can lead active, productive, and community-oriented lives. Granser did not shy away from the quirkiness of such a community and the artificiality of such an existence, in a seemingly idyllic setting complete with pink flamingos adorning the lawns. He portrayed these aspects of Sun City life in an anecdotal manner that is both straightforward and respectful.

The early retirees, who are the subjects of this series, lead vital, sun-drenched lives under perpetually blue skies. Wellness in older age is a pervasive theme, and Sun City's residents take every opportunity they can to keep their bodies and minds healthy and vital. Swimming, dancing, bowling, target practice and community volunteerism, ranging from assisting the police to picking up litter, all have been observed and documented by this artist. Floating on their backs in an azure colored pool, the man and the woman in *Couple in a Pool* (2000) seem to radiate the "good life" they are leading. The smiling faces and the Rockette-like poses of the relatively scantily clad group, *Tip Top Dancers* (2000), wearing short black skirts, silver heels, and yellow shirts with a red accent at their throats and around their necks, flaunt a defiance for their designation as senior citizens.

Chester Higgins' portrait of *Ruth Higgins* (2000) at the barre, displays how regular practice continues to hone her agility and ballet skills and has enabled her to grow old gracefully. Akin to Peter Granser's Sun City residents who worked hard at staying young while growing old, Higgins' subject demonstrates that maintenance of wellness in older age is not only desirable but also attainable.

In contrast to the subjects of the previous photographs by Higgins and Granser, in Melissa Ann Pinney's color photograph, *Kanaha State Park, Maui* (2002), her daughter, Emma, and some friends pose for the camera. As they play in the branches of a large portia tree not very high off the ground, Pinney's subjects are transported, like many youngsters who climb trees, to far away imaginary castles nestled in the limbs and daring adventures limited only by their own imagination. Emma is seated in the center of the trunk with her gaze turned upward toward another girl, who shares her pleasure in assuming a photogenic pose. Another friend, clutching a doll on the lowest limb in the foreground, stares straight at the camera and looks less happy that her play has been disrupted. With their shoes strewn on the ground as well as suspended from the tree, this image epitomizes the reckless abandon of childhood so cherished in later years, when youthful play is replaced by the obligatory run or hour in the gym as part of a regular exercise regime.

Yet youth athletics today can certainly not be characterized as carefree for either the juvenile athletes or their parents, who often juggle their already

inordinate professional responsibilities with driving, coaching and watching endless soccer games, baseball games, football games, neighborhood basketball, tennis games and gymnastics. What motivates photographer Dona Schwartz and other parents to keep up with these demanding schedules is a belief "that sport teaches kids cooperation, drives their competition, drives their competitive spirits, helps them learn self-sacrifice ('there is no "I" in team')."[44] Playing sports is valued for teaching important lessons as well as imparting critical later life skills. These events also provide an opportunity for mothers and fathers alike to catch up with their own friends and benefit from the parental camaraderie. In her *Soccer Mom Series*, Schwartz has focused on her own experiences as both onlooker and coach, portrayed by the vigilant mother in *Fractured Coach* (2006), who appears to be juggling attentiveness to the game with the responsibilities of supervising the younger siblings who watch at her feet.

Catherine Opie previously produced significant bodies of work on surfing, icehouses, and gays, among other subjects. She recently turned her camera on the game of high school football and the players through portraits of individual teammates like *Dusty* (2006), as well as in shots of several teams on the playing field. Beyond his superbly conditioned youthful physique, the look on Dusty's face reveals how high school competition - with its strenuous physical demands - is an apt metaphor for the peer pressure, parental pressure and academic pressure that seethes at this age. We also catch a glimmer of Dusty's awareness of just how easily the hope for a professional career can be shattered. In men's football, only 5.8% of those who play in high school will move on to play at college on the NCAA teams. Of those who play on NCAA teams, only 2% or fewer are drafted by professional teams. And even for the relatively few who play professionally, their careers will last only an average of three to four years.[45]

Yet no matter how time-consuming and competitive the middle school and high school athletic programs may be, they contrast sharply with the regimented life of Marco van Duyvendijk's, *Contortionist girl in action at the state circus, Ulaanbaatar, Mongolia* (2004). This series of photographs portrays a young girl whose entire life is centered on her mastery of acrobatic skills that require not only extraordinary dedication and training but also remarkable agility. The lithe young contortionist received her training at the Mongolian State Circus, where the leading contortionists in the world are trained.

The California surfers LeRoy Grannis captured were adroitly displaying their mastery of the waves. In contrast, Italian photographer Massimo Vitale's beachside subjects like those in *Untitled (beach scene)* (2000- 2008) are caught off guard and simply enjoying themselves in fairly unremarkable ways that become remarkable through his portrayal of them. Vitale shoots his hallmark large format photos of people at leisure in bustling densely populated beach scenes from a tripod perched 20 feet above them. Just as lifeguards sit above the beach, so they can constantly guard the swimmers with their vigilant gazes, Vitale has turned his gaze toward the beach as well as the surf to capture everyday situations in amazing detail with his large photographs. He makes the viewer intensely aware of how even the most unsightly bodies are casually bared for public viewing in what of necessity becomes a communal activity. Vitale's bathers walk, frolic, and play ball in the sea, some conscious of the benefit of such exercise, while others simply enjoy their time at the shore.

Although the swimmers in his *The Elements: Air/Water Series* were practicing for the Olympics, what piqued Joel Meyerowitz's investigative curiosity was not their athletic prowess but the visual display of elemental phenomena created by their movements through water. As he has explained, "I watched as the air bubbles the diver brought in with her slowly gathered together, rose to the surface and went back into the atmosphere."[46] His repeated viewing of these movements from an underwater observation room caused him to reflect not only on the nature of the four basic elements of air, water, earth and fire, but also to wonder whether he could capture these phenomena in photos large enough so that the viewer could be as engaged by observing them as he was. The commanding presence of the life-size *The Elements: Air/ Water Part I, No. 6* (2007) transports the viewer to this underwater terrain and convincingly portrays both the motion and its elemental magic. Yet Meyerowitz took a liberty with this photo not available to photojournalists covering Olympic events. As he prefers to show it, the photo is turned upside down, so that what appears to be a swathe of bubbles around the diver as she rises to the surface, was actually created as she dove into the pool. The artist plans a second series that will explore Earth and Fire.

Both *Roller Coley* (2007-2008) and *Running Field* (2007-2008) by Ryan McGinley were taken during the summer of 2007, when the New York artist traversed the United States accompanied by a crew and sixteen models. Intent on capturing activities that pushed his models to the limits of their physical abilities as well as providing spectacular landscape settings, he often stretched safety guidelines by staging them cavorting amidst exploding fireworks and other special effects. McGinley takes a great deal of pride in his elaborate settings as well as his selection of the natural landscapes that serve as a foil for the physical exertion of his subjects.

Roller Coley exquisitely captures the breakneck speed of the youthful model gliding on roller blades with body bent, arms and legs extended. The raking yet diffused light bathes the energetic subject and highlights his prominent features and muscles. The golden light dissolves distinguishing landmarks in the foreground and background. Coley's position close to the left edge of the photo conveys the frenzy and rapid pace of his movement caught by McGinley just as he looks up at the viewer and the track in front of him before he vanishes out of view.

The exuberance and physical prowess of youth is also ingeniously captured in *Running Field*. Once again the viewer is captivated by the palette

and the vast, breathtaking terrain in which bleached blades of grass meet a cloud-infused sky to form the perfect backdrop for the physical exertion of the nude runner. Caught in mid-air, wearing only gym shoes, the fast paced runner appears quite literally to have leapt into our view. McGinley has not only documented youthful physical prowess, but also the exhilaration experienced by athletes performing daredevil stunts.

These photographs encompass a wide range of ages, physical activities, and degrees of exertion. Whether the activity is as everyday as Art Shay's *Hula Hoop Fun for the Whole Family* (c. 1960, 1990s print*)*, as focused as a practice routine in the morning mist before a major fight as Gordon Parks' *Muhammad Ali, Hyde Park, London* (1970), as elaborately captured as Harold Edgerton's studies of motion or as complexly staged as Ryan McGinley's feats of extreme physical prowess, the overarching theme portrayed in this section is that taking care of our physical well-being is a critical component of leading healthy, productive lives.

Caregiving & Healing

Our focus in this section is on the extraordinary actions of doctors, nurses, and others in the health profession, who compassionately tend to the needs of patients, including those suffering with terminal or chronic illnesses, rather than on specific issues relevant to their care. We also look at family members, who often heroically tend to loved ones, and in so doing make personal sacrifices and difficult decisions. What moved me profoundly when first encountering a number of these photographs is the immeasurable comfort visibly derived from an almost imperceptible exchange between a caregiver and someone who is ill.

Those individuals featured in this section are providing care at all stages of life. And just as there are many kinds of illnesses and injuries, there are many kinds of caregivers, and many kinds of healing experiences. Today healing touch, once considered a counter-culture therapy, is integrated into the spectrum of care offered in established hospitals as well as outpatient facilities and hospices. This acceptance is just one manifestation of how alternative approaches to healing and patient care are being re-evaluated in traditional medical settings.

Julie Winokur's enlightening observations about caregiving originally appeared in an award-winning study on aging illustrated with photographs by Ed Kashi. She writes:

> For those who take on the challenge of caregiving, the rewards are immense. They perform hands-on chores that take care of bare physical needs while unearthing the purest emotions. They recognize that it is an opportunity — not a burden — to stand face-to-face with mortality and to rise to the occasion. …These are the people who have the fortitude to journey into life's most fearsome destinations, and who survive the experience greatly enriched. [47]

W. Eugene Smith took some of the most memorable photographs of healing ever shot. After working as a freelancer for several magazines including *Newsweek*, *Collier's* and *Harper's Bazaar*, he joined the staff of LIFE magazine in 1939. Smith was unswervingly committed to the ability of photography to change the world by raising social consciousness. Smith's daredevil drive to capture an authentic sense of the perils and vicissitudes of battle, finally got him wounded by shrapnel on an assignment during the invasion of Okinawa during World War II.

After his arduous recovery, Smith manifested a particular affinity for the healing process and the caregivers who contribute to the recovery of those afflicted with either injury or illness. John Szarkowski, director of the Department of Photography at The Museum of Modern Art, New York, described the humanistic photo essays that Smith produced in the decade following the Second World War as probably representing "the highest success that photography achieved within the format of the magazine photo story." [48]

Country Doctor, Ernest Ceriani, Kremmling, CO (1948), from his photo essay about a country doctor, shows the devoted physician compassionately tending to the eye of a young girl who had been kicked in the head and seriously injured by a horse. Dr. Ceriani single-handedly tended day and night to all the ailments of the 2,000 citizens of the small town. When interviewed about his special interest in the concept of healer, Smith asserted: "I felt an affinity with the kind of hero you could touch back, who could inspire someone to change his life. *Country Doctor* affected people that way…That essay changed peoples' lives and gave them a feeling of inspiration for good and compassion." Smith bemusedly confided that the fascination with his article once prolonged his own treatment in an emergency room by at least four times what it should have taken for the emergency doctor to remove a piece of glass from his hand, because he was so interested in trying to figure out whether he should become a country doctor or not. [49]

This same fascination with the healing process motivated Smith's groundbreaking story, *Nurse Midwife*, published in 1951. He took this assignment so seriously that he trained for six weeks and became certified as a midwife before asking his trainer if he could do a story on her. His acclaimed photo-essay on Dr. Albert Schweitzer, *A Man of Mercy*, continued his fascination with the medical profession. For this essay, Smith visited the Albert Schweitzer Hospital, in Lambaréné, Gabon (formerly French Equatorial Africa), where Schweitzer and his wife had founded their famous missionary hospital in 1912. Smith's photograph of *Erna Spohrhanssen, nurse at Eugenia's funeral* (1954) was significant to him because the elderly woman, who is identified only by her first name, had received care at Dr. Schweitzer's hospital for a very long time.

In 1972, Smith and his wife moved to Minimata, Japan, to document the epidemic number of genetic deformities in children who had been poisoned

by industrial mercury in water contaminated by waste from the Chisso Corporation factory. The heart-wrenching photo of Ryoko Uemura holding her desperately ill daughter, Tomoko, in her arms in *Tomoko in Her Bath* (1972), epitomizes the saga of a loving mother caring for a sick child. More forcefully than any ad campaign, this photo confronted the public with the disastrous effects caused by an environmentally unfriendly and greedy corporate entity that put profit before the health of its workers and the surrounding community. Like the best of his photographs, this one was the outgrowth of a trusted relationship that had developed between the mother, Smith and his wife. Smith recalled that every time they passed by the house where Tomoko lived, "we would see that someone was always caring for her. I would see the wonderful care that the mother gave...the more I watched, the more it seemed to me that it was a summation of the most beautiful aspects of courage that people were showing in Minimata fighting the company and the government."[50] Smith also remembered that although the compositional elements of the photo took shape just as he had imagined, his greatest challenge was taking the photo through his tears. Smith used his characteristic strong darks and lights to intensify the contrast between the robust health of the mother who gazes downward unflinchingly, with the frailty and dependence of her desperately ill daughter.

This series of photos achieved Smith's desired results. The industrialists who had poisoned the waters that caused the deformities were criminally charged for their negligence. This unforgettable image has come to stand for unconscionable environmental damage by industrialists everywhere. Unfortunately, once again, he was injured while on assignment. In this egregious instance, the Chisso Corporation robbed him of his equipment and beat him so badly that he never recovered from his injuries. His wife had to take over for him and complete the story.

Bob Gomel's photograph, *Noted physician Dr. Benjamin Spock looking amused by two young patients during examination* (1962), captures a light-hearted moment in patient care. Dr. Spock's book on *Baby and Child Care*, with its detailed advice for parents, sold more than 50 million copies, making it second in sales only to the Bible itself. When we are fortunate enough to learn the stories, the drama behind many photographs is as interesting as what is captured in film. Gomel recently confided that he had taken his new wife on this photo assignment and did not think of giving her any advice about how she should conduct herself in advance of his photo shoot. To his utter dismay, his young wife took advantage of the opportunity to question Dr. Spock about some of his rules for parenting with which she disagreed.[51]

Although care for those critically ill at any age is challenging, care for Alzheimer's patients, who often appear quite healthy and yet require constant vigilance, is inordinately stressful, especially when the caregiver is a family member. Alzheimer's disease is a progressive brain disease that destroys brain cells and causes problems with memory, thinking and behavior severe enough to affect work, lifelong hobbies and social life. Alzheimer's gets worse over time and is fatal. According to the "Facts and Figures" produced by the Alzheimer's Association in 2008, someone develops Alzheimer's every 71 seconds. As many as 5.2 million people in the United States are living with Alzheimer's, and 10 million baby boomers will develop this illness, which today is the sixth-leading cause of death in the United States.

Photographers Peter Granser and Tatsumi Orimoto tackle this disease in distinctively different ways and from dissimilar vantage points, based on their relationship to, and involvement with, the care of Alzheimer's patients. Peter Granser was motivated to address this tough subject by watching his grandparents age and die. His *Alzheimer's Series*, which studies a group of individuals who will "loose everything they experienced during their life,"[52] is devoid of the lighthearted touch of his *Sun City Series*. Granser's compassionate documentation of the residents of Gradmann Haus, a facility for people with Alzheimer's in Stuttgart, Germany, near his home, does not need to show the anguished moments and distress of the patients for his viewers to sense their deep loss and bewilderment. Granser slowly won the trust of the institution, the patients and most importantly, their families. As a result, his up close documentation of the residents and their setting, bathed in gentle pastels, captures the frustration, resignation, daily challenges and deprivations experienced by his subjects. The patient's hand in *Portrait 6* (2001) moves in the jittery manner often associated with the restlessness that this disease causes in those afflicted with it. The unidentified hand placed on the patient's head and his lack of responsiveness to it, acutely expresses the exasperation of those who care for someone afflicted with Alzheimer's. These caregivers often remark that they are not even sure if their loved one realized who was with them or knew that they were there at all.

While working as an assistant to video art pioneer Nam June Paik in the early 1970s, Japanese artist Tatsumi Orimoto was greatly influenced by the interdisciplinary Fluxus movement style of Performance Art practiced by Paik, John Cage and other international artists. Fluxus encouraged an improvisational use of whatever materials were readily available. Orimoto subsequently traveled the globe, staging his own Fluxus-inspired performances, which provoked stares, hilarity and questions about his sanity wherever he appeared with multiple loaves of bread tied about his head obscuring his vision. These events garnered the nickname "Breadman" for Orimoto.

Orimoto's mother, Odai, who suffers from Alzheimer's, has been the repeated subject of his photographs as well as his performance partner. The artist's devotion to his mother, with whom he lives, is obvious as he chronicles his role as caregiver and her gradual deterioration from the illness. The multi-panel work in this exhibition from his *Breadman Son + Alzheimer Mama Series* (1996–2007) portrays a playful and tender interchange between mother and son for whom traditional forms of communication are no longer possible. Whereas in earlier photographs his mother appeared alone, in recent years,

he has assiduously documented both of them together as if to hold onto and record what he can of her before she is lost to him. Whether hugging her, playfully holding her upraised hand while he assumes a comic pose, or seated on the floor and holding her in his arms and between his legs, his devotion and attentiveness to her every need are obvious.

Orimoto's mother was the willing subject and fellow performer in his works long before Alzheimer's took its toll on her. In contrast, Maggie Steber's mother never permitted her daughter to photograph her before her physical and mental deterioration from dementia. At that time, her daughter moved her to Miami, where she lives, so that she could take care of her. For Steber, an accomplished photojournalist, whose assignments for various magazines including *National Geographic* and LIFE, took her to more than forty countries around the world, her most arduous assignment has been the chronicling of her mother's struggle. Steber first documented her mother's illness and decline in an article for the *AARP Journal*, which appeared online. Through family snapshots as well as her own recent photos, this multimedia presentation follows her mother's gradual transition from independence to assisted living and dependence on caregivers. The artist narrates the poignant piece, and her words and tone convey the full range of painful emotions that she experienced long after her mother could. She recounts:

> My mother Madge is experiencing the melancholic voyage of memory loss. Her ship is at sea and as her only child, I have booked passage on her final voyage. As we sail across on the sea of memories that describe her life…It is excruciating to watch as she disappears before my eyes. With each day she nears the horizon in this voyage she will have to finish alone…[53]

Steber confides that photo documentation is helping her deal with her sorrowful situation. She also believes that after the loss of her mother, this process will eventually help her find her own way "back home" and create "new memories" for her to cherish. Steber praises the caregivers who treat her mother "like a Princess," dressing her, feeding her and celebrating her 87th birthday with both of them. One of these caregivers is featured in her photo of her mother *Madge at Lunch* (2008).

Gillian Laub's photograph of *Ayal with his Mom and Dad on his Birthday, Tel Aviv, Israel* (2003) gives witness to another kind of family drama provoked not by illness but by the conflict in the Middle East and the coincident toll on innocent civilians as well as soldiers. Inspired by a trip she made to Israel as a teenager in 1990, Laub has returned more than a dozen times since, drawn not only by the personal discovery of her Jewish origins, but also by her intense interest in hearing the individual stories — both Arab and Israeli — "of the joy and resilience of humanity, even in the midst of this continuous political labyrinth."[54] The photographs in her *Testimony Series* were taken between 2002 and 2006, when she met with many young people irreparably scarred by the ongoing Arab-Israeli conflict whose shadow haunted their daily lives. Laub's unforgettable

photographs are each accompanied by a statement from her subject written as if it were their last will and testament. The very volatility of daily life in Israel made this fatalistic approach not unusual. Heart-wrenching photographs such as this one not only documented the healing process of these individuals but also contributed to it.

In Laub's photograph, each parent holds one of their son's hands. Amazingly, Ayal, who lost his sight and hearing when a suicide bomber seated next to him on a bus blew himself up, does not harbor resentment, but rather demonstrates remarkable compassion for the perpetrators. As he explained to Laub in Tel Aviv two years after the photograph was taken: "I understand people in pain and how they can do crazy things because of it, but I just want to live a normal peaceful life. That's why my family came here from Russia."[55]

Both leprosy and hydrocephalus, the subjects of Mary Ellen Mark's photographs, *Leprosy Patient* (1990) and *Hydrocephalic Girl* (1990) are illnesses associated with guilt, a sense of taboo, and rejection by society instigated by fear as well as misunderstanding. Her subjects and their caregivers or family members partially diffuse these myths. Their interactions demonstrate a warm bond between two individuals, both of whom are visibly benefiting from their interchange.

Mary Ellen Mark's answer to interviewer Anne-Celine Jaeger's query, "if she ever feels guilty or as if you're exploiting your subject, for example, when you took the picture of the hydrocephalic girl?"[56] reveals both her approach to picture taking as well as the feelings of her subjects. Mark replied that not only did the parents give their permission but they also expressed their pleasure that she was taking it. According to Mark: "Often viewers project their own embarrassment and discomfort when they look at difficult images. It is important to recognize all people, especially the poor and disabled. They have the right to be seen and heard also."[57] Mark's empathetic approach certainly contributed to the nurse's pleasure at being photographed with her severely disabled leper patient, flashing a smile that belies the gravity of her patient's condition.

For each compassionate caregiver and dedicated health professional who makes an incredible difference in the lives of those for whom they care, millions of others are out of reach either geographically or financially. Sebastião Salgado's documentation of efforts to administer polio vaccine worldwide was motivated by his profound desire to educate as many people as possible about the crippling effects of polio and how the illness could be eradicated through the easy administration of now readily available drugs. The efforts of the Global Polio Eradication Institute, founded in 1998, include the door-to-door distribution of polio vaccine illustrated in Salgados's photograph, *Moradabad District, India* (2001). Such concerted vaccination programs have contributed to a drop in the number paralyzed by polio from 350,000 in 1988 to fewer than 500 in 2001.

Gideon Mendel, who was born and raised in South Africa, has undertaken a similarly motivated crusade to photograph and educate about AIDS in Africa. He started photographing the AIDS epidemic in 1993 in Zimbabwe. Although vast numbers of people were already infected with the disease, there was a stigma associated with the illness. Embarking on this project took considerable commitment and courage. In Africa one out of ten adults is now infected with HIV, a greater number than anywhere else in the world. Although Mendel chose to document the AIDS epidemic in his native country, the epidemic is global. Since the first cases were diagnosed in 1981, more than 25 million people have died of AIDS. Today approximately 30 million individuals are infected with AIDS, 2 million of them children. In 2007, approximately 2 million deaths were attributed to AIDS. Since AIDS was first diagnosed in the United States in 1981, more than one-half million people have died from the disease. Currently more than 500,000 people are infected with HIV/AIDS, and each year about 56,000 new cases of HIV are diagnosed.[58] Thanks to recently developed antiretroviral drugs, a diagnosis of HIV/AIDS is no longer a death knoll but a fairly manageable chronic illness.[59] The fact that the prognosis has changed so drastically in such a short period of time attests to the concerted efforts of physicians and researchers around the world.

Gideon Mendel's haunting photographs of those suffering from AIDS as well as those striving to educate populations where the disease is pandemic exemplify some outstanding efforts to defy health statistics and expectations for many formerly out of reach of medical assistance. The anguish on the face of the young man in *Mission Hospital in Zimbabwe* (July, 1993), one of the photographs that Mendel took on his first trip to document AIDS in Africa, exemplifies the sorrow and desperation of those infected by this illness. The clasped hands — all that are visible of the unidentified individual in the foreground — are symbolic of the many who watch helplessly as someone they love or know fights off this illness.

The subject of Mendel's other photograph from the *Mission Hospital in Zimbabwe* (July, 1993), has just lost his fight and has succumbed to kidney failure. Surrounded by grieving family members and a tending physician, Mendel's straightforward photographic style makes the case for the much-needed education and medical aid requisite if this devastating disease is to be stopped.

Claire Yaffa is known for her realistic depiction of tough topics such as child abuse, children with AIDS, orphans and the homeless. When Tracy, the child portrayed in two heart-wrenching photographs *A Dying Child is Born, I* and *A Dying Child is Born, II* (1990) was born, many HIV-infected children were living into late childhood. Tracy was not so fortunate. Her mother abandoned her in the hospital after giving birth and never returned. Her numerous medical conditions kept her hospitalized until she was eight months old, when she was transferred to the Incarnation Children's Center in New York. There she spent the rest of her short life being cared for by a dedicated team that specialized in treating children with AIDS. Two individuals clutch the frighteningly tiny child in the hope of providing some solace from her pain and misery. Yaffa's poignant photo essay, *A Dying Child is Born*, follows Tracy's journey through her illness and care to her death on June 29, 1991, at Harlem Hospital, New York. Without the selfless devotion of her caregivers, this deserted baby would have died alone.

Much of Deborah Willis' work as teacher and historian has focused on the image of African Americans in photographic history. She has also conveyed this story through her own photography as well as in a series of quilts that combine fabric and photos as a way of literally and figuratively stitching together the story of her family's life. Her father had been a tailor as well as an amateur photographer, and both her grandmother and great aunt had made quilts. After being diagnosed with breast cancer in 2002, Deborah Willis turned her lens on her own journey as a breast cancer patient. Although "devastated" by the diagnosis, Willis has written that she "decided to photograph the changes in my body when I felt well enough to do so. I also wanted to photograph the moments when I felt lost so I would have a visual diary about the experience from diagnosis through chemotherapy."[60]

At the time she was diagnosed, she was chronicling the culture of African American women through a series on women in hair salons, locations where secrets about both beauty and lives are frequently shared. In the same way that she photographed her subjects in the most humbling of moments, with hair in the sink and rollers on their heads, she photographed her own scar, her transfusions, her loss of hair and her nausea. In *Sing and Chemo* (2001) her niece extends a simple but much appreciated gesture by manicuring her nails while Willis receives chemotherapy, providing company and distraction from the life-sustaining but rigorous process. In data made available by the American Cancer Society, there were 559,650 deaths from all types of cancer in the United States in 2007. Of these deaths, 40,460 were due to breast cancer. As with AIDS, extraordinary breakthroughs have been made in breast cancer therapies and outcomes, making more treatment options available and offering a better prognosis for survival.[61]

Like many photographers in this exhibition, the work of Eugene Richards can be placed in more than one section. In fact, Richards has devoted his entire career to telling the stories of individuals in tough situations ranging from sharecroppers in the South, the Ku Klux Klan, the last events of the Civil Rights movement, the death of his first wife Dorothea from breast cancer, the narcotics scenes in Detroit, North Philadelphia, and the crack houses in the Red Hook housing project in Brooklyn, New York. These interests are not surprising for an individual who began his career working for VISTA (Volunteers in Service to America) in eastern Arkansas.

For Richards, what started as a magazine assignment, turned into a compelling eight-year commitment to capture the stories of life in a big

city emergency room at Denver General Hospital from 1980 to 1987. He produced a book as a document of this experience called *The Knife and Gun Club: Scenes from an Emergency Room* (1989). The title was derived from the ER's nickname because of the enormous volume of knife and gun-inflicted injures that were treated there.

The pace is relentless, the needs extraordinary and the professional demands virtually unequalled except on the combat field. Despite the horrific sights and sounds, what at first was abhorrent and frightful to Richards transformed him so that he felt an ingrained commitment and need to portray the life and death dramas that play out in emergency rooms around the globe every second of the day. Richards has described the seemingly miraculous events he witnessed that inspired him:

Now and then someone who surely would have died lived, and there were children who stopped crying and old people who could go back home…when my magazine assignment was up and I had to go home, I knew I wouldn't stay away. My own momentum wouldn't let me. [62]

The magazine assignment metamorphosed into a lifestyle. He arrived at 6 AM in the morning, witnessed the preparation of the emergency crew and then hopped on board the ambulance as they drove at a frantic pace to pick up a succession of emergency room patients. Richards became part of the life of the emergency room in a manner experienced by only a few who are not ER personnel. Transcripts of 911 calls requesting emergency care as well as statements by the doctors, paramedics and other emergency room personnel accompany Richards' photographs. Both attest to the extraordinary dedication, professional skills, inconceivable pressures, heartbreaking and heartwarming dramas central to the lives of the staff and the emergency room patients.

Exhausted Nurse in the Operating Room (1989) could only have been photographed by someone invisible to those involved in the drama as well as profoundly sensitive to the arduous demands on those who travail in such settings. This photo seethes with compassion for both patient and nurse whose plaintive expression and gesture engender concern for both the patient's prognosis as well as that of the overstrained health care professional.

Founded in 1971 by a group of French physicians, Doctors Without Borders or Médecins Sans Frontières has engendered controversy because of their belief that everyone has the right to medical care regardless of race, religion, creed or political affiliation. This fearless group of doctors was awarded the Nobel Peace Prize in 1999 in recognition of their amazing contributions to those in need of acute medical care in regions where such care is virtually unavailable or extremely dangerous to provide. Ron Haviv, a member of VII Photo Agency, has documented the work of Doctors Without Borders in numerous field locations. In the photo, *Médecins Sans Frontières, Tche camp for internally displaced persons, Ituri province, Democratic Republic of the Congo* (2005) a member of the group holds a Hema child at the Tche camp in the eastern part of the Ituri province, D.R. Congo. Members of the

Hema tribe had fled their homes after attacks in January 2005, five months before this photograph was taken. More than 3.8 million people have died in the Congo conflict since 1998, the majority due to disease and hunger.

Politics, economics, medical ethics and basic healthcare are uneasy bedfellows. Financial considerations impact medical care regardless of one's ability to afford it, and questions of probable outcome, end of life decisions and the allocation of research dollars increasingly rely on dwindling resources. [63] In the midst of the maelstrom of controversy surrounding medical practices and research today both at home and in remote locations, competence, self-sacrifice and compassion in the face of illness remain the core values for the practice of medicine. The physicians, nurses and other health care professionals who maintain these concerns are the true heroes of the story.

Aging

What began as a story by photographer Ed Kashi and writer Julie Winokur for *The New York Times* Sunday Magazine developed into a multi-year study, *Aging in America: The Years Ahead*, the first comprehensive visual account of senior living in America. With the new demographics tipping the scales in the direction of a drastically growing number of individuals living into their later years, what partially initiated their study was not only recognition that "…the social impact of longevity is the single greatest challenge for the twenty-first century… [but also that] America is a society in collective denial of aging… [64] Their growing knowledge of the social, political, financial and emotional impact of aging in America transformed their own lives and gave them tremendous insight into the aging process that they became deeply committed to share.

For those who age gracefully, Chester Higgins' heartwarming portraits in his publication and accompanying exhibition, *Elder Grace: The Nobility of Aging*, epitomize those who look upon their later years as a time to be relished rather than plagued by melancholy. Happily, they also belie the photographer's original motivation when he began this body of work on African American elders. Higgins started his study, frustrated by a society, that neither "honor[s] its elders…[nor is] emotionally comfortable within our older bodies." [65] Esteemed poet Maya Angelou also found reassurance in the subjects of Higgins' powerful group of portraits and expressed it in the Foreword to *Elder Grace*: "The smiles reassure. 'Life is worth the living of it. Do it with your whole heart'." [66] Like Kashi and Winokur, Higgins' original study led him to photograph the elderly in other communities. With dramatic lighting on her glistening white hair and exquisite face, the dignity and resolve of the elderly is portrayed in his portrait of *Renee Leong* (1998). She epitomizes Higgins' mission to provide incontrovertible evidence that, "Aging is a blessing… aging gracefully can become a work of art." [67]

Many great masters in the history of art have worked productively well into their later years, facing dwindling capacities with inventive ways of maintaining

their studio schedules, Rembrandt, Matisse, Monet and Picasso, among them. Matisse, for one, developed his innovative and masterful paper cutout technique during the last fifteen years of his life, when his motion was restricted. Following in their footsteps, *Grandma Moses on her 100th birthday, Eagle Bridge, New York* (1960), photographed by Cornell Capa, shows how, with her indomitable spirit, Moses spent at least part of this significant birthday painting, as she always did.

Despite these positive reflections, the needs, challenges and vicissitudes of our aging population are staggering. AARP, formerly known as the American Association for Retired People, is now marketing its services to individuals beginning at age 50. By stretching its guidelines to include the baby boomers born after World War II, AARP today boasts 35 million members, making it the second largest institution in the United States after the Catholic Church. Looking to the future, statistics on the web site of the American Association of Homes and Services for the Aging (AAHSA) indicate that by 2026, the population 65 and older will double to 71.5 million; between 2007 and 2015, the number of Americans ages 85 and older is expected to increase by 40%. Among people turning 65 today, 69% will need some form of long-term care; and by 2020, 12 million older Americans will need long-term health care.[68] Already, as reported in the September 2008 *AARP Bulletin,* "about 44 million Americans act as caregivers to their spouse, parent or other adult family member or friend, a role that can be stressful—physically, emotionally and financially. Their quiet service as caregivers in their own homes is valued at a whopping $350 billion a year…"[69] The statistics relevant to this under-appreciated sector in America are staggering. Fifty percent of the members in this group care both for children and their own parents or other elders; the rate of those in the group who suffer from depression is about twice that in the general population; the caregivers spend about forty-one hours a week in their caregiving responsibilities; 20% of family members give up their own work to care for a relative, leading to significant financial loss in terms of their retirement savings and Social Security benefits.[70] Despite this sobering data, caregiving grows visibly and will continue to escalate with every future generation. As Rosalynn Carter has said, "There are only four kinds of people in the world: those who have been caregivers, those who are currently caregivers, those who will be caregivers, and those who will need caregivers."[71]

There are many encouraging stories, however, of older adults extending their active professional lives, exercising vigorously although adjusting their workouts commensurate with their diminishing capabilities, and living independent lives without daily care from either relatives or other caregivers.

In *Yale/New Haven* (1955), Elliott Erwitt captures a spunky nonagenarian seated in the back of a convertible at a pre-game parade at his Alma Mater, proudly flaunting the sign "Yale's Oldest Living Graduate 1881." The same spryness is manifest in Ralph Crane's photograph of *Elderly couple dancing,* *woman's red skirt swirling, in retirement community* that appeared in LIFE magazine in 1970. Although one couple is featured in the foreground, a number of other couples are seen square dancing in the rear. Their energetic performance shows that although this may be called a retirement community, these senior citizens are anything but retiring at such social events. Sylvia Plachy's parents in *Grandma and Grandpa (*1979) have the same love of life. Seated in the back seat of the family car, they are obviously delighted by the bubbles that their grandson is blowing in their direction.

Diane Arbus took her photograph of *The King and Queen of a Senior Citizens' Dance, New York City* in 1970. Bedecked in party garb replete with cloaks and crowns befitting their regal status, the bespectacled and wand-bearing King and Queen, Charlie Fahrer and Yetta Grant, stare directly, and proudly at the photographer.

For photographer David Finn, the opportunity to photograph his revered and beloved uncle, *Rabbi Louis Finkelstein* (1966), was a way of paying homage as well as an opportunity for dialogue with this esteemed Judaic scholar, prolific author and chancellor of the Jewish Theological Seminary in New York. Finn has gratefully recalled the opportunity to work with his uncle. The Rabbi's accomplishments include creating the Conference of Science, Philosophy and Religion, which brought outstanding priests, ministers, rabbis and philosophers together to discuss problems and issues that challenged them and the peoples of their faiths. Finn remembered taking this photograph in the Rabbi's book-lined study at a moment when, "he had his eyes closed with his hand on his face worrying about some of the deep challenges facing our time, and hoping that the search for wisdom would enable us to find meaningful solutions."[72] Surrounded by Hebraic volumes including the Mishna, the major work of Judaic law, with commentary by Medieval Torah scholar Maimonides as a backdrop, this photograph is as much a portrait of someone who is aging, as it is a portrait of his learned life.[73]

Larry Sultan began photographing his parents in 1982. He recalls his motivation at the time: "I was in my mid-thirties and longing for the intimacy, security and comfort that I associated with home. But whose home? Which version of the family?"[74] Ten years later in the process of planning for his 1992 exhibition at the San Jose Museum of Art, Sultan continued taking photographs of his father, who had recently lost his corporate job to a younger man. One night the artist woke up with the stunning and anguished realization that:

> These are my parents. From that simple fact, everything follows. I realize that beyond the rolls of film and the few good pictures, the demands of my project and my confusion about its meaning, is the wish to take photography literally. To stop time. I want my parents to live forever."[75]

From that time on, the rolls and rolls of film, documenting the most mundane moments of his parents' lives including joint efforts to turn on an electric sweeper and his father's posed golf swing in their living room, took on a new

significance for all of them. In *Untitled, (My Mom Posing for Me, Palm Springs)* (1989), from *Pictures from Home,* his mother compliantly poses against a lime green wall, while his father watches television, absorbed and oblivious to her or anything else. Sultan seems to be commenting through their postures, that although they are together, there is much solitude in their daily existence. *Moving Out* (1988) documents a major life change. His parents stand somewhat wistfully in the now empty green room. Sultan has seized one last opportunity to photograph them in his family home, even though all traces of their family history have been erased, and the contents placed in moving vans. His parents are in close proximity to each other, yet separate again, each perhaps dealing with this life change differently. Although depressing, Sultan has documented this rite of passage as if even their presence in an empty room is preferable to no presence at all.

At first glance, Nic Nicosia's *Domestic Drama #7* (1982) may look somewhat humorous. In his characteristic tableau style, the artist has depicted an elderly wife's attempts to open an umbrella before venturing out in the rain, while her husband, clad in only his underwear, rocks in a chair in which he has fallen asleep with the newspaper he was reading dropped on the floor. With a topsy turvy shelf filled with objects perched unstably on a crumbling wall, exhibiting the neglect of both body and surroundings stereotypical of old age, Nicosia affords us not only a voyeuristic look into the life of this couple but also addresses his own fear of growing old.

The partial humor in Nic Nicosia's composition has been utterly left behind in the confrontational works of both Donigan Cumming and Jim Goldberg. In an unsparing four-photograph-portrait *April 27, 1991* (April 27, 1991, printed 1992) of an elderly woman from the subversively titled *Pretty Ribbons Series* , Cumming portrays his subject in a fetal-like position on what appears to be a faded brocade fabric. She is clothed in only one of them. Since her eyes are closed and her face expressionless, her story is told through her wrinkled body, decrepit frame, and the manner in which, partially enveloped in the sleeve and flowing skirt of a delicate blue and white dress in the last of the four photos, she clings to two framed photos from her long past youth.

Jim Goldberg took a series of photographs of the residents of Neville Manor, some of which became part of a permanent installation at this nursing home as well as the content of a traveling exhibition. Each resident had the opportunity to write comments on his or her portrait. His reclining subject in *Mary E.H., Neville Manor* (1982), from the *Nursing Home Series* leaves nothing to the viewer's imagination in her strident admonishment to the younger generation, who "turn their backs" on the lonely residents at Neville manor, that "THEY'LL LEARN EVERYBODY GETS OLD."

In *Last Portrait of My Father, New York City, NY* (1978), Arthur Tress has photographed his elderly father seated outdoors on an ornate high-backed chair on ground covered by snow that is still falling lightly and dusting his father's long coat, an apt metaphor for the winter of his life. The wood carving on the chair echoes the curving boughs of the leafless trees in the background. His father's eyes are closed, his legs slightly spread and his hands are placed firmly on both arms of the chair. Is this simply a moment of repose in an unimaginably cold and not so comfortable setting or does this constructed scene imply more? His isolated pose in this frosty setting evokes the Eskimo tradition of putting their elders on an iceberg on which to float from the waters of this world to the next, slowly and painlessly freezing to death. As the title indicates, Tress recognized this photograph as documenting a rite of passage for his father.

The subject of Kaylynn Deveney's series of photographs and book of the same name, the *Day-to-Day Life of Albert Hastings*, is her neighbor Mr. Hastings. This sometimes charming and sometimes depressing series documents Hasting's life as well as the lonely existence of many older individuals who have lost a loved one or spouse and now go about their daily activities pretty much on their own. Life's simple pleasures such as an evening whiskey, feeding pigeons in the park, repairing a wind-broken daffodil, and daily necessities such as preparing a solitary meal or drying pajamas, all are documented in Deveney's photographs as well as the words that she asked Hastings to write to accompany them. Through Deveney, we become an eyewitness not only to Hastings' shrinking existence, awareness of his wrinkled body, and newfound daily necessities like tending to dentures, but also imagine our own future.

Angela West's *Gracie #1* and *Gracie #2* (2006) are from an ongoing series of works about her father as he ages. West poignantly depicts her father's deterioration as well as that of his favorite pet, Gracie. With his head on the bed while petting the beloved cat, her father shows not only his tenderness for the feline but also his own weariness with life. In *Gracie #2*, her father puts his much-loved pet to rest in a grave that he laboriously dug himself. Older age naturally provokes reflection as well as nostalgia for earlier times amidst cognizance of diminishing skills, dwindling days, and unavoidable losses.

Disaster

There are as many photographs devoid of human presence in Disaster, as there are populated ones. This is partially attributable to the fact that in some cases the devastation was so extreme there are no human remains, and all that is left to bear witness to a catastrophe is a ravished landscape. In these selections I was wary of not wanting to take advantage of what author Susan Sontag described as the "the innumerable opportunities a modern life supplies for regarding — at a distance, through the medium of photography — other people's pain." [76] I did not want to exploit the subjects of these photos in any way. I also did not want those selected either to become symbolic of other people's suffering, or to diminish the significance of their own personal stories.

Sontag's concerns were echoed by authors Mark Reinhardt and Holly Edwards in the essay "Traffic in Pain" that appeared in a catalog accompanying the exhibition paradoxically titled *Beautiful Suffering* organized by the Williams College Museum of Art in 2006. In their words, "every day, without much effort, one may come across exquisite images of other people's suffering."[77] This was the fate of the Afghan girl, Sharbat Gua, photographed for *National Geographic* in 1985 by Steve McCurry, while covering the refugees in flight to escape the Russian invasion of their country. Following the 9/11 attacks and renewed interest in this part of the world, *National Geographic* launched a campaign to find the unidentified girl and did. Her face again appeared on the cover of *National Geographic* accompanied by an article "Found After 17 Years: An Afghan Refugee's Story." Sharbat Gua captivated the imagination of the world, which not only marveled at the magazine's sleuthing prowess but also at the young refugee's ability to survive[78] Although this story reacquainted the public with this era, when freedom from the stranglehold of the Taliban was exacted at great personal cost to thousands like this girl and her family, this reminder exacted an irreparable toll on her private life.

Additional moral questions arise when the suffering and misfortune of others depicted in either a photograph or video, subsequently becomes a part of the content in an exhibition, publication or documentary. Great care was given to maintain the dignity of the subjects of selected photographs by the manner in which they were portrayed. Nonetheless, some will give our viewers pause, and others may be painful to look at it. Lamentably, without these photographs, our times and the subject matter could not be accurately portrayed. In the end, just as Gideon Mendel did not want to record the death of a patient with AIDS that he had unknowingly witnessed, but was encouraged by the physician in charge to go ahead and do his job, I have also gone ahead and done what I felt was mine.

In the context of aestheticizing disturbing images, as Reinhardt and Edwards also observe, "[w]hat appears at first to be a concern about a particular kind of picture, then often turns out on closer scrutiny to be a fear of picturing."[79] I think this fear incites an even more visceral reaction attributable to the nature of that which is being pictured. It is impossible to view photographs of the casualties resulting from an act of terrorism, civil war or natural disaster without having the complacency we have adopted about our own safety and that of those we love, shaken.

I was wary from the onset that the omissions in Disaster would be judged most critically. In other sections, I was comfortable with attributing the selection process to curatorial prerogative. The omissions in Disaster felt more onerous, especially when one death is symbolic of many. Photographs have not ony elicited protests and exposed the horrors of war, as evidenced in the Vietnam era, but also legitimized further acts of barbarism incited in the guise of securing peace. There have been such an unfathomable number of major disasters around the world — natural or man-made — that I could

not begin to do justice to the scale of suffering endured, or the scope of kindnesses extended to the victims and their families in times of need.

At the request of the Spanish government, Pablo Picasso painted *Guernica*, a powerful scene of brutality and carnage exacted on innocent men, women, children and animals several weeks after the Germans bombed Guernica, Spain, on April 26, 1937, during the Spanish Civil War. Although Picasso did not venture to the battlefront, his composition in black and white pays homage to the photojournalistic reportage of those who did. Many of the photos in Disaster function in much the same way, to invoke the horrors of war.

Photojournalists, whose work makes up the preponderance of photos in this section, have ventured into many war zones to cover the more than one hundred million soldiers and innocent civilians whose lives were lost during the 20th and 21st centuries on blood-drenched battlefields. The gut-wrenching shadows of wars fought for both just and unjust causes around the globe are etched in history thanks in part to their memorable photographs: Omaha Beach, the Battle of the Bulge, Choeng Ek, Inchon, Stalingrad, Kuwait City, Auschwitz, Nanking, Hiroshima, Baghdad, Darfur, Rwanda, Afghanistan.

Before the advent of photography, artists were taken to battlefields with the express purpose of recording the battle for posterity in the manner in which their commander wanted it portrayed. Napoleon's Minister of the Arts, for example, directed the legions of artists who accompanied their commander on his military campaigns.[80] Following his directions, the heroism and bravery of Napoleon's forces were depicted in a manner that today would be classified as military propaganda. Goya, whose Spanish heritage aligned him with those whose lives and homeland were being destroyed during Napoleon's incursions into their country from 1808 to 1814, depicted these events in a totally different manner. His haunting renditions of the bestiality of the fighting and the suffering of the Spaniards is graphically illustrated in his famous series of prints known as *The Disasters of War*. Subsequent photojournalists who ventured to the front and portrayed war in its most bestial manifestations have paid tribute to Goya as an influence on their frank style of reportage.

Roger Fenton, recognized as the first war photographer, was engaged by the British government to cover the Crimean War in 1855 in the hope of changing popular opinion about an unpopular war.[81] U.S. Civil War photographers Timothy O'Sullivan, Matthew Brady and others are known to have rearranged the bodies of dead Confederate soldiers to make better compositions. During the First and Second World Wars, photographs of casualties came under strict military review prior to release, until 1943, when President Franklin Delano Roosevelt allowed Americans to see the cost of war. During the first Gulf War, in 1991, media access to war dead returning from Iraq and Afghanistan was barred. Under President Barak Obama, the Department of Defense has lifted this 18-year-old military policy,

once again granting access to the soldiers' flag-draped coffins, providing permission is granted by family members.

Although war can be cosmeticized by editorial viewpoint and censorship, an amazing and irreversible transformation in war journalism occurred with the advent of digital technology. Beyond the innumerable digital editing techniques available is the flood of images transmitted directly and immediately from the battlefield via cell phone, computer, and numerous handheld devices, thus breaking the stranglehold of military scrutiny. The infamous scenes from the Abu Ghraib prison in Iraq are a case in point.

In looking back at previous war coverage, it is still astonishing to see how one image, shot with black and white film, can evoke the death and suffering of millions of innocent men, women and children as impactfully as George Rodger's captioned photo for LIFE magazine, *Behind the barbed wire fence of the recently liberated Bergen-Belsen concentration camp, female prisoners lie dying of typhus and starvation on the ground outside Bergen-Belsen, Germany, mid-April 1945*. This photo incites a visceral reaction and revulsion that is as potent today as it was when first seen more than 60 years ago.

Larry Burrows' fearless and often reckless coverage of the Vietnam War from its beginning in 1959 produced some of the most memorable images of the time. They were also noteworthy because he was the first reporter to shoot a war entirely with color film. Bleeding G. I.'s maimed in combat, dead Vietcong, harrowing moments in battle, perilous rescues of military comrades, all were his subject matter. Burrows seemed to miraculously escape injury or death until his last story, when he and a group of other journalists convinced a South Vietnamese general to fly them over Laos and drop them as close as possible to the front lines. Their inept pilot steered their chopper over an enemy position, where it was shot down, and everyone on board was lost. Tragically, Burrows became another casualty of the war he was so passionately, compassionately and heroically covering for LIFE magazine.

Burrows not only covered the American soldiers fighting and patrolling below the DMZ, he also sympathetically reported the Vietnamese casualties of war exemplified by *Grieving widow crying over plastic bag containing remains of husband recently found in mass grave of civilians killed by the Vietcong at Hue during the Tet offensive* (1969), as this great LIFE photograph is captioned. The image of a solitary distraught woman screening her face with a straw hat as if to shield her ineffable grief is iconic in its power to symbolize the tragedies of any war, anywhere, as well as the immeasurable suffering incurred by those who have lost a loved one on the battlefield.

The year before his death, Burrows traveled to East Pakistan in what is now Bangladesh, to document the effects of the devastating 1970 cyclone. The somber tear-laden face he photographed at close range in *Cyclone Survivor, East Pakistan* (1970) shows his uncanny ability to unobtrusively catch his subjects at their moments of deepest suffering. Burrows' compassion for those in pain was never as palpable as in this photo.

Where words fail, photographs often suffice to bring closure in their place. David Friend, *Vanity Fair*'s editor of creative development and formerly LIFE's director of photography, has written in his book, *Watching the World Change: The Stories Behind the Images of 9/11*, about how transformative changes in media and the way the public gets news had a profound impact on coverage of this disaster. Many of our indelible memories of these events are attributable to the coverage via satellite newsgathering and transmission as well as the digital images that were sent as soon as shot and then filled every publication around the world twenty-four hours a day for eight days following the attacks. In this unprecedented manner, stories of bravery and profound loss were brought to a nation and world in real-time.

David Friend has also noted the remarkable differences in the way the public remembers and refers to the assassination of President John Fitzgerald Kennedy and 9/11: "For decades after the Dallas shooting, Americans would ask one another, 'Where were you when you heard the news?' And each would have a private recollection of that first alert…In contrast, when re-calling that instant of recognition on the eleventh of September, many tend to pose a slightly different question: 'Where were you when you saw it?'"[82] He continues, "we observe, remember and relive events, faces and places not in the blur of motion pictures, but in discrete photo-like 'stills'."[83] Friend also ascribes to the multitude of photographs taken an enormous role in "our understanding of the week's events and [and how they] have helped us mourn, connect, communicate and respond."[84]

Three photographs in this exhibition exemplify the inconceivable occurrences and courageous acts of numerous individuals, both trained first responders and everyday volunteers, who helped in any way they could. The silhouettes of the five firefighters against the ghostly remains of the fallen towers at dusk on the day after the attacks in Fred George's *Ash Wednesday, Dusk, 9/12/01* (2001) and firefighters *Bill Ryan and Mike Morrissey* (2001) photographed by Joe McNally, immediately provoke memories of the day. In a similar manner, the mournful words that Duane Michals has inscribed below his *Untitled* (2001) referring to the "empty sky" where once the Twin Towers stood, have the power of a dirge. McNally's portrait is one of many that he shot using the only giant Polaroid camera in the world, which enabled him to capture his subjects, all of whom had been involved in the tragedy in some way, in life-size format. Working round the clock to complete what is called The Ground Zero Portrait project, McNally took the photographs whenever the various individuals completed their shifts as detectives, iron-workers, construction crews, etc.

In response to the attacks on 9/11, on October 7, 2001, the United States commenced a military action known as Operation Enduring Freedom - Afghanistan. Its objectives included the destruction of terrorist training

camps and the cessation of terrorist activities in Afghanistan, as well as the capture of al-Quaeda leader Osama bin Laden, the mastermind behind the 9/11 attacks. Sean Hemmerle traveled to Afghanistan "as a protest to our government's response to 9/11."[85] Whether his subject was a solitary chair in a destroyed building, a deserted military tank by the side of a mountainous rode, or *Minefield–Jalalabad, Afghanistan* (2002) with the red and white markers each indicative of a mine waiting to be detonated, Hemmerle found both beauty and hope in the aftermath of destruction. In this instance, the vast numbers of mines tagged for detonation give an indication of the extent of the fighting there. These tags also help insure that no further injuries will be incurred accidentally, one of the greatest tragedies of such war-pocked landscapes around the world.

The Iraq War, also known as the Second Gulf War, began on March 20, 2003, when a multinational force invaded Iraq. This ongoing campaign was initially justified by allegations that Iraq, under the leadership of Saddam Hussein, possessed weapons of mass destruction that posed a serious threat to world peace and safety. Gary Knight is a founding member and chairman of the board of VII Photo Agency, a small agency founded just before 9/11. His photojournalism takes him regularly to settings where human rights crimes are prevalent and war ongoing. Knight's bloody scene, *U.S. Marines, Baghdad* (2003), from the *Bridge Series,* shows U.S. Marines of the 3rd Battalion, 4th Marines tending to a colleague badly wounded by Iraqi artillery at Diyala Bridge, in the suburbs of Baghdad, Iraq. The splattered bodies in this scene of bloody disarray demonstrate how radically guidelines for war coverage have changed.

Unlike Knight and Hemmerle, who both traveled to the war zones, Cynthia E. Warwick took the Polaroid snapshots in her multi-part composition *Wake Up People* (2001–2008) off the television screen in her New York apartment, where she watched the horrors unfold. Each of her small Polaroids contributes to this 27-part-vignette with her dire warning reinforced by a photograph of Bin Laden, a skeletal visage, and statistics recording U.S. military casualties, in a manner that mocks anyone with a shred of complacency about how precarious our quest for peace in both the Middle East and home truly are. Punctuating the scenes of devastation are imagery and script from advertising campaigns and other popular imagery.

The Middle East conflict, complicated by religious fervor and disparate political agendas, is frequently the subject of reportorial journalism that captures bleeding bodies as well as horror on the faces of women and children alike, often shot from a particular angle and undeniably dependent on the agenda of the photographer and his or her news agency. Gillian Laub's photographs are distinguished by the absence of such a viewpoint, as she tells the stories of both Arabs and Jews caught in the conflict with equanimity. Her photograph of *Aliza at Friends' Memorial, Tiberias, Israel* (2002) along with members of her Israel Defense Force platoon depicts a memorial

ceremony for their friends Adi Avitan, Benny Avraham, and Omar Suad. An exquisite beauty in military garb, Aliza's prayerful sorrow is manifested in her tearful eyes and somber gaze, and bears testimony to the internecine warfare that plays an importunate role in everyday life in the Middle East for Jews and Arabs alike. The three soldiers had been kidnapped exactly one year before by Hezbollah guerrillas from Lebanon inside the borders of Israel, posing as relief workers from the United Nations. Aliza explained to Laub, that the motivation behind their ceremony,

> …is so we can call out to them in Lebanon, letting them know they have parents, friends, and many other people waiting for them at home. Hopefully one day they'll come back into the arms of those who love them. We must keep this hope for their safe return. Sometimes soldiers are kidnapped, and every day soldiers die for the cause of peace and security in Israel. Like they say in the song: 'I have no other country, even if my land is burning. I will not stop crying out because my country has changed its face. Only a prayer in Hebrew penetrates my veins and my soul. With a pained body, with a hungry heart, here is my home'.[86]

Remorsefully, their prayers were in vain, and in June 2004, under Israeli Prime Minister Ariel Sharon and Defense Minister Shaul Mofaz, a deal was struck with Hezbollah for the return of the bodies of the three dead Israeli soldiers.

The monumental devastation inflicted by warfare is sometimes equaled by the aftermath of natural disasters. James Balog is one of the most respected nature photographers. He has not only captured the beauty of endangered animals but also the havoc created by natural disasters. Balog traveled to Banda Aceh one month after the tsunamis, which ravaged the islands of Indonesia on December 26, 2004, and left 122,232 dead and 113,937 missing. Balog spent one week in Banda Aceh, an area that was among those hardest hit, taking photographs as well as assisting relief efforts, including the body recovery teams. One of these mask-clad teams is his subject in *Body Recovery Team, Banda Aceh, January 31, 2005*. Just as Larry Burrows' solitary cyclone victim symbolized the thousands of others who were not portrayed, similarly, Balog's *Woman at Indonesian Red Cross Headquarters, Banda Aceh, January 28, 2005,* is representative of many other pitiful instances of a mother seeking sustenance for her child after the devastation. Although this photograph does not tell us so, one can intimate that this woman is one of thousands who lost husbands or wives, children and other loved ones in a matter of minutes, in a merciless sea driven by a wall of unforgiving water that turned an idyllic day into one of unimaginable horror.

Although he continued shooting photos as well as assisting in the recovery efforts, the potentially inherent moral conflict experienced by photographers who document the suffering of others was remorsefully expressed by Balog who recalled: "There were pictures everywhere I'd turn. Visually it was intense… I couldn't stop photographing. Then at night I'd grit my teeth and cringe. I

knew it was so visually rich because of so much sadness and horror."[87] Balog's sentiments have been echoed time and again by photographers who venture into the path of danger, devastation and recovery.

Whereas Balog's photographs focused on the destruction of lives, Sasha Bezzubov's *Things Fall Apart Series* (2001–2007) documents landscapes around the world in which no human presence is visible after natural disasters such as tornadoes, hurricanes and tsunamis. Bezzubov came to Banda Aceh three weeks after the tsunami in 2005 and spent about one month there. He used a large format camera to capture the monumental destruction more from a philosophical, somewhat existentialist, viewpoint than a reportorial one. Bezzubov often photographs situations that he feels express man's "helplessness in the face of natural disasters and the fragility of our environment." He was drawn to this remote village by how powerfully the aftermath of the tsunami there exemplified "disaster, decay and devastation as an underpinning of life."[88] His diptych, *Tsunami #3, Indonesia* (2005), depicts how the entire three-mile stretch of road that ran alongside the sea and to Banda Aceh was decimated and turned into rubble by the relentless surging sea.

During the final week of August, 2005, Hurricane Katrina exerted a hypnotic spell on viewers, not unlike that of 9/11, through incessant media coverage as well as numerous unforgettable photographs that memorialize the unimaginable occurrences in New Orleans, Louisiana, and neighboring Gulf Coast communities. As John Updike eloquently recounted, "A major American city was depopulated with a suddenness and thoroughness war itself could not surpass."[89]

Using a format that he had recently employed for a study on trees, James Balog conceived of his photograph of *The 17th Street Levee* (2005) as a triptych of unequal parts to convey both the sense of scale and fragmentation exacted by Katrina. This photograph is very much a product of his interest in how nature is impacted by such disasters.

In contrast, Robert Polidori focused on the devastation exacted on homes and other man-made structures. The hundreds of photographs that he took on four visits to New Orleans between September 2005 and April 2006 are devoid of any human beings, yet uncannily convey the devastation and horror of the lives destroyed, the decay of the former society, and the total havoc experienced by the population of New Orleans. Nevertheless, his empathy for the inhabitants of this once grand city, in whose Gentilly neighborhood he lived as a teenager, is conspicuous in every crumbling fragment he detailed. The sagging bed with its four pineapple posters memorialized in *6328 North Miro Street, New Orleans, LA* (2005) is all that remains of a formerly welcoming interior. The once stately piece of furniture is surrounded by piles of rubble fallen from both ceiling and walls that have also covered the bed. A nearby dresser tilts on its side. The distressed paint, the molding walls, the sagging fabric of the curtains, aptly serve as a metaphor for the toll that Katrina exacted on the once bustling Ninth Ward, where this photograph was shot.

Nine months after Katrina, Steven Maklansky, former curator of photography at the New Orleans Museum of Art, mounted an exhibition at the Museum of some seven hundred photographs submitted by professional and amateur photographers alike. This large group shared one important thing: they had both witnessed Katrina and recorded it via photography. Far from being a dispassionate and objective chronicler, this curator's efforts were skewed — in a good way — because the people, streets, places and history chronicled were those of a city he also called home and whose losses he mourned in a way only possible for someone who truly shares in the loss. To Maklansky, the deluge of photos and video that recorded the storm were both a revelation and a means of coming to terms with the events. In his words: "Like plucking a struggling victim of circumstance from the deluge, taking a picture is a rescue — a way of preserving a little rectangle of history from oblivion."[90] *Katrina Exposed: A Photographic Reckoning*, contained the all too familiar images of the Astrodome, helicopter rescues, abandoned people on bridges awaiting airlift, relief workers trudging in high boots through unimaginably foul water, stranded men, women and children perilously perched on the roofs of their homes surrounded by threatening water, holding aloft signs begging for rescue.

Two of these photographs are included here. Of the many indelible post-Katrina scenes, few so forcibly convey the horror depicted in Charlie Varley's photo *October 7th, 2005. When the power went out the old man slipped and fell. He never work up. New Orleans* (2005) with its grim pronouncement "Body Inside" inscribed in red paint on a boarded up window. This photo memorializes the bleakest of homecomings, when all too many who returned hopeful to find loved ones were confronted instead by this stark announcement. Varley's chilling record is offset by other heartwarming scenes of rescues by many first responders from the city itself as well the legion of others who came to New Orleans to help humans, animals and the very infrastructure of the city. The boots at the prow of the boat captured in Jonathan Traviesa's photograph, *Untitled* (2005), symbolize the valiant efforts of many rescue workers who ventured, often at great peril, to assist people stranded in the submerged areas of the city.

In a world replete with an unpreventable and untold number of natural disasters inflicting monumental destruction, the incontrovertible environmental devastation inflicted by man is all the more reprehensible. Governmental agendas, corporate greed and legislative denial of obvious danger signs contribute to what is hopefully not an irreversible global situation. In one devastating example, a government's lax regulation of safety standards compounded by the political climate of the Cold War contributed to the worst nuclear disaster in history. On April 26, 1986, a series of explosions occurred at Chernobyl, a Soviet nuclear plant in the Ukraine. These blasts and the resultant devastation were evaluated at level 7 on the International Nuclear Event Scale, which rates such events on a scale from 1 to 7. The

accident was caused by a flawed reactor design maintained by inadequately trained personnel without sufficient safety precautions. As a result of the explosions, approximately 600,000 people suffered significant radiation exposure; 336,000 people were evacuated and resettled; thirty power plant employees and firemen died within a few days or weeks, twenty-eight of these directly attributable to exposure to radiation.

Timur Grib has documented the disaster and its after effects for a number of years. Many of his photos focus on the birth defects in children whose parents were exposed to the radiation that contaminated neighboring areas, especially those downwind, after the blast. His heartbreaking picture of a youth born eleven months after the disaster, *Chernobyl's Boy* (1991), dramatically attests to the lingering, life-compromising wounds inflicted upon an innocent population. David McMillan's photograph *Dormitory Room, Pioneer Camp* (October, 1997) from his *Chernobyl and Villages Series* documents the devastation still visible in an evacuated village near the reactor more than ten years after the event. Despite the unassailable evidence provided by these two photographs, the after effects of radiation from the disaster continue to be reported dissimilarly by different organizations, some of which minimize the impact.[91]

Robert Glenn Ketchum began using his exquisite photographs of both natural habitats and their destruction as a powerful tool in his prescient environmental advocacy even before it was acceptable to do so. Cited by *Audubon Magazine* as one of one hundred champions "who shaped the environmental movement in the 20th century," his successful campaign for wildlife preservation through photography places him at the forefront of artists who are dedicating their work to their concern for the preservation of our environment. For his book, *The Tongass*, about the Tongass National Forest in southeastern Alaska, Ketchum spent fourteen months immersing himself in the region and its environmental issues to produce the magnificent photographs in this publication. The largest national forest in the United States, the Tongass is a temperate rain forest, which provides a safe habitat for many species of endangered flora and fauna. In his study, Ketchum presented both the natural wonders of the Tongass as well as its blighted forests and heavily industrialized ports. In 1990, three years after the book was published, the Timber Reform Bill passed in Congress, largely due to the concerted efforts of Ketchum and others sympathetic to the issues. Ketchum's instrumental role in the passage of this legislation garnered national attention for his work.

Care for Earth (1991), is not only the title of Ketchum's photograph in this exhibition, but also his overarching life theme. By combining three separate images in a wet darkroom before the advent of digital imaging, Ketchum forcefully contrasted the beautiful virgin old growth forest that dominates the composition, with a black and white photo of clear cuts that starkly demonstrate the rape of the pristine woodlands.[92] The bold graphic message "Care for Earth," coupled with the brilliant illumination of soft light that suffuses the forest, strengthens his case for the preservation of such natural landscapes. Ketchum, an indefatigable crusader for the environment, hopes to protect Bristol Bay, Alaska, the most productive wild salmon fishery in the world from being destroyed by offshore drilling as well as onshore mining.

Chinese artist Chen Qiulin has personally experienced the devastation of family and culture by the destruction of her native landscape. She grew up in Wangchou City, formerly called Wanxian, in Sichuan province. Her small town was partially submerged by the construction of the Three Gorges Dam on the Yangtze River. Not only was the landscape obliterated but more than one million people in eleven cities were displaced by the rising water which destroyed their homes and properties and turned the area into a lake in less than six months.

The exquisite beauty of the youthful artist clad in traditional wedding garb and applying her makeup in front of a paint and dirt-smeared mirror in *Ellisis's Series #3* (2002), creates a strong contrast with the ravaged landscape and smoke issuing from two nuclear reactors in the background. Chen Qiulin's image epitomizes the sentiments of many who yearn in vain for a return to the lifestyles and traditions they enjoyed before industrialization came about. The strong contrasts in this setting also remind us how impending disaster is an ever-present force in the daily lives of all those who live in proximity to industrialization and its detritus. This photograph, and the accompanying video, comment on the impact of industrialization as well as on the status of women in modern China. Chen reminds us of how other brave Chinese women — Pearl Buck most notably among them — have dared to raise their voices for social change in a country where time-honored traditions have often cruelly resisted and suppressed them. Whereas other artists focus on environmental destruction, Chen Qiulin's compositions are distinguished by her expression of the widespread psychological damage coincident with the ravaged landscape.

Canadian photographer Edward Burtynsky has also made the calamitous destruction of this dam his subject in, *Wushan #4, Yangtze River, China (2002)* from his *Three Gorges Dam Series*. The rich detail and large scale of his compositional elements in numerous series revolving around various subjects including stone, minerals, oil and transportation, confront the viewer with how industry transforms our natural environment. Although sometimes his message is more ambiguous, the scale of the shocking debris that remains after unleashing the waters of the dam on this once vibrant and populated landscape portrays aptly *"the dilemma of our modern existence,"*[93] which is his goal. It also conveys the controversy inherent in our dependence on the natural environment to provide us with many products that fuel our 21st century lifestyles and yet leave a wake of destruction in the process.

Whereas some disasters strike a limited geographic area, others are more widespread. Hunger is a worldwide disaster, and according to the World Food Program (WFP), the United Nation's frontline agency in the fight against hunger, 86.1 million people in 80 different countries are suffering from a lack of food; 53.6 million of them are children. WFP strives to save lives by quickly getting food to the hungry. Its activities also include educating the people on how to better provide for themselves and their children in the future. Although much of WFP's efforts have of necessity focused on intervention in times of emergency, through sophisticated evaluation techniques including satellite imagery, staffers are also working to identify future food crises in an effort to assist and better prepare the humanitarian community. The impact of the unstable global economy must be dealt with as well. As Josette Sheeran, World Food Program's Executive Director reported in January, 2009, "The financial crisis is hitting the world's hungry hard. Unemployment's increasing, remittances are decreasing, global trade is decreasing. For the poorest of the poor it means their budget for food is shrinking."[94]

Photographer Diego Fernandez Gabaldon has taken his photographs, *Care* (2006), *Malnutrition* (2006), *Fleeing* (2006), and *IDP Camp* (2006), in Darfur from the unusual perspective of both photographer and WFP aid worker. Gabaldon, a former student in international economics, was responsible for ensuring that food reached the refugee camps in southern Sudan. At some times of the year, this distribution, which is complicated by impassable roads or no roads at all, reaches six million people, nearly half the country's population. Gabaldon has explained that what brought him there was WFP's response to "the ill-fated succession of events that developed in Darfur [and] left thousands of people dead and even more homeless. Families torn apart, orphaned children, the drama of malnutrition and the appalling undermining of human dignity and self-respect are part of day-to-day reality in Darfur."[95] The needs of these people were his everyday charge as well as his subject matter.

Many Darfurians, like the caravan of human beings depicted in *Fleeing* (2003), travel great distances in harsh conditions in order to reach refugee camps. Despite the horrific displacement, approximately 2.5 million people now live in these camps, where they are provided security and nourishment to keep them alive. Regardless of their deplorable living circumstances, Gabaldon was impressed with the people's resiliency and their hospitality. He was also amazed how mothers like the one in his stunningly beautiful photo Care tend to their normal maternal duties in the midst of the most deplorable conditions. Dressed in resplendent colors, the baby is enveloped not only by the mother's arms but also by her stunning cobalt blue veil. As Gabaldon has written, the "little joys and beauty of life continue despite the tragedy."[96]

Whether disaster is inflicted by man out of greed, a desire for world power, unequivocal malevolence, ignorance, a disdain for the environment, or provoked by the relentless forces of nature, the result is often the same: death, ravaged landscapes and devastated lives. Photography has journeyed into the deepest abysses of 20th and 21st century life to capture and confront us with an unfathomable number of scenes of devastation of apocalyptic proportions. They issue a dire warning we all must heed.

Remembering

Remembering is a recurrent theme in this exhibition and in our lives. The very nature of photography is its existence as a medium that enables the picture taker or the subject of the picture to remember, or be remembered, as they are or as they would like to be. Simple everyday occurrences are often staged to make them grander than they actually were. Grand events are recorded as someone wanted history to remember them. Some of those remembered and those remembering knew each other well or were even related; some are haunted by occurrences they do not want others to forget. We share a past filled with recollections of family events, school events, world events, events of minor significance and others in which the lives of hundreds, thousands or even millions were affected. In his epic *Remembrance of Things Past*, Marcel Proust has written about how our memories indelibly store events we do not want to forget alongside others we wish could be eradicated from the history of mankind, "We are able to find everything in our memory, which is like a dispensary or chemical laboratory in which chance steers our hand sometimes to a soothing drug and sometimes to a dangerous poison."[97]

Photographers record things of personal significance as well as great historic events. Whether cataclysmic or pleasant, remembering is a potent tool of transmission from one generation to the next. The lesson shared might be as simple as how a holiday tradition was observed or as calamitous as a war of staggering proportions. Nobel Peace Prize winner and Holocaust survivor Elie Weisel often states that he has devoted his life to telling the story "because I felt that having survived I owe something to the dead and anyone who does not remember betrays them again."[98] Most are not gifted like Weisel with the ability to enshrine people and events through their words. Photography is a medium that welcomes everyone from amateurs to professionals alike, and remembering is intrinsic to the task of taking pictures.

One of the most powerful and touching descriptions of the capability of photographs to conjure not just the memory but also the very essence of someone no longer with us was written by Roland Barthes as he grappled with how he experienced his mother through photographs after her death. Barthes poignantly recalls:

In order to 'find' my mother, fugitively alas, and without ever being able to hold onto this resurrection for long, I must, much later discover in several photographs the objects she kept on her dressing table, an ivory powder box (I loved the sound of its lid), a cut-crystal flagon, or else a low chair which is now near my own bed, or again the raffia panels she

and trains and refugee camps, its smells and sounds and cultural values" that was obliterated for her and an "international Diaspora of exiles and their descendants — who correspond on the Internet, and who increasingly avail themselves of newly open borders to tread the streets of their ancestors and search for clues to the fate of family members lost in the maelstrom of war and genocide."[116]

The photograph *Paula & I*, taken in an old Jewish cemetery in Transylvania in 1994, appears on the far right of de Swaan's triptych *The Site of Our Heritage* (2008). In this photograph, the artist holds pictures of herself as a young child and her friend Paula against the sober backdrop of funereal stones. The other two photos were taken on a trip in Fall 2008 to Chernivsti (Chernowitz), where de Swaan was born. In the center photo, an elderly man stands at the grave of Edi Wagner, a Jewish youth who, falsely accused of inciting a fight between Jews and Romanian fascists on August 4, 1936, was tortured and brutally beaten by the police and then thrown out the window of their headquarters to his death. The inscription Edi's mother wrote for his tombstone recounts the tragic tale of senseless death and family grief: "Come often to my grave, but do not wake me up: just think of what I suffered in that short life of mine."

Whereas de Swaan records memories of specific friends and relatives who were lost during the Holocaust, Sylvia Plachy took her photograph of the uniforms of two unidentified inmates in *Dachau* (1985), on a trip with her family to this former concentration camp, which is now a museum. Although Dachau was considered a "work camp" rather than a death camp, innumerable lives were lost there. These uniforms hang suspended, ghostlike, in a display case in the museum. Plachy thinks of the reflection of the uniforms in two large windows as a fitting reference to the spiritual presence of the thousands of individuals who are no longer here.[117] Although Plachy and her immediate family were among the fortunate Eastern European Jews who escaped death in the camps, the barbaric events that occurred during World War II haunt her nevertheless. Since she emigrated in 1956 with her family to the United States from Hungary, Plachy has returned to Europe a number of times, camera in hand, as a means of reconciling her present and past lives and coming to terms with her heritage.

In Andrea Robbins' and Max Becher's *Dachau, Execution Range and Blood Ditch* (1994) from their *Dachau Series*, the only indication to the casual observer of the unfathomable crimes that occurred in this now park-like setting is the cement marker at the site of past executions. The words in this title more than suffice to conjure images of the heinous daily activities in this location, however, closer inspection reveals bullet holes behind the vines that climb the walls, one of many ways that former crimes have been hidden to make visits to Dachau less horrifying for historic tourists. This photo is one of a series of these "sanitized" settings taken by Becher and Robbins as their own wry acknowledgement that try as they may, the Germans will never be able to mend this scar in their country's history. Hopefully also, they will never forget.

In 2001, Susan Meiselas returned to the village of El Mozote in Morozan, El Salvador, a location where twenty years before she and other reporters from *The New York Times* and *Washington Post* had covered a massacre that occurred there on December 11, 1981. Details were shrouded in controversy, and the deaths falsely attributed to guerrilla warfare. Reporters were fearful for their lives as well as for implicating the United States military, who had been training the very Salvadoran forces that killed the men, women and children, in what has become recognized as the greatest human rights violation in Salvadoran history. In her recent photograph, *Return to Site, El Mozote Massacre* (2001), Meiselas holds a photo that she took on her first assignment in this area in front of a location, where excavations are taking place today. This photo is being used now to aid a team uncover the burial sites of some 800 people lost in the 1981 massacre. The hope is that by locating and exhuming the bodies of the victims, the perpetrators can at last be charged with and punished for their murderous crimes.

Sheng Qi's, Jonathan Moller's, and Sebastião Salgado's photographs also attest to the lingering impact of previous wars. The ornate native garb worn belies the somber mood of the three Guatemalan women in Moller's photograph, *Three women, themselves survivors of the violence, watch as the remains of relatives and friends who were killed in the early 1980s are exhumed, Nebaj, Guatemala* (2000). Although much time has passed, their presence gives testimony to how senseless violence perpetually mars their existences as well as that of countless other innocent victims. The captioned title for the following photograph by Sebastião Salgado recounts a similar story in another part of the world, *Beharke, Iraqi Kurdistan: On July 31, 1981, Iraqi soldiers arrived unexpectedly and took away all the men in every family; they were never seen again. Under Muslim law, women cannot remarry, so they are left waiting* (1997). In this case, religious constraints necessitate lifelong remembrance in a way that the women might not have otherwise chosen.

Moller's and Salgado's photographs document atrocities inflicted at the hands of enemies. Sheng Qi's photograph *Memories (Me)* (2000) is all the more disturbing because he mutilated his own hand in protest over activities in his native China. Born in Heifei in 1965, the artist fled to Europe after the Tiananmen Square uprising in 1989. In a troubling yet potent demonstration of the depth of his conflict and how remorseful he felt to be forced from a country by atrocities inflicted by his government on helpless fellow citizens, Sheng mutilated himself by cutting off a finger from his right hand. He then buried it in a flowerpot and left it behind in China to symbolize his personal torture and his desire to leave a part of himself in his native land. The smiling young boy in the small black and white photograph cupped by the artist in his mutilated hand is a portrait of Sheng Qi in happier times.

Most viewers have not personally experienced the majority of events depicted in the photographs in this exhibition and on these pages. Some contribute an unflinching and irrefutable record of barbarism, massacre, transgressions and misfortune that will be remembered by all who view them. Others depict joy, love, affection, hope and kindness — the full fabric of life. Collectively, they create a cumulative portrait of many life journeys depicted through photography. Just as great writers are endowed with the power to weave a web of words that often ensnare the unwary reader, so do images taken by outstanding humanistic photographers create visual entrapments that are equally mesmerizing.

From birth to death through struggle and triumph after disaster, the photos in this exhibit capture the complex interweaving of the individuals, families, communities, governments, and humanitarian agencies that assist us all in our collective, circuitous and unpredictable life journeys. These photos pay tribute to the multitude of amazing caregivers who assist on the family level, the community level and the governmental level in times of need. My only remorse in selecting the works for this exhibit is the many relevant and accomplished photographs that I had to leave out merely because of spatial limitations. In the more than four years during which I reviewed innumerable photographs in order to make the selections, I looked into countless highly personal moments in other people's lives. These confrontations led me, in turn, to reevaluate certain personal occasions, activities, relationships and even life goals. My own reaction is revelatory of the potency and unequalled widespread appeal of the photographic medium by virtue of its ability to convey authenticity, engender empathy and incite action.

Endnotes

1. Capa, Cornell. "Introduction" in *The Concerned Photographer*. (New York: Grossman Publishers, 1968), n.p.

2. Tremain, Kerry. "Introduction" in Light, Ken. *Witness in Our Time: Working Lives of Documentary Photographers*. (Washington, D.C. and London: Smithsonian Institution Press, 2000), p.6.

3. *Ibid*.

4. *Ibid*., p. 83.

5. Doisneau, Robert. Interview with Paul Hill and Thomas Cooper. In Hill, Paul and Cooper, Thomas. *Dialogue with Photography*. (Manchester, England: Cornerhouse Publications, 1992), p. 79.

6. Steichen, Edward. *The Family of Man*. (New York: The Museum of Modern Art, 1955), p. 2. Despite the popular response to the exhibition, there was much criticism of the unrealistic worldview that Steichen presented. As Allan Sekula points out in an essay, "The Traffic in Photographs" (*Art Journal* 41 no. 1, Spring 1981: 21, pp. 101-102), art critics like Hilton Kramer with leftist ideologies "attacked *The Family of Man* for displaying liberal naïveté in an era of harsh political realities." Sekula himself faulted the exhibition because the "peaceful world [it] envisioned…is merely a smoothly functioning international market economy, in which economic bonds have been translated into spurious sentimental ties, and in which the overt racism appropriate to earlier forms of colonial enterprise has been supplanted by the 'humanization of the other' so central to the discourse of neocolonialism."

7. http://www.census.gov/Press-Release/www/releases/archives/population/012496.html.

8. Grundberg, Andy. "Point and Shoot: How the Abu Ghraib images redefine photography." *The American Scholar* 74, no. 1, Winter 2005, p. 106.

9. Leibovitz, Annie. *A Photographer's Life 1990 – 2005*. (New York: Random House, 2005), n. p.

10. *Ibid*.

11. *Ibid*.

12. Sontag, Susan. *On Photography*. (New York: Farrar, Straus and Giroux, 1973), p. 8.

13. Galassi, Peter. *Pleasures and Terrors of Domestic Comfort* (New York: The Museum of Modern Art, 1991), p. 11.

14. For more information about this fascinating chronicling of American history see Crew, Spencer and Goodman, Cynthia, eds. *Unchained Memories: Readings from the Slave Narratives* (Boston and New York: Bulfinch Press, 2003). The entire *Slave Narratives Collection* of photographs and manuscripts is available online on the website of the Library of Congress at: http://lcweb2.loc.gov/ammem/snhtml/.

15. Agee, James and Evans, Walker. *Now Let Us Praise Famous Men*. (Boston: Houghton Mifflin Co., 1960), pp. iv and 13.

16. Barthes, Roland. *Camera Lucida: Reflections on Photography*. Translated by Richard Howard. (New York: Hill and Wang, 1981), p. 13.

17. Gowin, Emmet. "A Sublime Tenderness: The Portraits of Eleanor Callahan." In Cox, Julian. *Harry Callahan: Eleanor*. (Atlanta: High Museum of Art, 2007), p. 12.

18. As Eleanor Callahan has explained: "Here are two people who are spending twenty-four hours a day with each other and the photography takes on another form. It becomes just another part of your day… Any time or hour of the day when you get together like that — and we loved each other — it was just a very natural thing to do." Eleanor quoted in CCP Harry Callahan Archive, Box 1, Folder 13. Audiotape of an interview at the Art Institute of Chicago, January 1984, between David Travis, Curator of Photography and Eleanor and Harry Callahan. Quoted in Cox, Julian. *Harry Callahan: Eleanor*, p. 27. Maria Friedlander made a similar observation about Lee Friedlander's picture taking of their family: "His camera was part of the family and we all became accustomed to its presence. We mainly ignored him when he used it, sometimes obeying a request to stop or look up for a second but never paying it much heed." Friedlander, Lee. Preface by Maria Friedlander. *Lee Friedlander: Family* (San Francisco: Fraenkel Gallery, 2004), p. 7.

19. I am grateful to Stephanie Barron, Chief Curator of Modern and Contemporary Art, Los Angeles County Museum of Art, who organized the exhibition, *David Hockney: A Retrospective,* for pointing out Hockney's presence to me in a conversation about this photograph.

20. Rogovin, Milton. *The Forgotten Ones*. (New York: Quantuck Lane Press, 2003), pp. 110-111. Rogovin's son, Mark, kindly provided this information as well as that about his parents' special relationship with Joey.

21. Frey, Mary. Email correspondence to C. Goodman, October 26, 2008.

22. Sontag, Susan. *On Photography*. (New York: Picador/Farrar, Straus and Giroux, 1973), p. 9.

23. McEachern, Susan. "Feminism, Family and Photography," *Canadian Woman Studies, Les Cahiers de la Femme*, 1990, p. 4.

24. Carucci, Elinor. Quoted in *Fifty One Fine Art Photography* at: http://www.gallery51.com/index.php?navigatieid=9&fotograafid=29.

25. Faris, James C. *Navajo and Photography: A Critical History of the Representation of an American People*. (Albuquerque: University of New Mexico Press, 1996), p. 238. In his chapter on Laura Gilpin, James C. Faris criticizes Gilpin for misunderstanding why the Navajo denied her access to photographing healing rituals. He writes, "Gilpin's view that it was simply a matter of 'building up human relations' or rapport or trust reveals how little she really understood the Navajo culture."

26. Agnes Kelly Rostrum to James Barker in Barker, James. *Always Getting Ready: Upterrlainarluta Yup'ik Subsistence in Southwest Alaska*. (Seattle: Washington Press, 1993). I am thankful to Robert Glenn Ketchum for acquainting me with James Barker's work on the Eskimo people.

27. Barker, Robin. Email correspondence to C. Goodman, October 17, 2008.

28. Barney, Tina. Interview with Chris Lyons. Quoted in Brenson, Michael, "Tina Barney and Scenes of Her Life at the Modern," *The New York Times,* January 26, 1990, p. 23.

29. *Ibid*.

30. McDonald, Cecil. Email correspondence to C. Goodman, February 21, 2008.

31. Paar, Martin. *Our True Intent is All For Your Delight, The John Hinde Photographs*. (U.S.A./Canada: Chris Boot, 2003), p. 7.

32. Salgado, Sebastião. In Light, Ken. *Witness in Our Time: Working Lives of Documentary Photographers* (Washington, D.C. and London: Smithsonian Institution Press, 2000), p. 111.

33.Salgado, Sebastião. *Migrations: Humanity in Transition*. (New York: Aperture Press, 2000) p .314.

34. Sheikh, Fazal. In Light, Ken. *Witness in Our Time: Working Lives of Documentary Photographers*, p. 156.

35. Friedlander, Lee. *Family*. "Preface" by Maria Friedlander, p. 10.

36. Winsor, George Cecil. Quoted in Higgins, Chester, Jr. *Elder Grace:The Nobility of Aging*. (Boston, New York, London: Bulfinch Press, 2000), p. 22.

37. Harper, Jessica Todd. "Artist's Statement" in *Group Portraits* exhibition at Photographic Resource Center, Boston University, 2006. http://www.bu.edu/prc/groupportrait/harper.htm.

38. Philip Brookman, Curator of Photography at the Corcoran Gallery of Art, has credited Tress' tendency to stage his compositions as early as the 1960s with paving the way for more the more intricately staged photographic works that emerged in the 1970s and 1980s. Brookman, Philip. "Foreword" in *Arthur Tress, Fantastic Voyage, Photographs 1956–2000* (Boston: Bulfinch Press in ,association with the Corcoran Gallery of Art, 2000) p. 9.

39. This information and more about obesity and its impact on our health can be found at: http://www.cdc.gov.

40. *Global Strategy on Diet, Exercise, Physical Activity and Health*. (Geneva, Switzerland: World Health Organization, 2004). Additional information on the costs of inactivity is provided by Booth, F., and Chakravarthy, M. *Costs and Consequences of Sedentary Living: New Battleground for an Old Enemy*. President's Council on Physical Fitness and Sports: Research Digest, 3, 2002, pp. 1 – 7.

41. Kaye, Danny. Quoted at: http://www.unicef.org/people/people_danny_kaye.html.

42. Barilotti, Steve and Heimann, Jim, eds. *LeRoy Grannis: Surf Photography of the 1960s and 1970s* (Cologne: Taschen, 2007). Quoted at: http://www.taschen.com/pages/en/catalogue/photography/reading_room/157.surfings_golden_age.4.htm.

43. Granser, Peter. Email correspondence to Cynthia Goodman.

44. Schwartz, Dona quoted at: http://www.donaschwartz.com/soccerMomImages.html.

45. These statistics were provided by Dr. Robert Weinberg, Professor, Kinesiology and Health, Miami University, Oxford, OH.

46. Meyerowitz, Joel. Quoted at: http://www.galleryknog.com-joelmeyerowitz%20comment.htm.

47. Winokur, Julie. "Slow Down: Aging Ahead" in Kashi, Ed and Winokur, Julie. *Aging in America: The Years Ahead.* (New York: Powerhouse Books, 2003), p. 33.

48. Szarkowski, John. *Looking at Photographs: 100 Pictures from the Collection of the Museum of Modern Art*. (New York: The Museum of Modern Art, 1973), p. 150.

49. Smith, W. Eugene. Quoted in Hill and Cooper, p. 208.

50. *Ibid*., p. 220.

51. Gomel, Bob. Conversation with C. Goodman, December, 2008.

52. Granser, Peter. Email correspondence to C. Goodman, September 18, 2008.

53. Steber, Maggie. "Madge Has Dementia," *AARP Bulletin Today* at: http://bulletin.aarp.org/yourhealtharticles/madge_has_dementia.html.

54. Azoulay, Ariella and Zreik, Raef. *Testimony, Photographs by Gillian Laub*. New York: Aperture Press, 2006), p. 5.

55. *Ibid*. p. 76.

56. Jaeger, Anne-Celine. *Image Maker, Image Taker*. (New York: Thames & Hudson, 2007), p. 60.

57. *Ibid*.

58. http://www.avert.org/worldstats.htm75.

59. The World Health Organization makes available critical information about antiretroviral drug therapy as well as HIV/AIDS intervention and other care at: http://www.who.int/hiv/topics/treatment/en/index.html.

60. Willis, Deborah. *Family History Memory: Recording African American Life*. (Hylas Publishing, 2005), p. 12.

61. This information from the American Cancer Institute and more is available at: http://www.cancer.gov/cancertopics/cancer-advances-in-focus/breast. According to the American Cancer Institute, 35 years ago 75% of women diagnosed with breast cancer survived five years; mastectomy was the only accepted surgical option for breast cancer treatment; and only one trial of mammography for screening had been conducted. The advances available today enable 90% of those diagnosed with breast cancer to survive at least five years; for women with early stage breast cancer, lumpectomy, or breast-conserving surgery, is the preferable treatment for early detected breast cancers; and routine mammography is a standard procedure for early detection and has been proven to reduce mortality.

62. Richards, Eugene. *The Knife and Gun Club, Scenes from an Emergency Room*. (New York: The Atlantic Monthly Press, 1989), p 3.

63. As Carol Squiers points out in her "Introduction" in *The Body at Risk: Photography of Disorder, Illness and Healing. (*New York: International Center of Photography, 2006), pp. 9 – 10: [The body has irrefutably become] "the contested point around which revolve fierce debates in the natural sciences, social sciences, religion, medicine, culture, politics, economics and ethics about myriad issues…"

64. Kashi and Winokur, pp. 26 – 27.

65. Angelou, Maya. "Foreword" in Higgins, Jr., Chester. *Elder Grace:The Nobility of Aging*, p. 10.

66. *Ibid*., p. 7.

67. Higgins, Jr., Chester. Quoted at: http://www.chesterhiggins.com/reflections.html

68. This information was provided at: http://www.ahsa.org/aging_services/default.aspAmericans.

69. Basler, Barbara. "Care for the Caregiver," *AARP Bulletin Today*, September 8, 2008. Available at: http://bulletin.aarp.org/yourhealth/caregiving/articles/care_for_the_caregiver.html.

70. *Ibid*.

71. Carter, Rosalynn. Quoted in *Resources for Caregivers, MetLife Guide*, p. 1. This Guide was prepared by the National Alliance for Caregiving and the MetLife Mature Market Institute, in cooperation with the National Association of Area Agencies on Aging (n4a), 2007. The former First Lady has made addressing the caregiving crisis her focus by founding the Rosalynn Carter Institute for Caregiving.

72. Finn, David. Email correspondence to C. Goodman, January 27, 2009.

73. I am grateful to Rabbi and Mrs. Daniel Cooper for the identification of these volumes as well as their significance.

74. Sultan, Larry. *Pictures from Home*. (New York: Harry N. Abrams, 1992), p. 18.

75. *Ibid*.

76. Sontag, Susan. *Regarding the Pain of Others*. (New York: Farrar, Straus and Giroux, 2003) p. 13.

77. Reinhardt, Mark and Edwards, Holly. "Traffic in Pain" in Reinhardt, Mark, Edwards, Holly and Duganne, Erinna, editors. *Beautiful Suffering: Photography and the Traffic in Pain.* (Chicago, IL, and Williamstown, MA: Chicago University Press and Williams College Museum of Art, 2007), p. 7.

78. Edwards, Holly. "Cover to Cover: The Life Cycle of an Image in Contemporary Visual Culture," in *Beautiful Suffering: Photography and the Traffic in Pain* exhaustively and perceptively covers the story of this Afghan Girl on pp. 75-92.

79. Reinhardt and Edwards, *ibid*, p. 10.

80. Waring, Beile and Fee, Elizabeth. "The Disasters of War," *American Journal of Public Health*, January 2006, Vol. 96, No.1, p. 51.

81. Sontag, Susan. *Regarding the Pain of Others*, p. 48. Sontag's essay both chronicles the history of war photography as well as challenges its very mission

82. Friend, David. *Watching the World Change: The Stories Behind the Images of 9/11.* (New York: Farrar, Straus and Giroux, 2006), p. xviii.

83. *Ibid*, p. xx.

84. *Ibid,* p. xxi.

85. Hemmerle, Sean. Email correspondence to C. Goodman, January 8, 2009.

86. Aliza. Quoted in Azoulay and Zreik, p. 28.

87. Balog, James. Quoted in "James Balog: Breakthroughs" at: http://www.nikonnet.com.

88. Bezzubov, Sasha. Conversation with C. Goodman, March 8, 2009.

89. Updike, John. "After Katrina," *The New Yorker Review of Books*, Volume 53, Number 19, November 30, 2006.

90. Maklansky, Steven. *Katrina Exposed: A Photographic Reckoning.* (New Orleans: New Orleans Museum of Art, 2006), n.p. Maklansky was motivated to organize this exhibition by the manner in which Michael Shulan, Charles Traub, Gilles Peress, and Alice George organized the massive exhibition *Here is New York: A Democracy of Photographs.* (2002) after 9/11.

91. Reports from the United Nations and the World Health Organization attest to these profound differences. These reports are found at:http://www.who.int/ionizing_radiation/chernobyl/who_chernobyl_report_2006.pdf http://www.who.int/mediacentre/factsheets/fs303/en/index.html.

92. Ketchum, Robert Glenn. Email correspondence and interview with C. Goodman, January, 2009.

93. Burtynsky, Edward. Quoted at http://www.edwardburtynsky.com/.

94. Sheeran, Josette. Quoted at http://www.wfp.org/videos/wfp-executive-director-josette-sheeran.

95. Gabaldon, Diego Fernandez. Email correspondence with C. Goodman, January 25, 2009.

96. *Ibid*.

97. Proust, Marcel. "The Captive," vol. 10, pt. 2, chapter 3, in *Remembrance of Things Past* (1923). Translated by C.K. Moncrieff (London: Chatto and Windus, 1968).

98. Weisel, Elie. Quoted at: http://www.brainyquote.com/quotes/quotes/e/eliewiesel117181.html.

99. Barthes, Roland. *Camera Lucida: Reflections on Photography* (New York: Hill and Wang, 1984) pp. 64 - 65.

100. Grundberg, Andy. "Introduction" in *Tracing Cultures.* (San Francisco: The Friends of Photography, 1995) p. 20.

101. *Ibid*.

102. Inscriptions on the frames for both *Rock Shrine for My Father* and *Aunt Winnie* were provided to the author courtesy of Albert Chong.

103. Kittredge, William. "Hole in the Sky." Quoted in *Lee Friedlander: Family,* n.p.

104. Tomczak, Anna. Conversations with C. Goodman, February, 2008 and February, 2009.

105. Nakagawa, James, quoted at: http://www.mocp.org/collections/mpp/nakagawa_osamu_james.php

106. Clark, Edward. Quoted in the Editors of LIFE with Introduction by John Loengard. *The Great LIFE Photographers.* (New York and Boston: Bulfinch Press, 2004), p. 79.

107. Adams, Shelby Lee. Email correspondence to C. Goodman, March 9, 2009.

108. Michals, Duane, "Real Dreams" (1976). Quotation translated from the German from Kemp, Wolfgang. Theorie der Fotographie, Vol. III. (Verlag Schirmer/Mosel Munich, 1983), p. 232 and 235. Quoted in Kohler, Michael ed. *Arranged, Constructed and Staged-from Taking to Making Pictures.* (Munich and Zurich: Kunstverein Munchen and Edition Stemmle, 1989/95) p. 32.

109. Goldin, Nan. "Interview" with Philip Brookman. In Andre, Dena, Brookman, Philip, and Livingston, Jane, eds. *Hospice: A Photographic Inquiry* (Boston: Bulfinch Press Book in association with The Corcoran Gallery of Art and the National Hospice Foundation, 1996), p. 52.

110. *Ibid*, p. 53.

111. *Ibid*, p. 52.

112. Schumacher, Donald. Correspondence to C. Goodman, March 8, 2009. More information about hospice, advance care planning, and caregiving is available at www.caringinfo.org. Professionals in search of information to better serve patients and families should visit www.nhpco.org.

113. Mann, Sally. "Interview" with Philip Brookman. In *Hospice: A Photographic Inquiry*, p. 78.

114. Fields, Tom. Quoted at: http://www.nativefields.com/tom/main/links.htm.

115. Stevens, Jane. In Webster, Donovan. "Foreword" to Stevens, Jane Alden. *Tears of Stone: World War I Remembered.* (Cincinnati, OH: Jane Alden Stevens, 2004)*,* pp. 16-17.

116. De Swaan, Sylvia. Email correspondence to C. Goodman, December, 2008.

117. Plachy, Sylvia. Conversation with C. Goodman, January 19, 2009.

When asked about my work, I try to explain that there is no mystery involved. It is work. But things happen all the time that are unexpected, uncontrolled, unexplainable, even magical. The work prepares you for that moment. Suddenly the clouds roll in and the soft light you longed for appears.

Annie Leibovitz

Annie Leibovitz

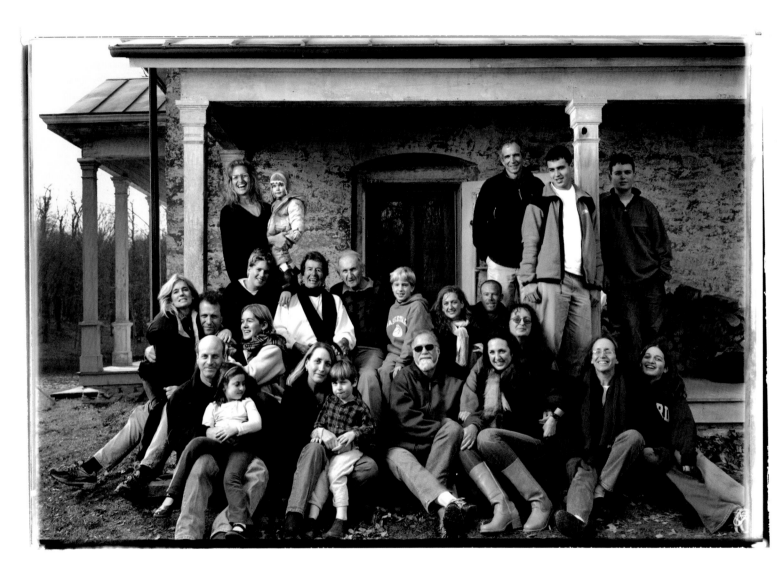

Thanksgiving, Clifton Point, New York, 2003

2003 Archival pigment print 20 × 24 inches © Annie Leibovitz Courtesy Leibovitz Studio, New York, NY

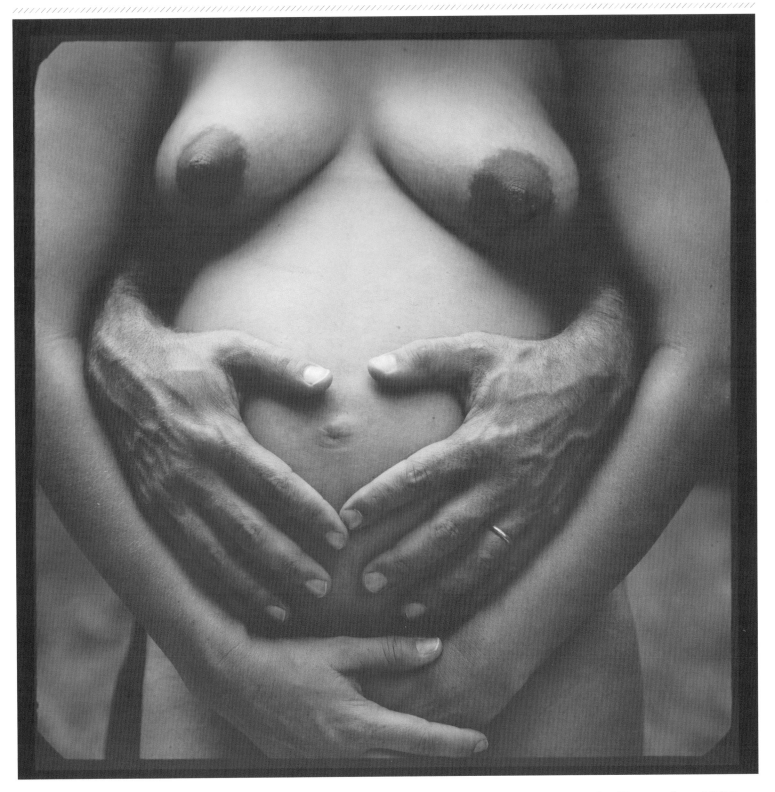

Bruce Willis and Demi Moore, pregnant with Rumer Glenn Willis, Paducah, Kentucky, 1988

1988 Archival pigment print 20 × 24 inches © Annie Leibovitz Courtesy Leibovitz Studio, New York, NY

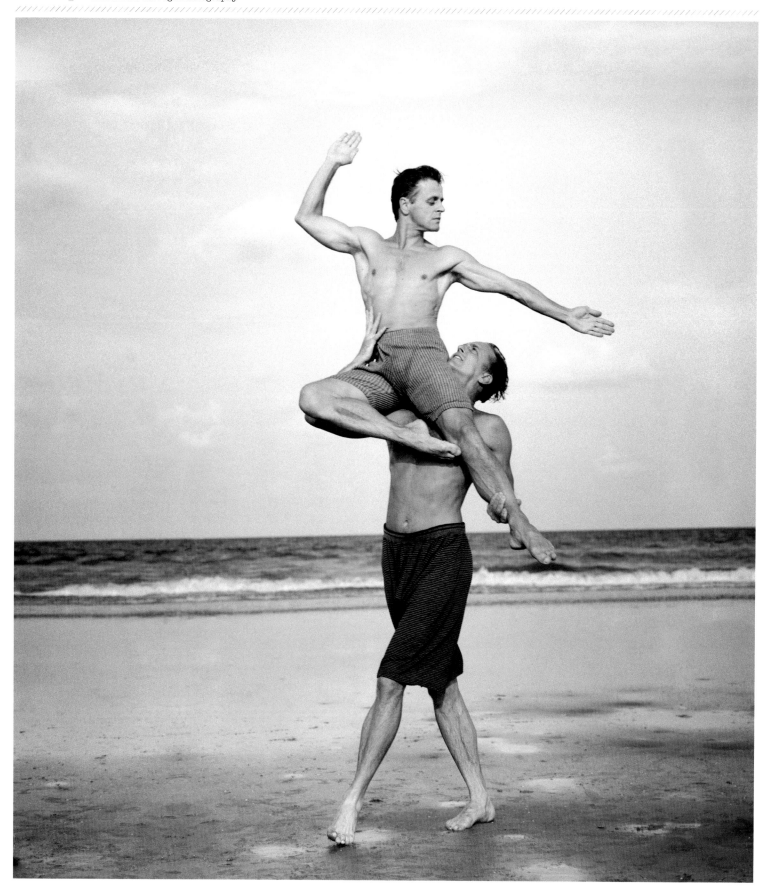

Mikhail Baryshnikov and Rob Besserer, Cumberland Island, Georgia, 1990

1990 Archival pigment print 24 × 20 inches ©Annie Leibovitz Courtesy Leibovitz Studio, New York, NY

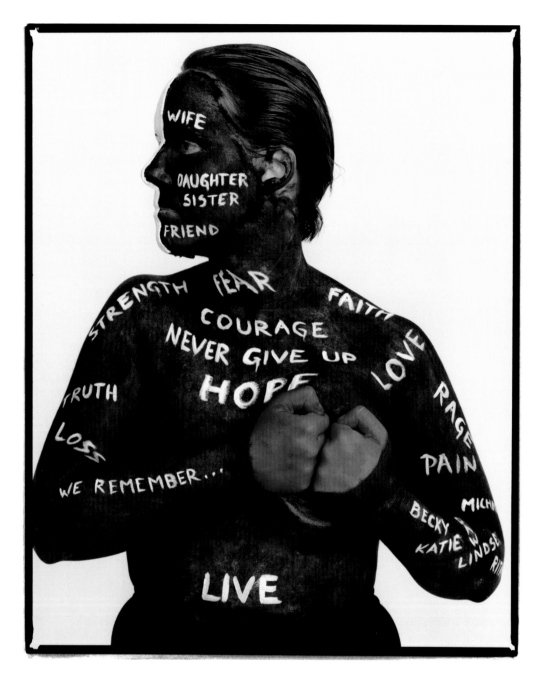

Rebecca Denison, founder of WORLD (Women Organized to
Respond to Life-threatening Diseases), San Francisco, 1993

1993 Archival pigment print 40 × 30 inches ©Annie Leibovitz Courtesy Leibovitz Studio, New York, NY

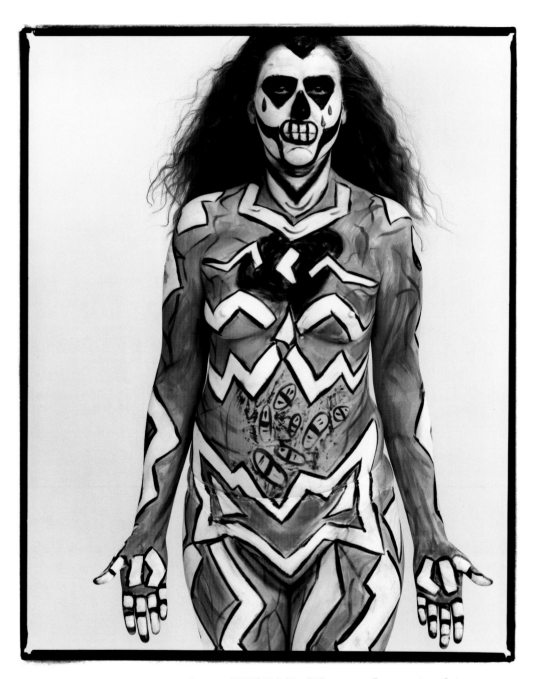

Kerie Campbell, member of WORLD (Women Organized to
Respond to Life-threatening Diseases), San Francisco, 1993

1993 Archival pigment print 40 × 30 inches © Annie Leibovitz Courtesy Leibovitz Studio, New York, NY

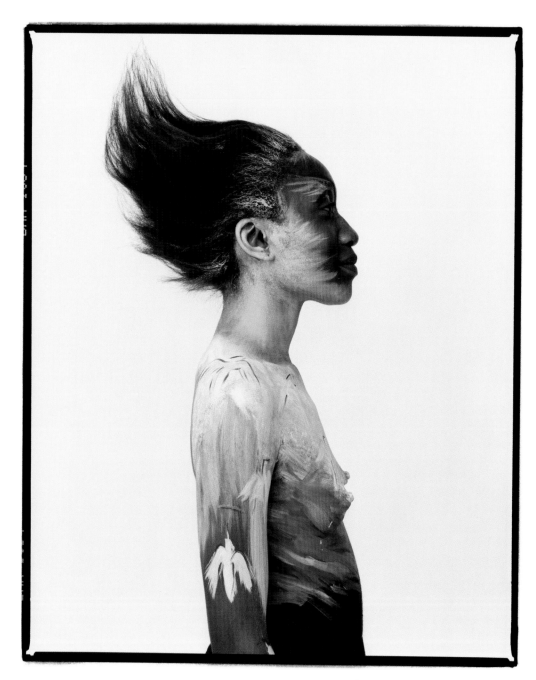

Glenda Thorton, member of WORLD (Women Organized to Respond to Life-threatening Diseases), San Francisco, 1993

1993 Archival pigment print 40 × 30 inches © Annie Leibovitz Courtesy Leibovitz Studio, New York, NY

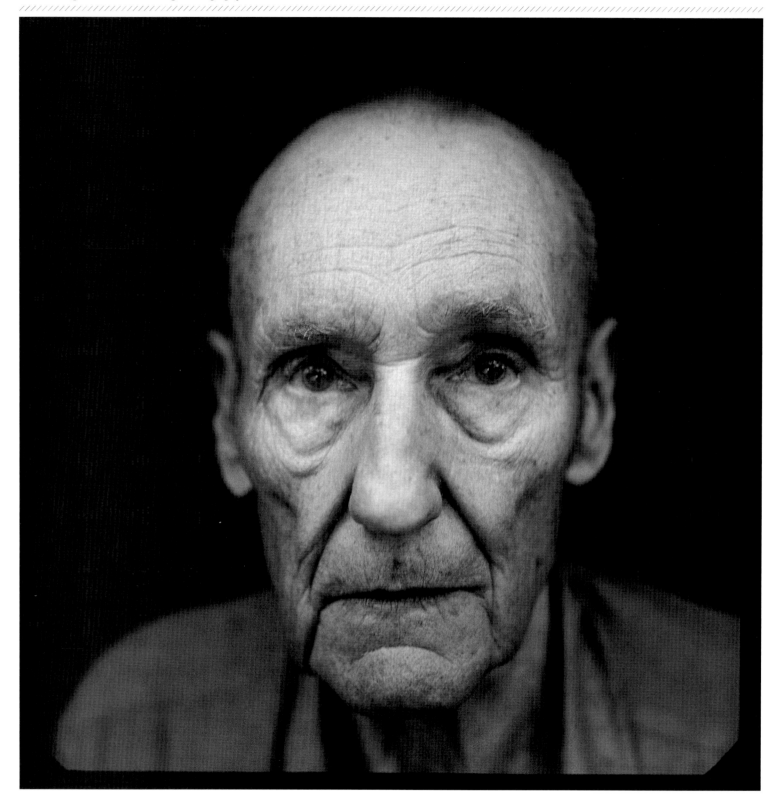

William S. Burroughs, Lawrence, Kansas, 1994

1994 2 Archival pigment prints each: 20 × 24 inches © Annie Leibovitz Courtesy Leibovitz Studio, New York, NY

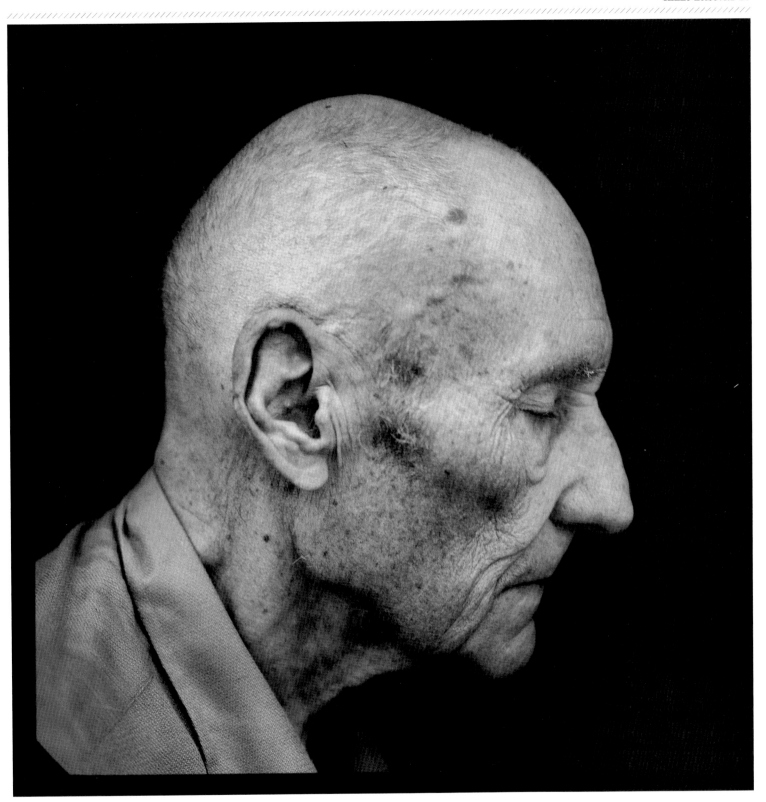

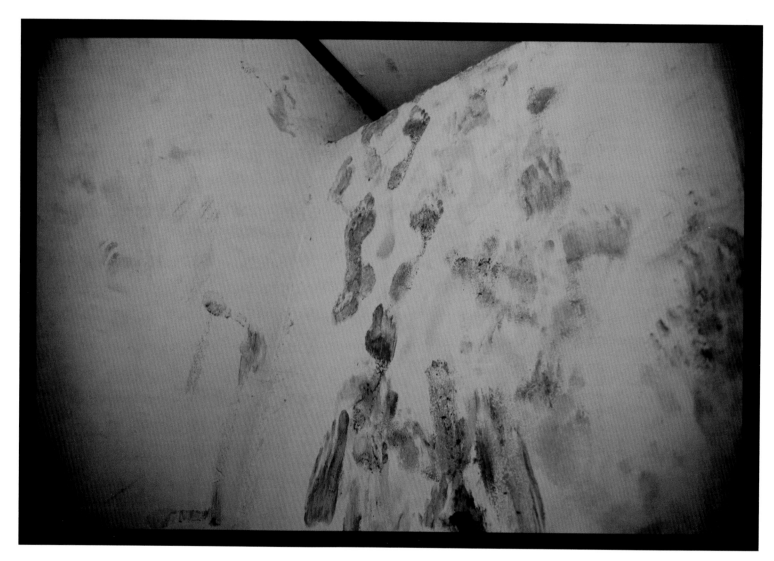

Traces of the Massacre of Tutsi schoolchildren and villagers on a bathroom wall,
Shangi mission school, Rwanda, 1994

1994 Archival pigment print 20 × 24 inches © Annie Leibovitz Courtesy Leibovitz Studio, New York, NY

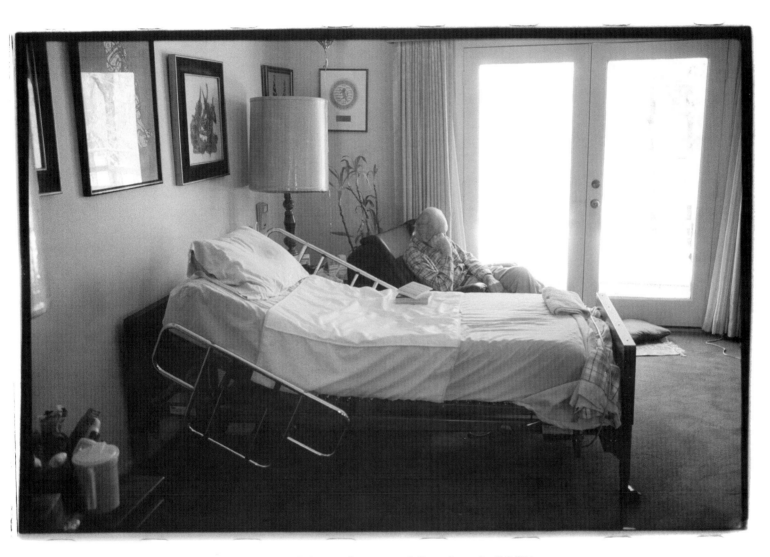

Living room of my parents' house, Silver Spring, Maryland, 2003

2003 Archival pigment print 20 × 24 inches © Annie Leibovitz Courtesy Leibovitz Studio, New York, NY

In every child who is born,
No matter what circumstances,
And of no matter what parents,
The potentiality of the human race
is born again...

James Agee

Children
& Family

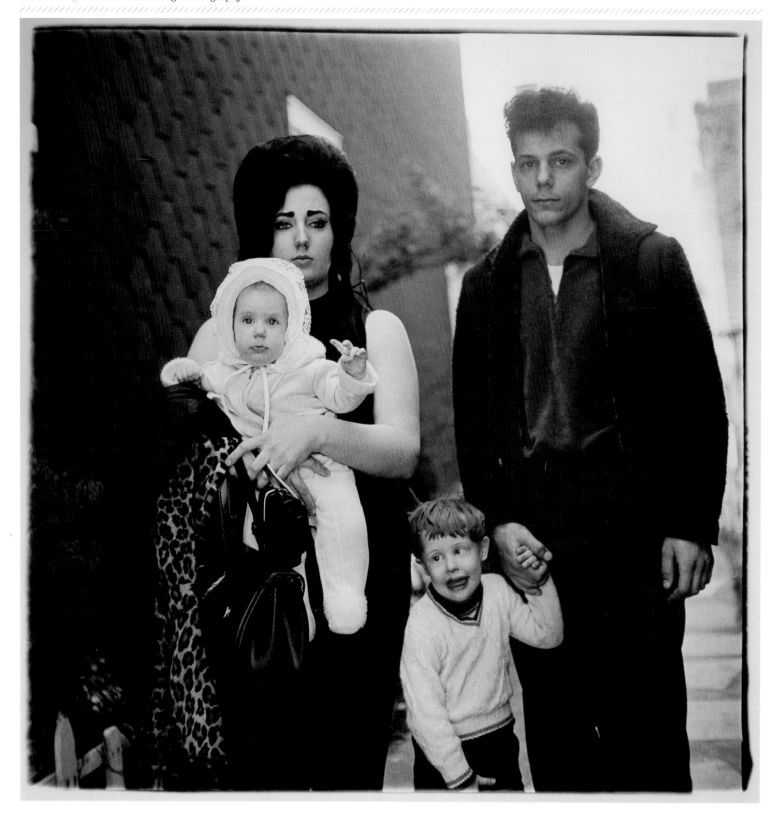

Diane Arbus
Family in Brooklyn

1970, printed 1973 Gelatin silver print 14 9/16 × 14 5/8 inches © Diane Arbus New Orleans Museum of Art, New Orleans, LA: Museum Purchase, Ella West Freeman Foundation Fund, 73.29.4

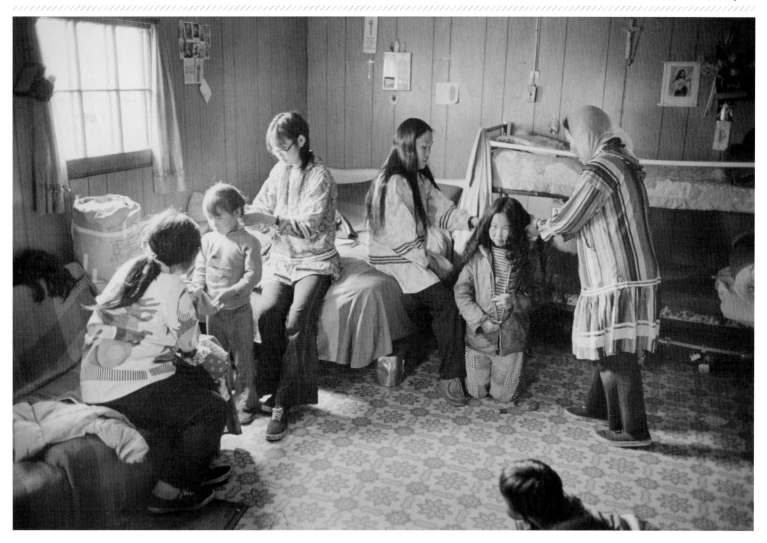

James Barker
Grooming in Angelina Ulroan's Home in Chevak, Alaska

1977 Gelatin silver print 16 × 20 inches ©James Barker Collection of the Artist

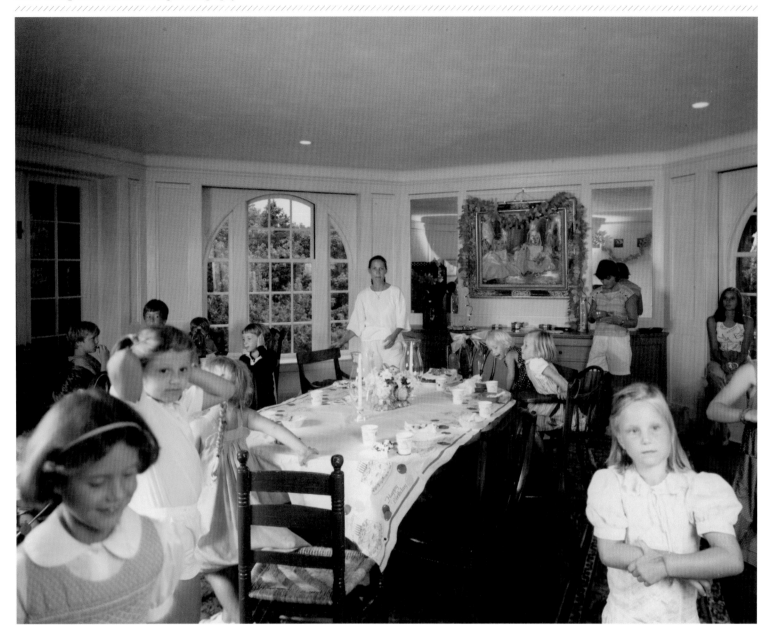

Tina Barney
Children's Party

1986 Chromogenic print 48 × 60 inches ©Tina Barney Courtesy Janet Borden Gallery, New York, NY

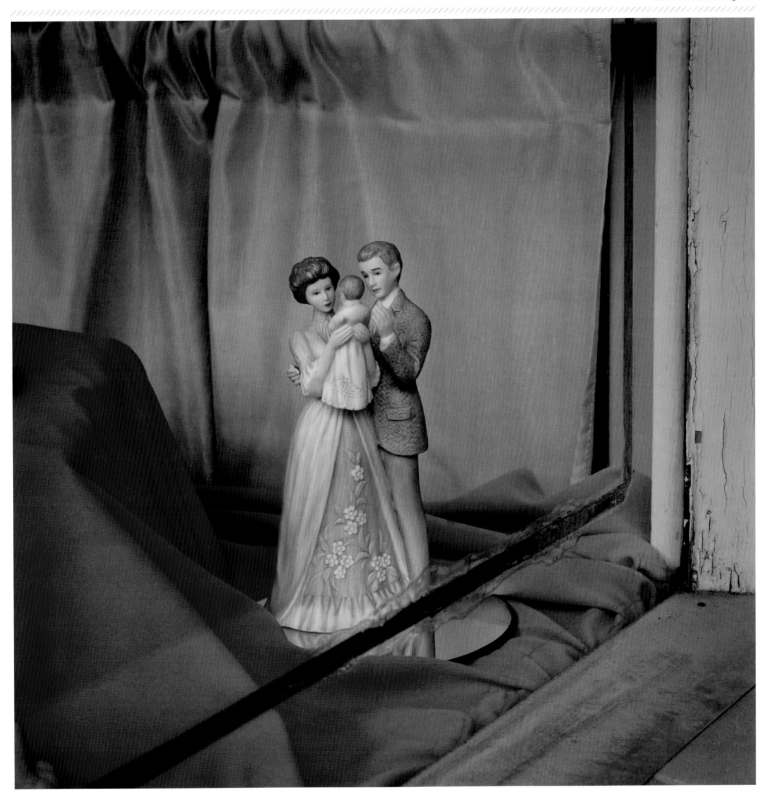

Phil Bergerson
Nuclear Ceramic Family

1994 Chromogenic print on archival board 30 × 30 inches © Phil Bergerson Courtesy Steven Bulger Gallery, Toronto, Ontario, Canada

Dawoud Bey
Nora, Mohamud, Dega, and Fos Osman, and Rukio, Safi, and Fiesel Omar

1993 4 Gelatin silver prints each: 5⅞ × 4¹¹⁄₁₆ inches ©Dawoud Bey The George Gund Foundation Collection in honor of David Bergholz,
The Cleveland Museum of Art, Cleveland, OH, 2004.125.a-.d

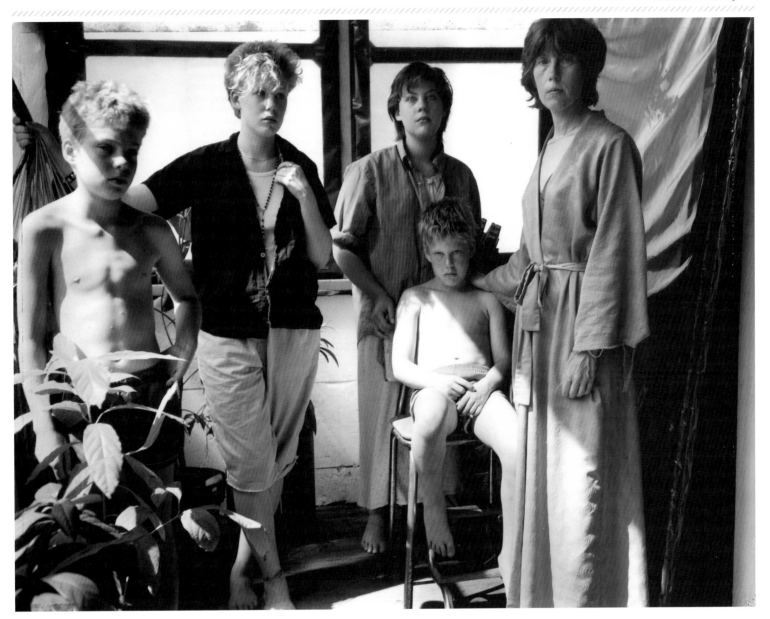

Judith Black
Self with Children (Before Vacation with Their Father), July 14, 1984

1984 Gelatin silver print from Polaroid Positive/Negative film type 55 12½×16¼ inches ©Judith Black Courtesy Catherine Edelman Gallery, Chicago, IL Courtesy the Polaroid Collections, Somerville, MA

Julie Blackmon
American Gothic

2008 Pigment ink print 22 × 29 inches ©Julie Blackmon Courtesy Catherine Edelman Gallery, Chicago, IL

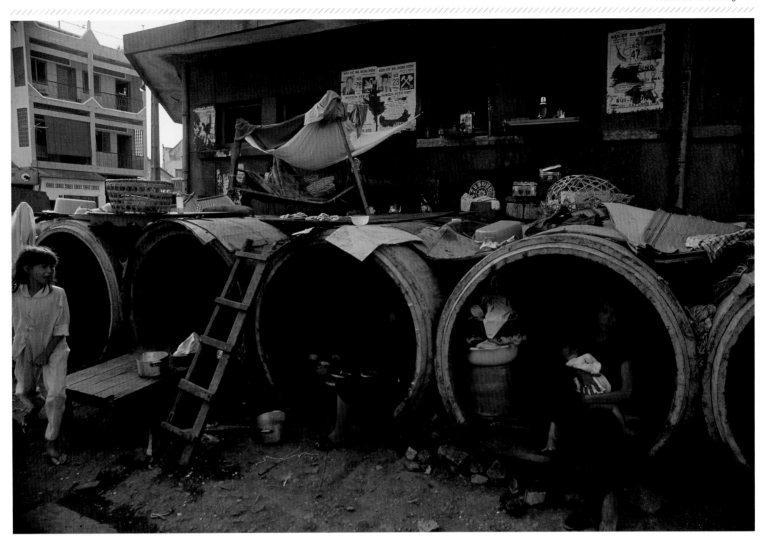

Larry Burrows
Refugees living in sewer pipes near Central Market

1969 Inkjet print 21½ × 36 inches ©2009 Time Inc. Used with permission. Time LIFE Collection

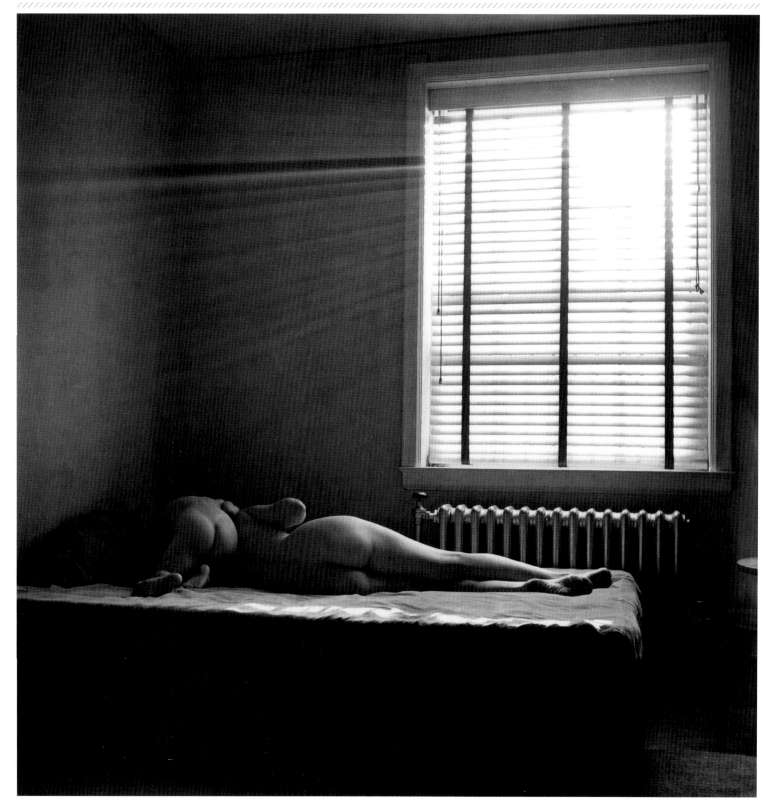

Harry Callahan
Eleanor and Barbara, Chicago

1954 Gelatin silver print 9⅝₆ × 9⅛ inches ©The Estate of Harry Callahan Courtesy Pace/MacGill Gallery, New York, NY
Center for Creative Photography, University of Arizona, Tuscon, AZ: Gift of Irving W. Rose

Henri Cartier-Bresson
A bewildered old man searches for his son as the new recruits called up by
the fast weakening Kuomintang government march off to defeat

1949, printed 1973 Gelatin silver print 12½ × 16¼ inches ©Henri Cartier-Bresson/Magnum Photos Norton Museum of Art,
West Palm Beach, FL, Gift of Baroness Jeane von Oppenheim, 98.129

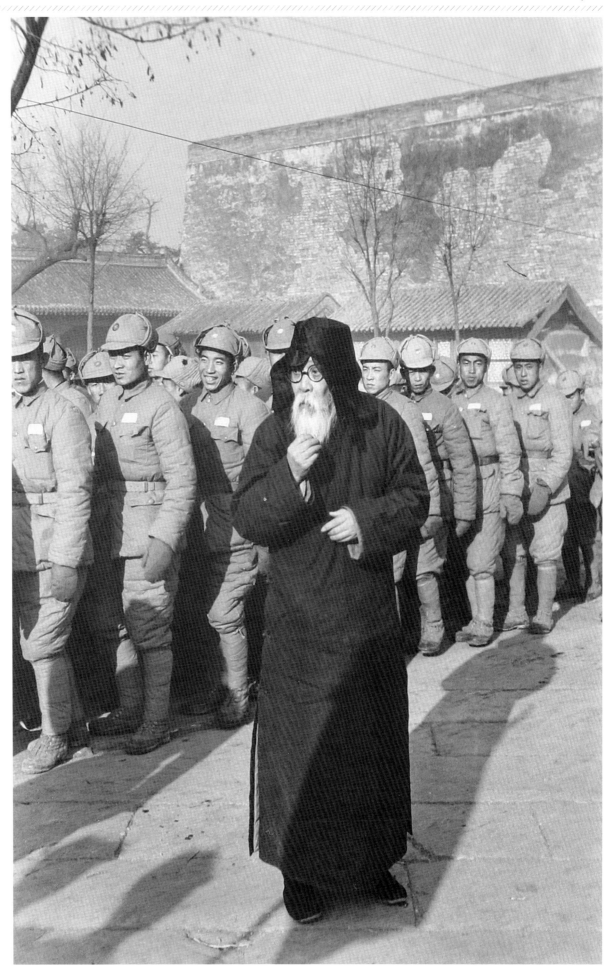

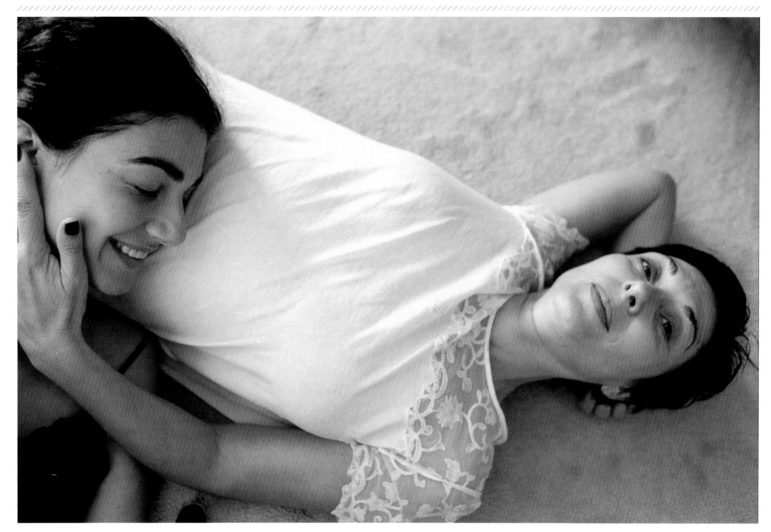

Elinor Carucci
My Mother and I

1996 Chromogenic print 16 × 20 inches edition 1 of 8 © Elinor Carucci Courtesy Edwynn Houk Gallery, New York, NY

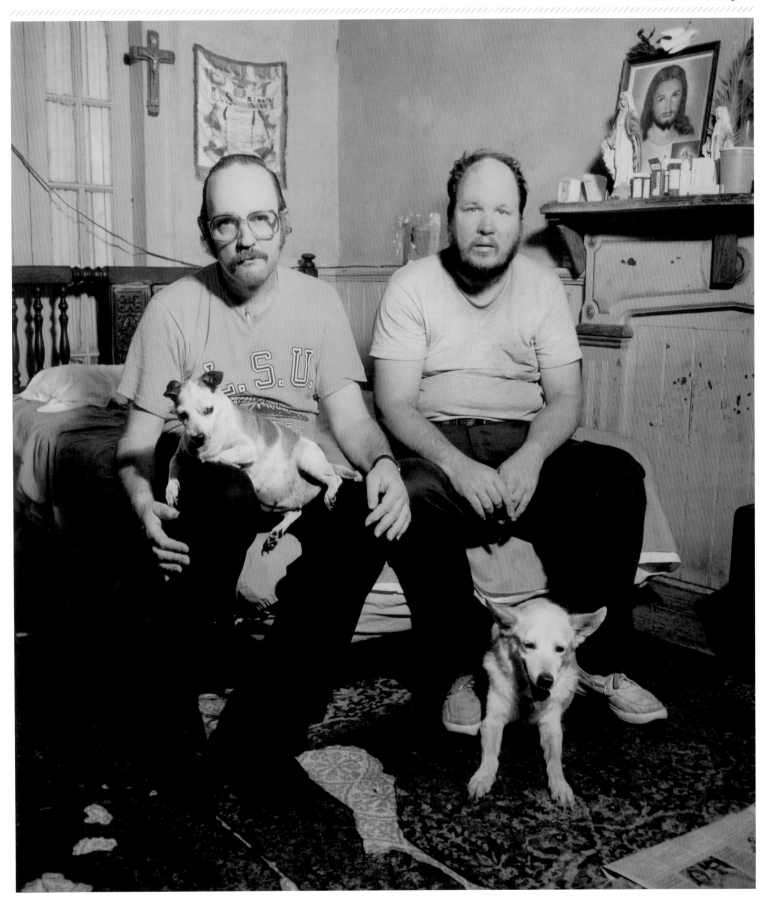

Judy Cooper
Mrs. Robertson's Boys

1989 Hand colored gelatin silver print 36 × 32 inches ©Judy Cooper New Orleans Museum of Art, New Orleans, LA: Museum Purchase, Clarence John Laughlin Photographic Society Fund, 90.191

1950 11/200 Harold Feinstein

Harold Feinstein
Father and Daughter on Beach, Coney Island
1950 Gelatin silver print 8⅜×12⅝ inches ©Harold Feinstein Cincinnati Art Museum, Cincinnati, OH, Gift of Susan Meyers-Falk, 1986.439

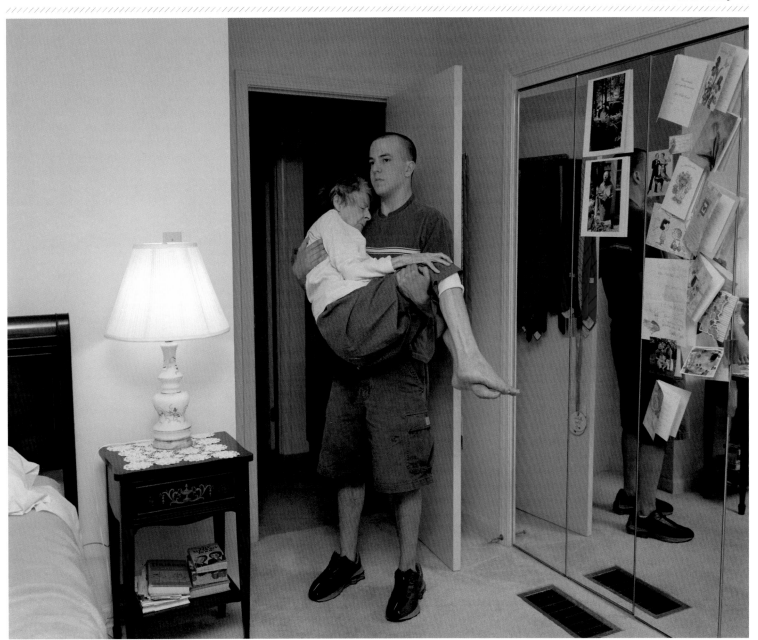

Mary Frey
My Mother, My Son

2004 Chromogenic print 24 × 30 inches ©Mary Frey Collection of the Artist

Lee Friedlander
Eri and Ava

1998 Gelatin silver print 14¼ × 14¼ inches sheet © Lee Friedlander Courtesy Janet Borden Gallery, New York, NY

Laura Gilpin
Francis Nakai and Family

1950 Gelatin silver print 13½ × 10½ inches © Laura Gilpin New Orleans Museum of Art,
New Orleans, LA: Museum Purchase through the National Endowment for the Arts Grant, 75.99

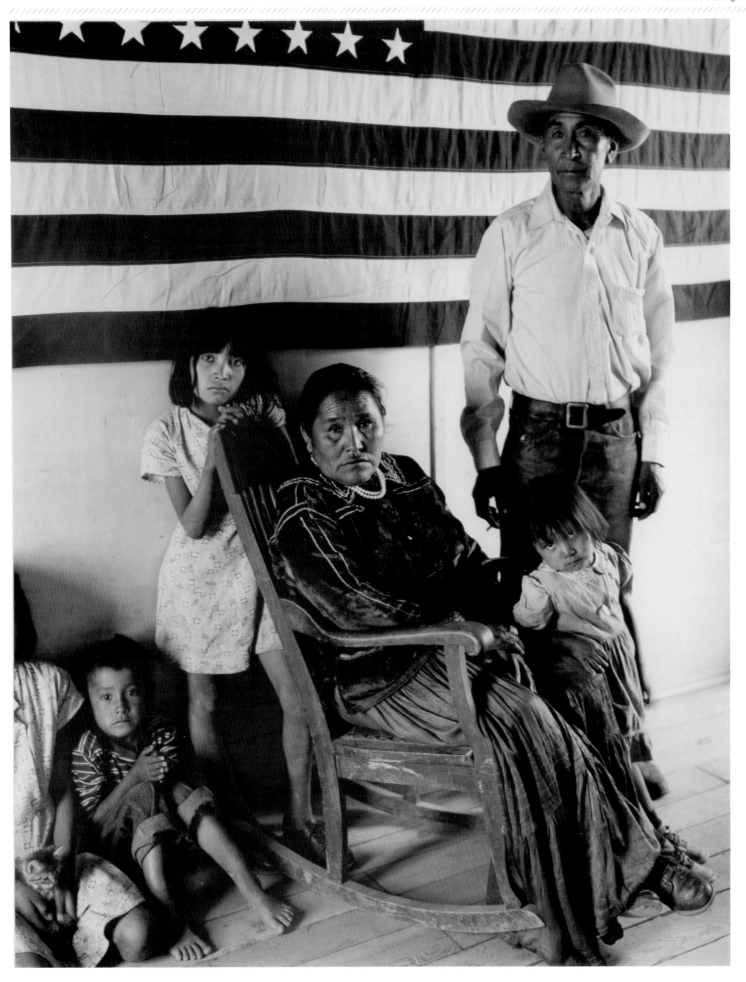

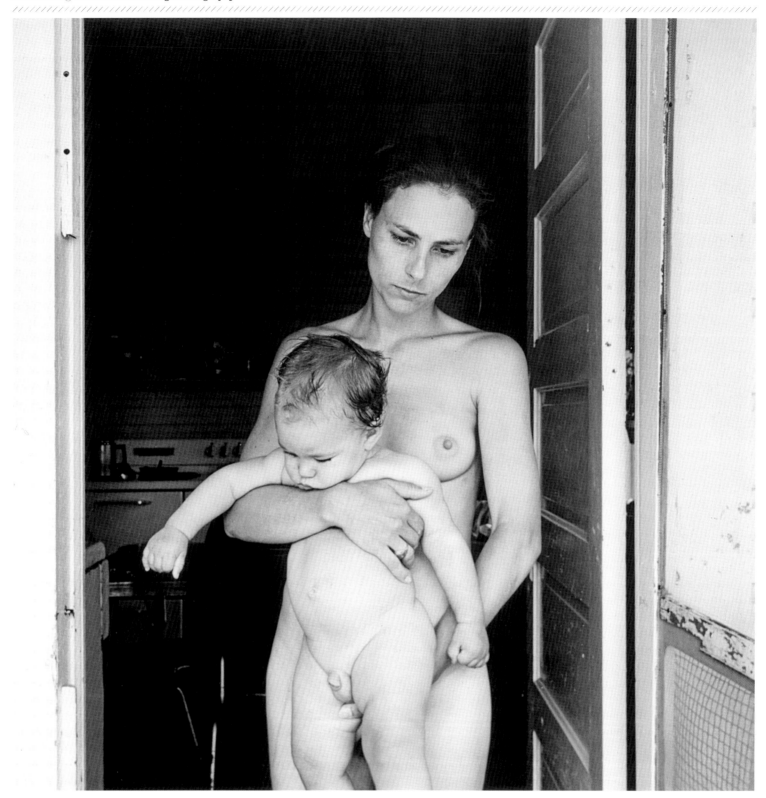

Emmet Gowin
Edith and Elijah, Danville, Virginia
1968 Gelatin silver print 5¾ × 5⅞ inches ©Emmet and Edith Gowin Courtesy Pace/MacGill Gallery, New York, NY High Museum of Art, Atlanta, GA; Purchase

Marie Hanson
Margaret O'Brien and her Spaniel, Maggie

1944 Inkjet print 25 × 24 inches ©2009 Time Inc. Used with permission. Time LIFE Collection

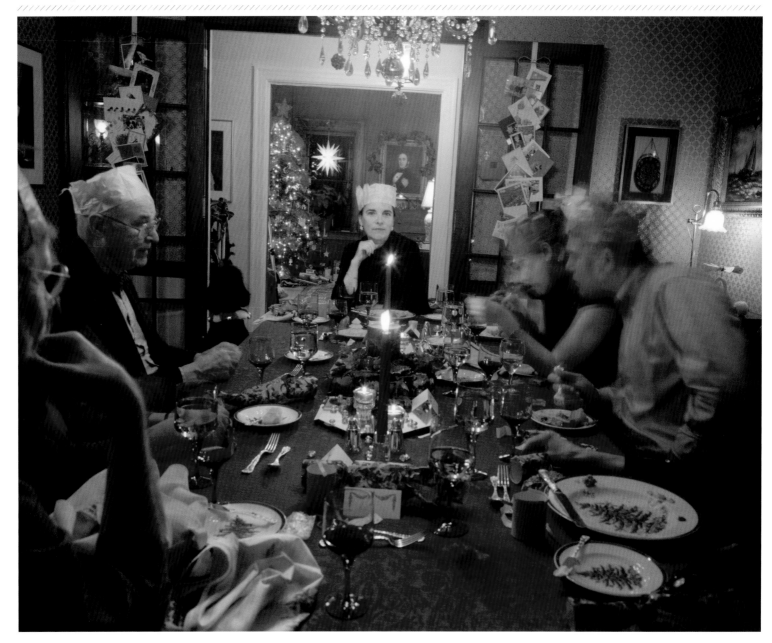

Jessica Todd Harper
Christmas Eve Dinner

2006 Chromogenic print 32 × 40 inches ©Jessica Todd Harper Collection of the Artist

David Hockney
My Mother, Bolton Abbey, Yorkshire Nov. 1982

1982 Photographic collage 47½ × 27½ inchesedition 4 of 20 ©David Hockney Courtesy David Hockney Studio, Los Angeles, CA

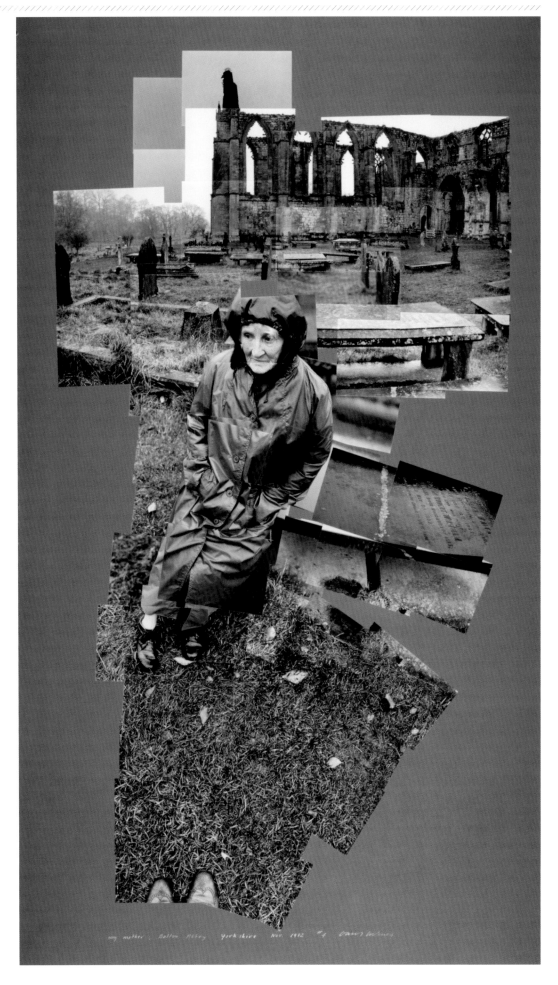

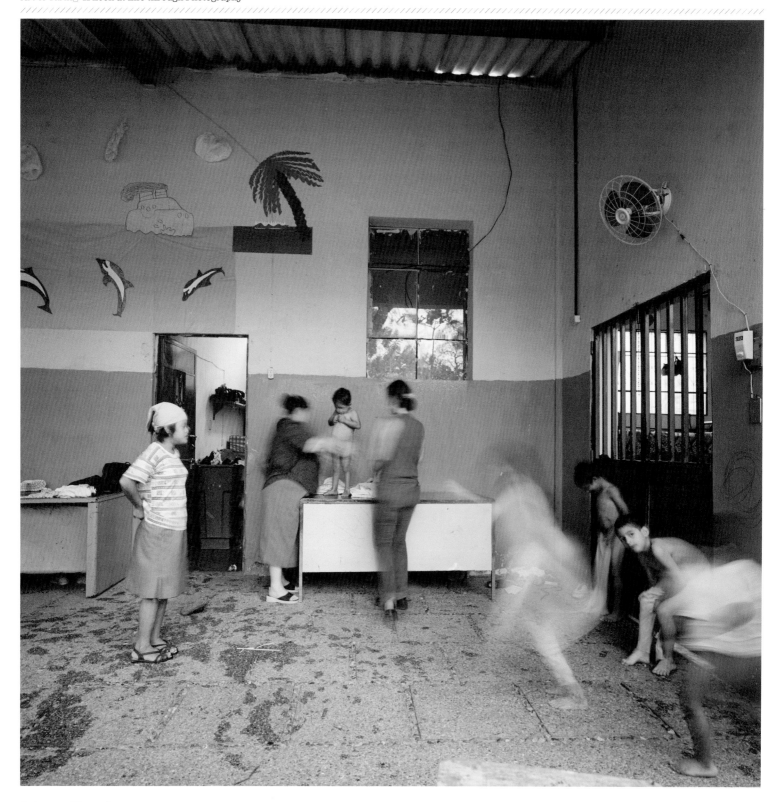

Misty Keasler
Afternoon Bathtime, Mi Hogan Zacapa, Guatemala, from the Orphanage Series
2003 Chromogenic print 19×19 inches ©Misty Keasler Courtesy PDNB Gallery, Dallas, TX

Nina Leen
Four Generations of an Ozark Family, with Ancestors' Portraits, Bellevue, Missouri
1946 Inkjet print 32×26 inches ©2009 Time Inc. Used with permission. Time LIFE Collection

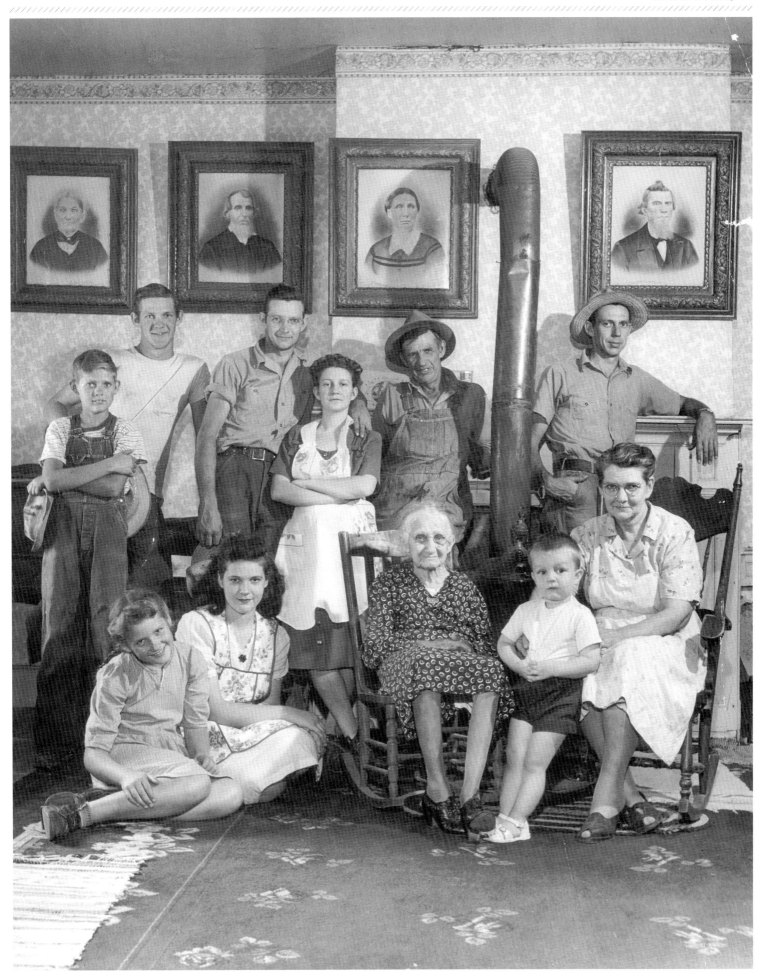

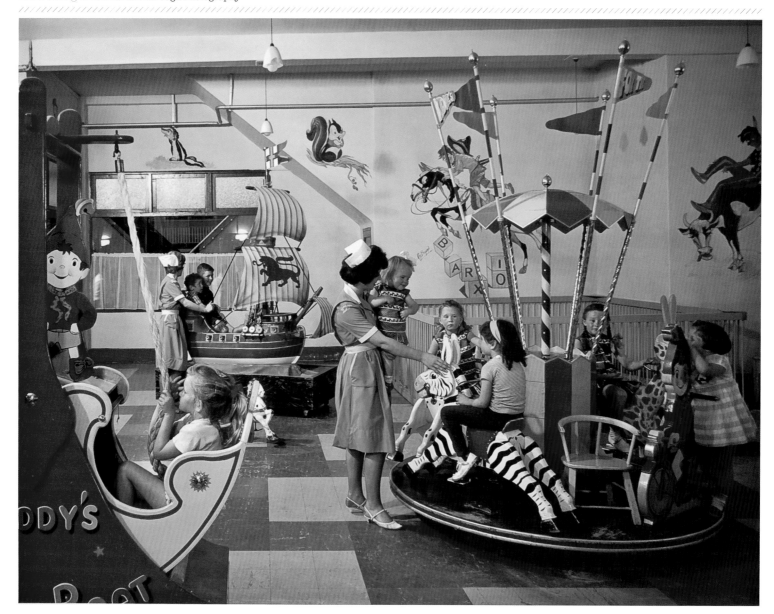

Elmar Ludwig for John Hinde Company
Corner of the Children's Playroom

Circa 1970 Chromogenic print 20 × 24 inches © Elmar Ludwig for John Hinde Company Courtesy Janet Borden Gallery, New York, NY

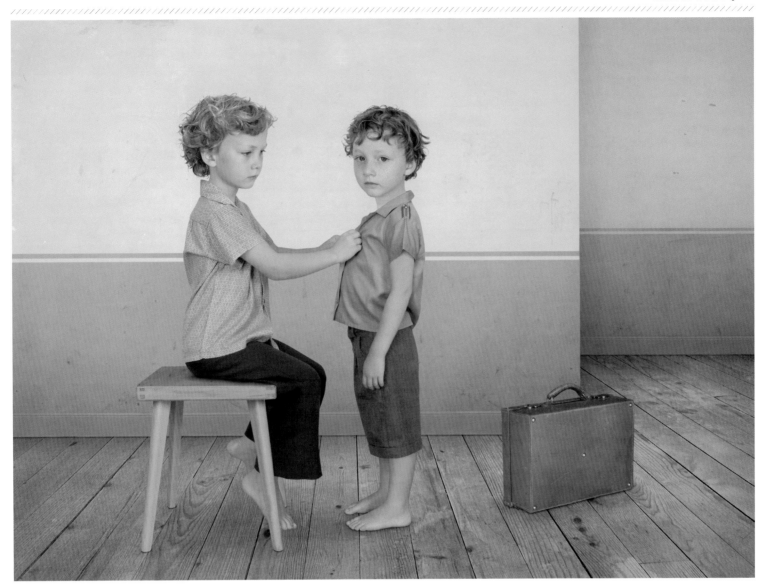

Loretta Lux
Hugo and Dylan 2

2006 Ilfochrome print 19⅝ × 25⅓ inches ©Loretta Lux Courtesy Yossi Milo Gallery, New York, NY

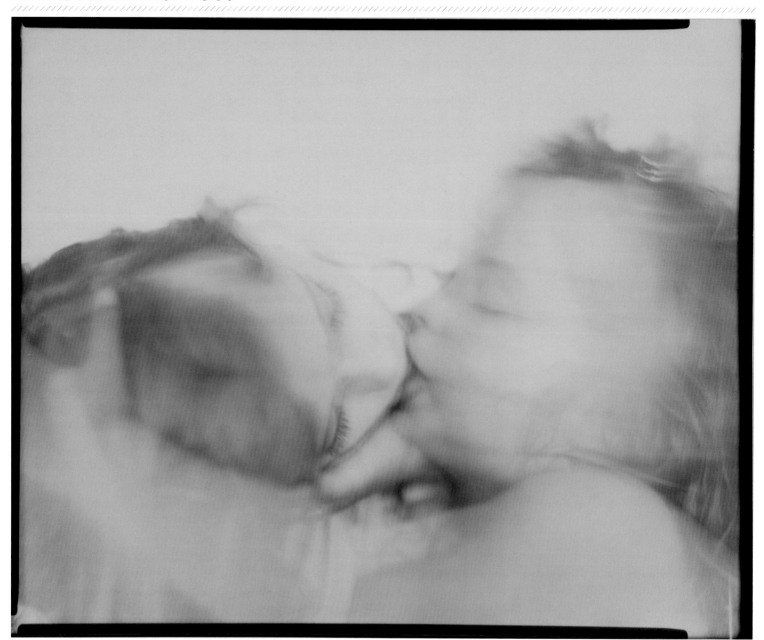

Sally Mann
Kiss Goodnight

1988 Gelatin silver print 8 × 10 inches © Sally Mann Courtesy Gagosian Gallery, New York, NY

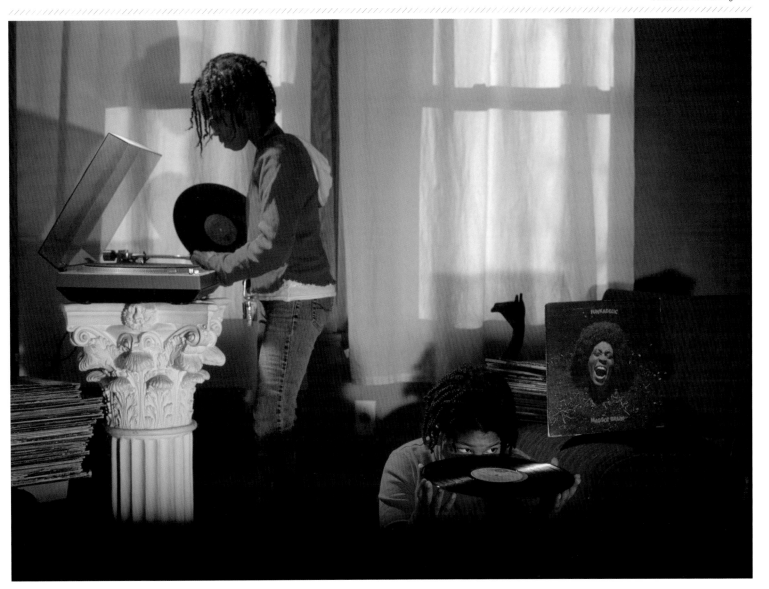

Cecil McDonald, Jr.
1200 Meditations, Things My Mother Gave Me

2005 Archival digital photograph 20 × 24 inches © Cecil McDonald, Jr. Courtesy Catherine Edelman Gallery, Chicago, IL

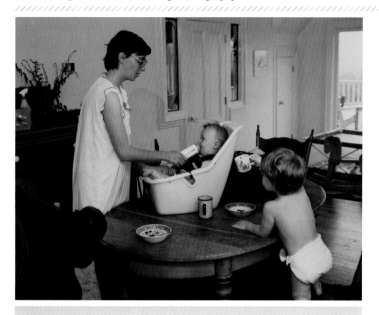

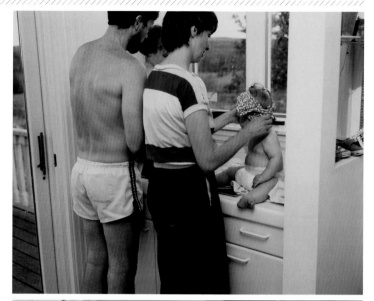

The family then is the type of an archaic society in
all of the modifications which it was capable of
assuming;...the persons theoretically amalgamated into
a family by their common descent are practically held
together by common obedience to their highest living
ascendant, the father, grandfather, or great-grand-
father. The patriarchal authority of a chieftan
is as necessary an ingredient in the notion of the
family group as the fact (or assumed fact) of its
having sprung from his loins;...
Henry Maine, 1861

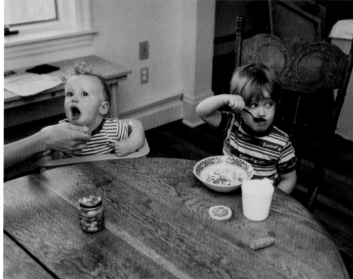

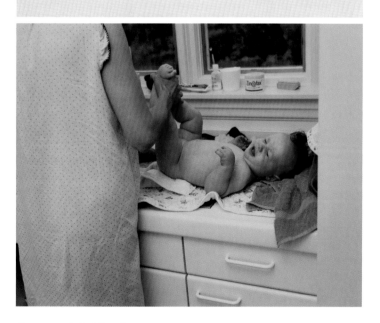

King Oedipus, who slew his father Laius and wedded his
mother Jocasta, is nothing more or less than a wish-
fulfilment - the fulfilment of the wish of our child-
hood. But we, more fortunate than he, in so far as
we have not become psychoneurotics, have since our
childhood succeeded in withdrawing our sexual impulses
from our mothers, and in forgetting our jealousy of
our fathers.
Sigmund Freud, 1900

Susan McEachern
The Family in the Context of Childrearing

1983–1984, printed 1987 12 Chromogenic prints each: 15¹¹⁄₁₆ × 19¹¹⁄₁₆ inches ©Susan McEachern Canadian Museum of Contemporary Photography, an affiliate of
the National Gallery of Canada, Ottawa, Canada; Purchased 1987

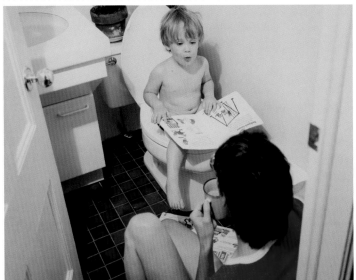

My grandparents' generation was the first generation
of my family to consider romantic love as a primary
consideration in the choice of a marriage partner.

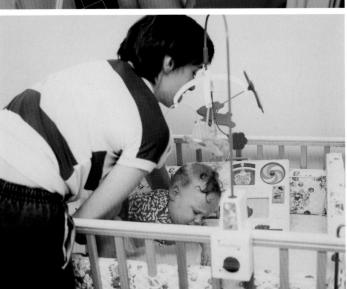

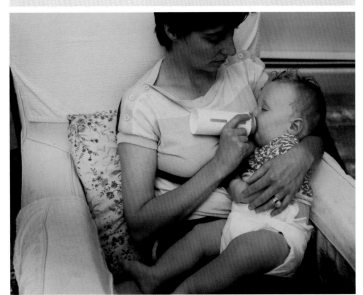

In rejecting the theory of the childhood fixation of
personality, I do not wish to minimize the role of family
factors. The thesis I wish to present may well imply
its even greater importance, for the heart of the con-
tention is that the family, like a great many other
determinants of behavior, operates throughout one's
entire life. Family factors, like old soldiers, never
die; unlike them, they do not even fade away.
James H.S. Bossand, 1953

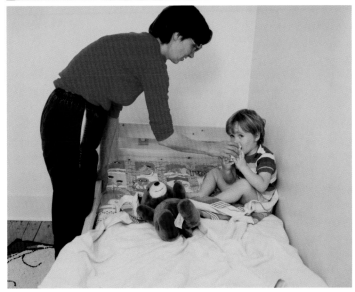

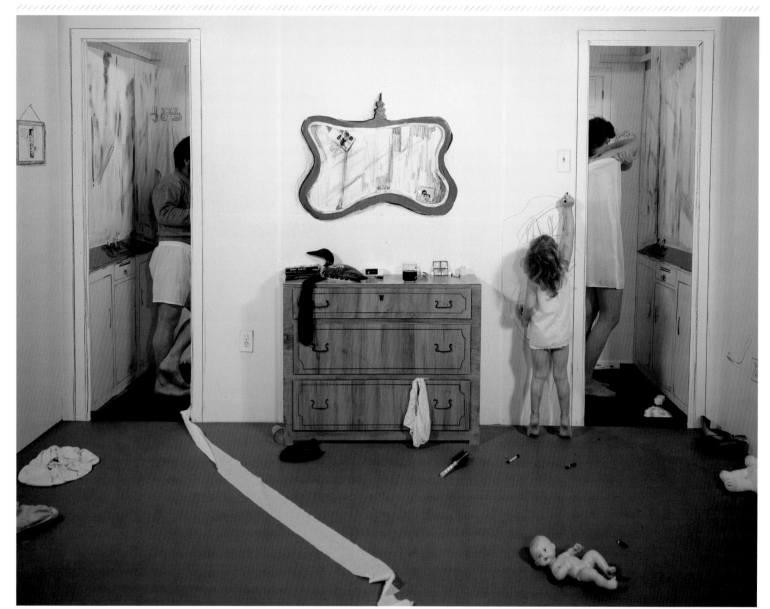

Nic Nicosia
Domestic Drama #1

1982 Archival inkjet print, on Somerset watercolor paper 40 × 50 inches edition 3 of 8 ©Nic Nicosia Courtesy Dunn and Brown Contemporary, Dallas, TX

Nicholas Nixon
The Brown Sisters

1980 Gelatin silver print 8 × 10 inches © Nicholas Nixon Courtesy Fraenkel Gallery, San Francisco, CA and Yossi Milo Gallery, New York, NY
Cincinnati Art Museum, Cincinnati, OH, Museum Purchase with funds provided by Carl Jacobs, 2005.13

Bill Owens
We're really happy. Our kids are healthy, we eat good food, and we have a really nice home

1971 Gelatin silver print 11 × 14 inches © Bill Owens Courtesy PDNB Gallery, Dallas, TX

Marian Penner Bancroft
2:50 a.m. Mission Memorial Hospital…six hours into labour…Judy and
Tennyson…dance a slow one

1982 3 Gelatin silver prints each: 26 × 38½ inches © Marian Penner Bancroft Canadian Museum of Contemporary Photography, an affiliate of the
National Gallery of Canada, Ottawa, Canada; Purchased 1984

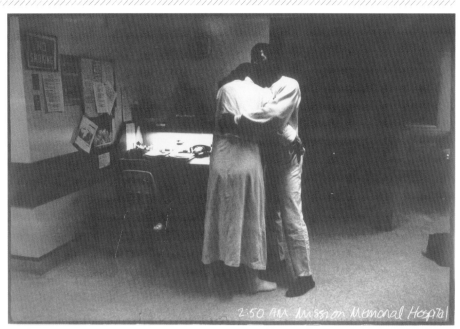

2:50 AM Mission Memorial Hospital

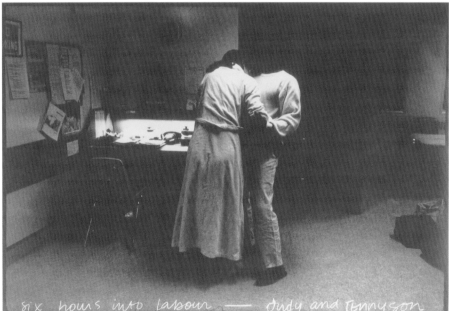

six hours into labour — Judy and Tennyson

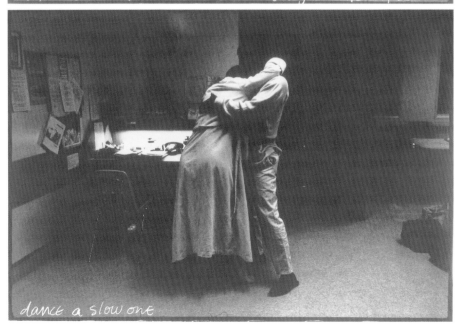

dance a slow one

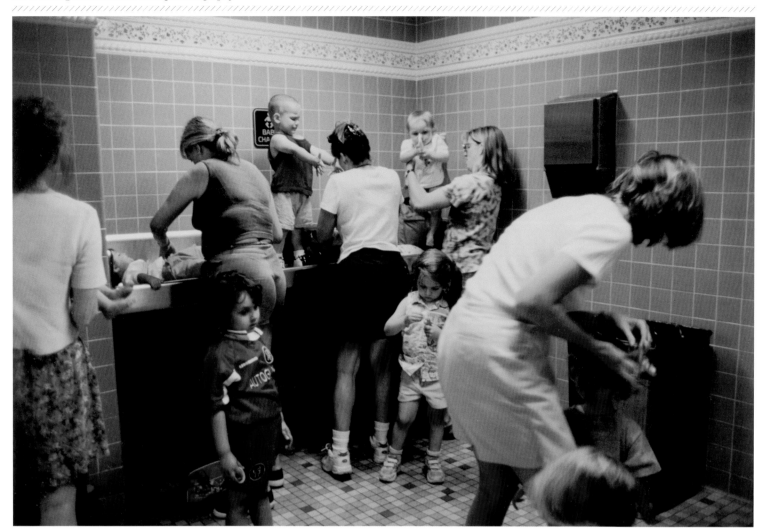

Melissa Ann Pinney
Disney World, Orlando

1998 Chromogenic print 15½ × 23 inches © Melissa Ann Pinney Courtesy Catherine Edelman Gallery, Chicago, IL Museum of Contemporary Photography,
Columbia College Chicago, Chicago, IL

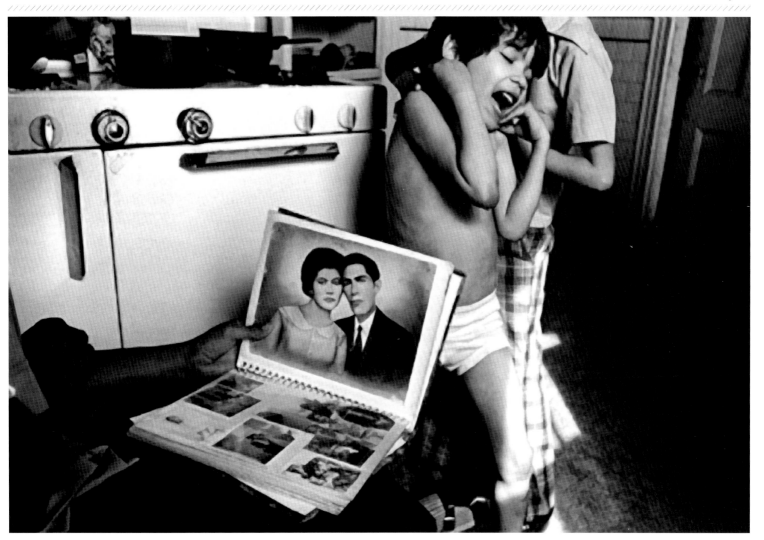

Eugene Richards
Family Album, Dorchester, Massachusetts
1976 Gelatin silver print 11⅞×17½ inches ©Eugene Richards Museum of Contemporary Photography, Columbia College Chicago, Chicago, IL

Milton Rogovin
Lower West Side Quartet (Grandparents-Baptism Boy)

1974–2002 4 Gelatin silver prints 6 × 5 inches, 6 × 6 inches, 6 × 6½ inches, 6 × 6 inches ©Milton Rogovin Courtesy the Rogovin Collection, LLC

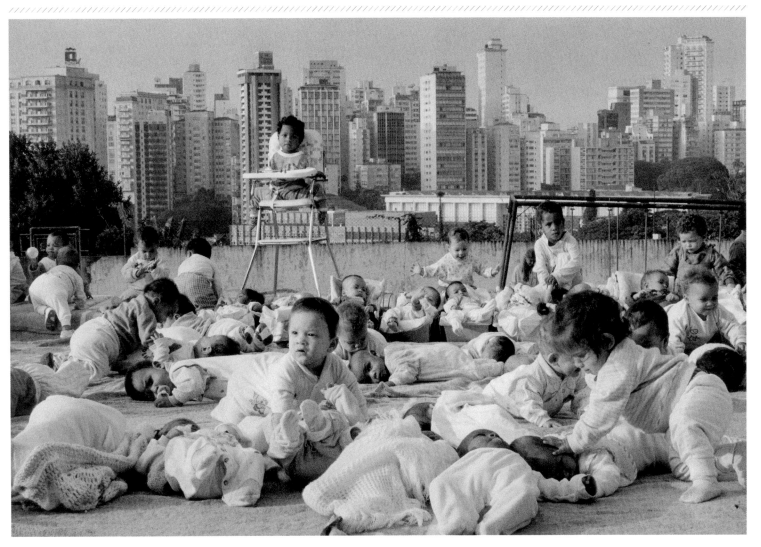

Sebastião Salgado
Sao Paulo, Brazil : Abandoned Babies playing on the roof of FEBEM (Foundation for
Child Welfare Center)

1996 Gelatin silver print 13¾ × 20½ inches ©Sebastião Salgado Courtesy the Artist and Amazonas Press, Paris, France

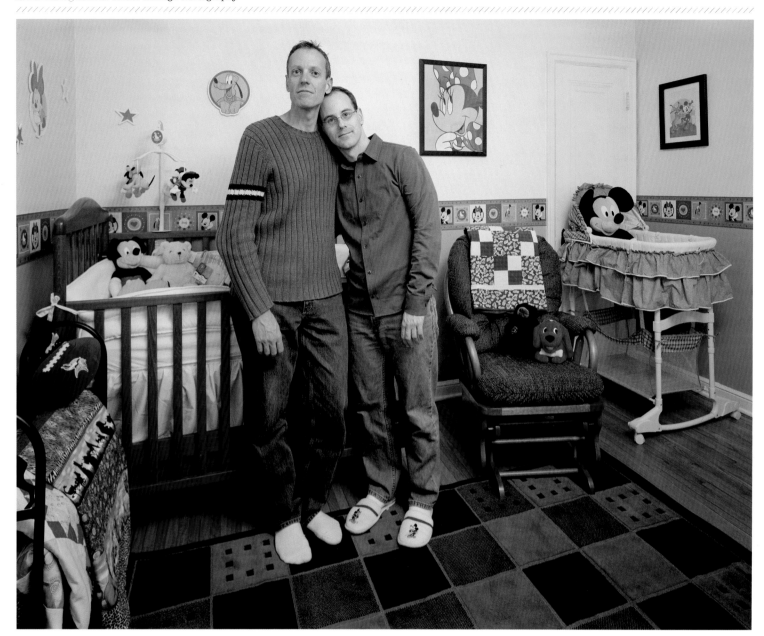

Dona Schwartz
Jason and Kevin, 7 Days, from the On the Nest Series

2007 Chromogenic print 48 × 60 inches ©Dona Schwartz Courtesy Steven Bulger Gallery, Toronto, Ontario, Canada

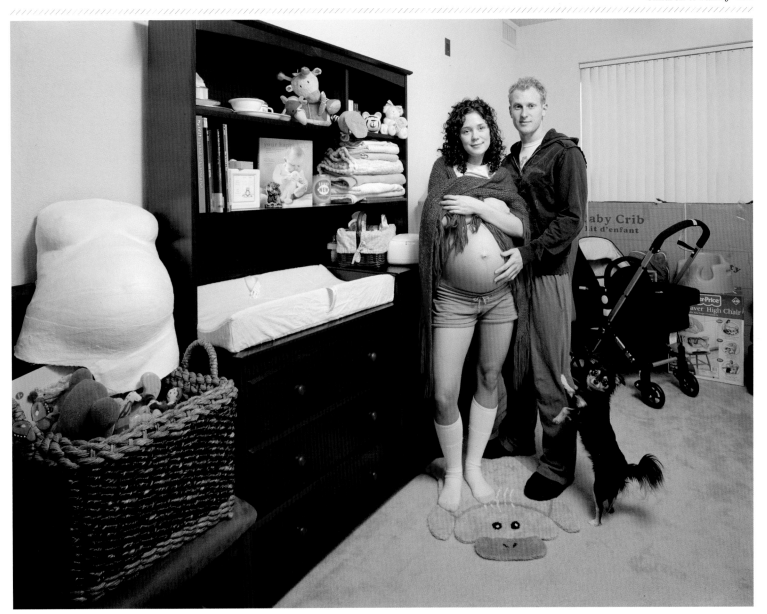

Dona Schwartz
Kristin and Ryan, 18 Days, from the On the Nest Series
2006 Chromogenic print 48 × 60 inches ©Dona Schwartz Courtesy Steven Bulger Gallery, Toronto, Ontario, Canada

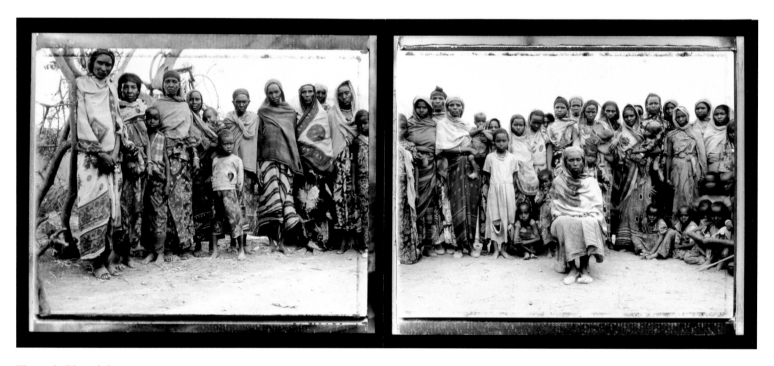

Fazal Sheikh
Gabbra tribal matriarch with Gabbra women and children, Ethiopian refugee camp, Walda, Kenya

1993 3 Gelatin silver prints from Polaroid Positive/Negative film type 665 each: 14½ × 17½ inches © Fazal Sheikh Courtesy the Artist and Pace/MacGill Gallery, New York, NY
Courtesy The Polaroid Collections, Somerville, MA

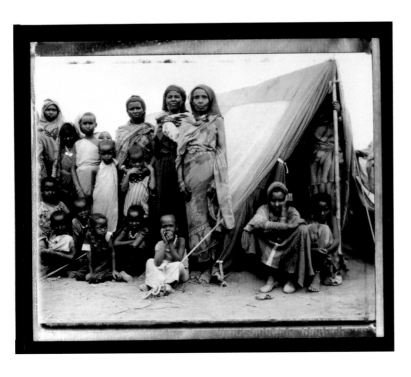

THREE GENERATIONS OF
PROUD
AMERICANS

1ˢᵀ. ROY T. MILLER SR., U.S. ARMY – 1938 thru 45, 3ᵈ CALVARY, 101ˢᵀABN.

2ᴺᴰ. ROY T. MILLER JR., U.S. ARMY – 1966 thru 68, 101ˢᵀ ABN DIV. 2/502 RECON

3ᵈ. ROY T. MILLER III., THE FUTURE OF AMERICA'S FREEDOM THRU A STRONG DEFENSE! D.O.B. 7-16-84

"THOSE WHO DO NOT
REMEBER THE PAST
ARE CONDEMNED TO
RELIVE IT."
GEORGE SANTAYANA
1883-1952

"ASK NOT WHAT YOUR COUNTRY
CAN DO FOR YOU, BUT WHAT
YOU CAN DO FOR YOUR-
COUNTRY"
J.F.K.
FOUNDER OF: SPECIAL FORCES

Future generations should be proud to set ideals and then stick by them, not change in mid stream. Our government officers work for the people and should be directed by you.
Vietnam 1968;
STRIKE FORCE, 2/502 continually sought to tailor its organization and weaponry, and develop its tactics to better meet the special challenge of jungle and counterguerilla warfare.

Santa Fe, 1988

God Bless my father for giving me his strength and pride.

Spike Miller

Marco van Duyvendijk
Eaglekeeper with his Granddaughter, Olgiy Mongolia

2004 Chromogenic print mounted on aluminum 38³⁄₁₆ × 27⅝ inches edition 1 of 10 © Marco van Duyvendijk
The Grinnell College Art Collection, Faulconer Gallery, Grinnel, IA: Gift of the Artist, 2006

Don Unrau
Spike Miller

1987 Gelatin silver print 18½ × 14¼ inches © Don Unrau Collection of the Artist

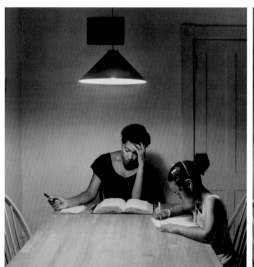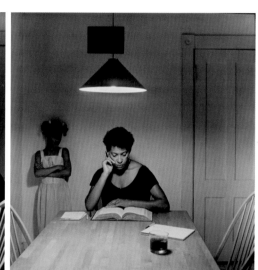

Carrie Mae Weems
Untitled #2450

1990 Gelatin silver print triptych each: 28¼ × 28¼ inches © Carrie Mae Weems Museum of Contemporary Photography, Columbia College, Chicago, Chicago, IL

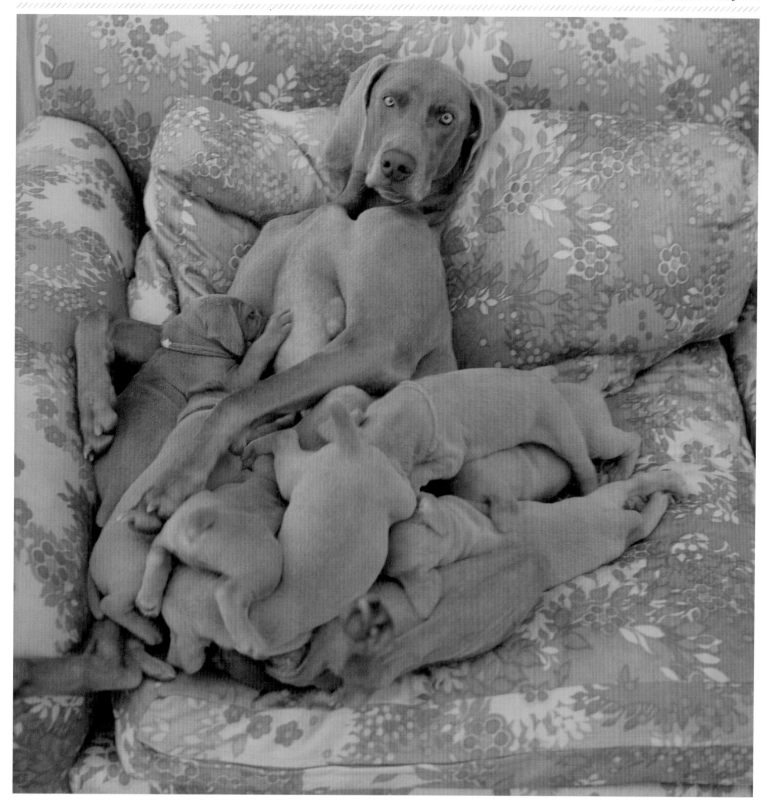

William Wegman
Mother's Day

1989 Chromogenic print 18 × 18½ inches ©William Wegman Courtesy William Wegman Studio, New York, NY

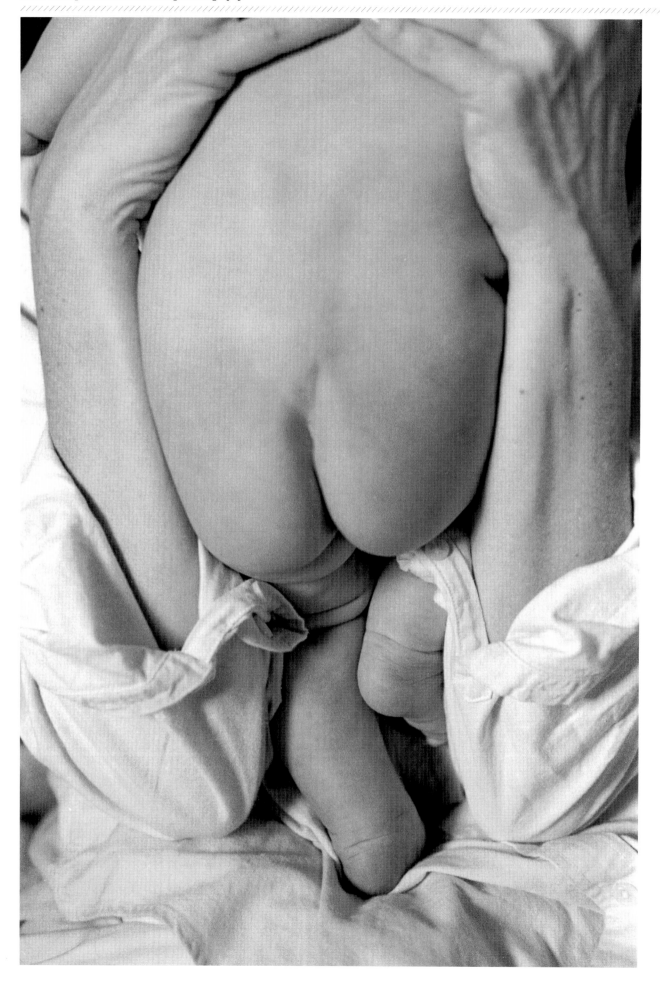

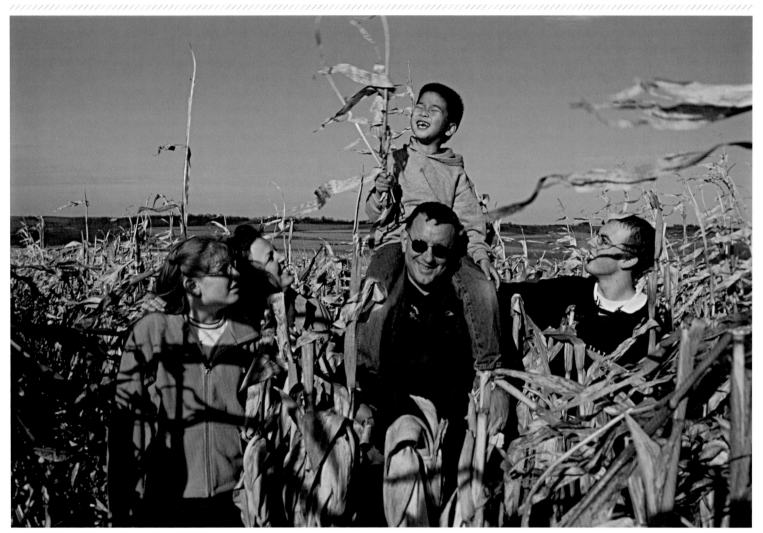

Taro Yamasaki
Sam Donovan with His Adoptive Family on Their Farm in Iowa

2000 Inkjet print 16 × 24 inches ©Taro Yamasaki Collection of the Artist

Claire Yaffa
Mother and Child

2002 Gelatin silver print 6¾ × 9¾ inches ©Claire Yaffa Collection of the Artist

The key to a happy marriage is having a keen understanding of your spouse. Even if you disagree, listen.

George Cecil Winsor

Love

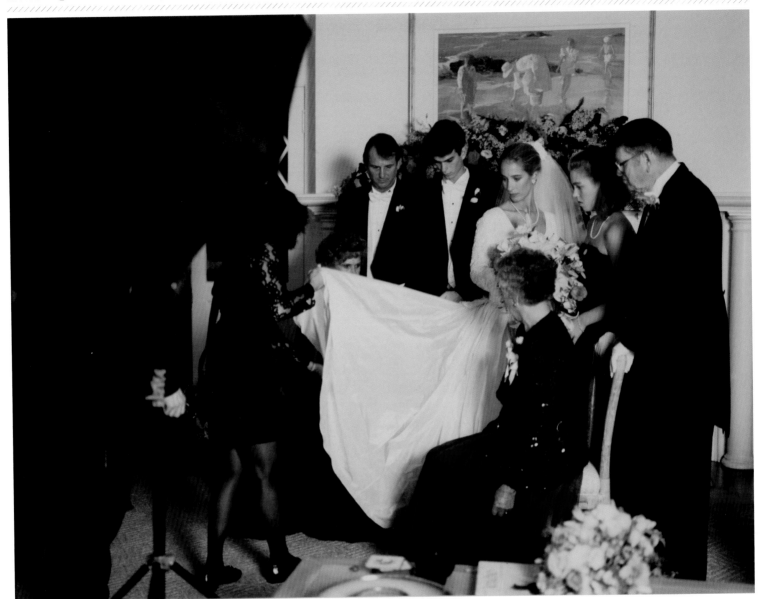

Tina Barney
The Wedding Portrait

1993 Chromogenic print 11×14 inches ©Tina Barney New Orleans Museum of Art, New Orleans, LA:
On Loan from H. Russell Albright, M.D., EL.2001.67

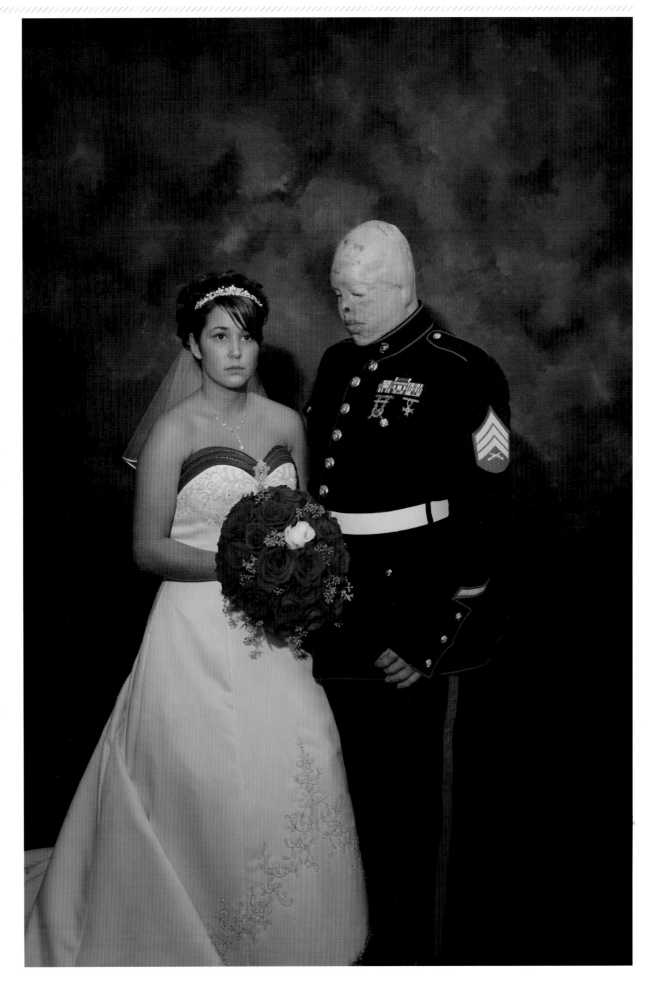

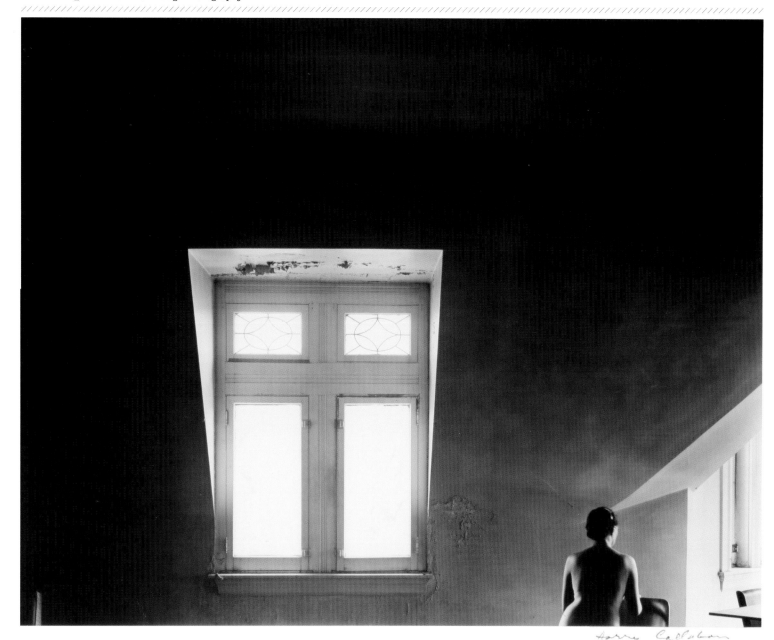

Harry Callahan
Eleanor, Chicago

1948 Gelatin silver print 9³⁄₁₀ × 9 inches ©The Estate of Harry Callahan Courtesy Pace/MacGill Gallery, New York, NY
High Museum of Art, Atlanta, GA; Purchase with funds from Georgia-Pacific Corporation, 1984.233

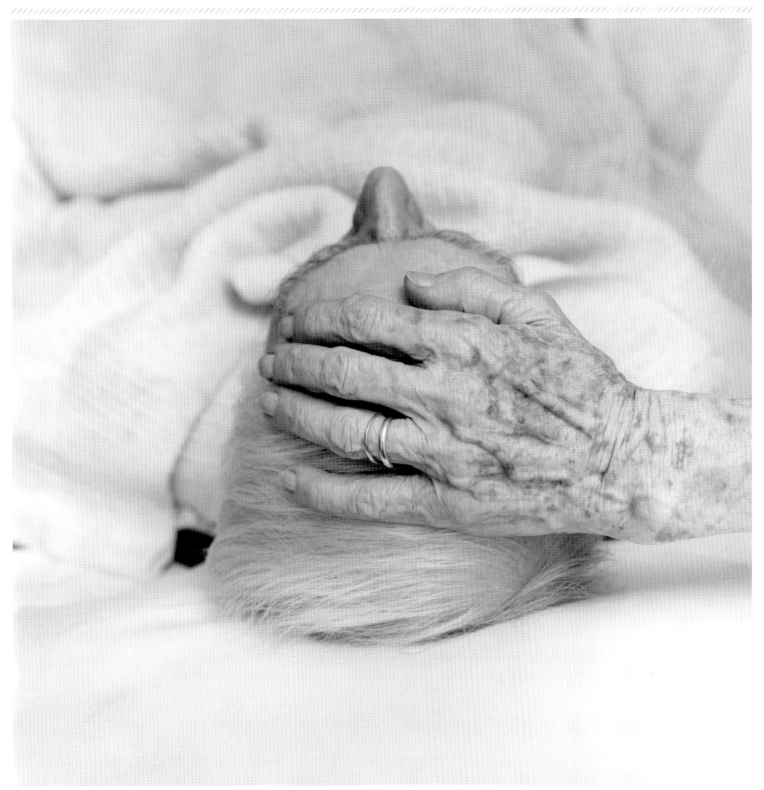

Keith Carter
Wedding Ring
1981 Gelatin silver print 20×16 inches ©Keith Carter Courtesy Howard Greenberg Gallery, New York, NY

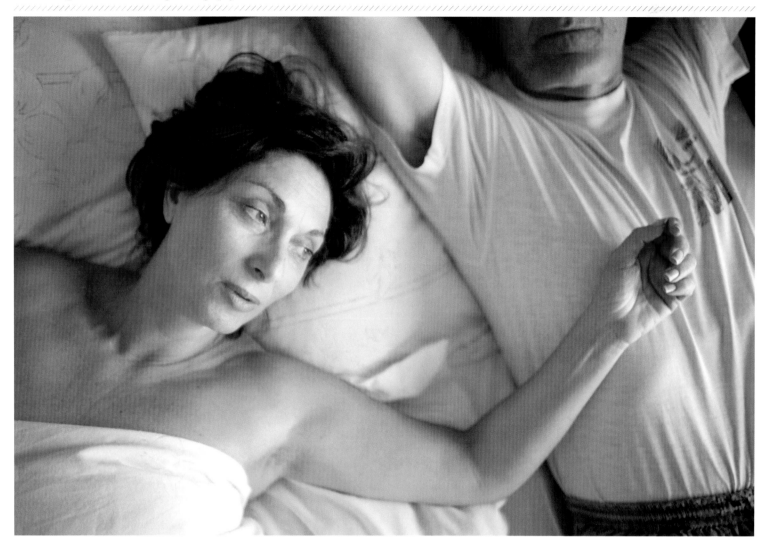

Elinor Carucci
My Parents #1

2003 Chromogenic print 16 × 20 inches edition 1 of 8 © Elinor Carucci Courtesy Edwynn Houk Gallery, New York, NY

John Dominis
Steve McQueen and Wife Neile, Hollywood

1963 Inkjet print 16 × 12 inches © 2009 Time Inc. Used with permission. Time LIFE Collection

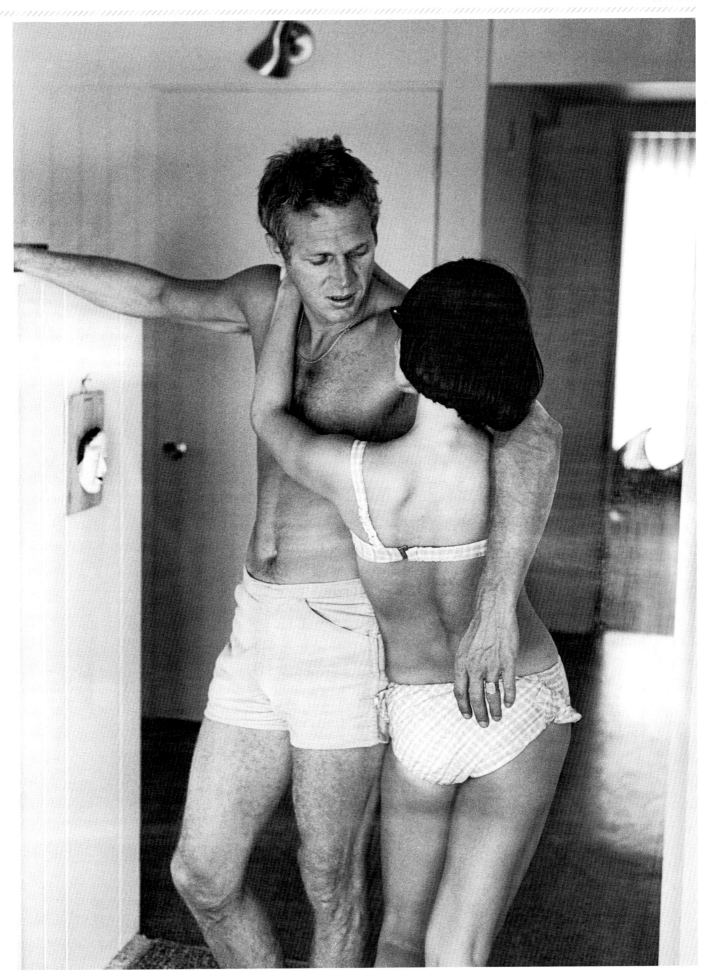

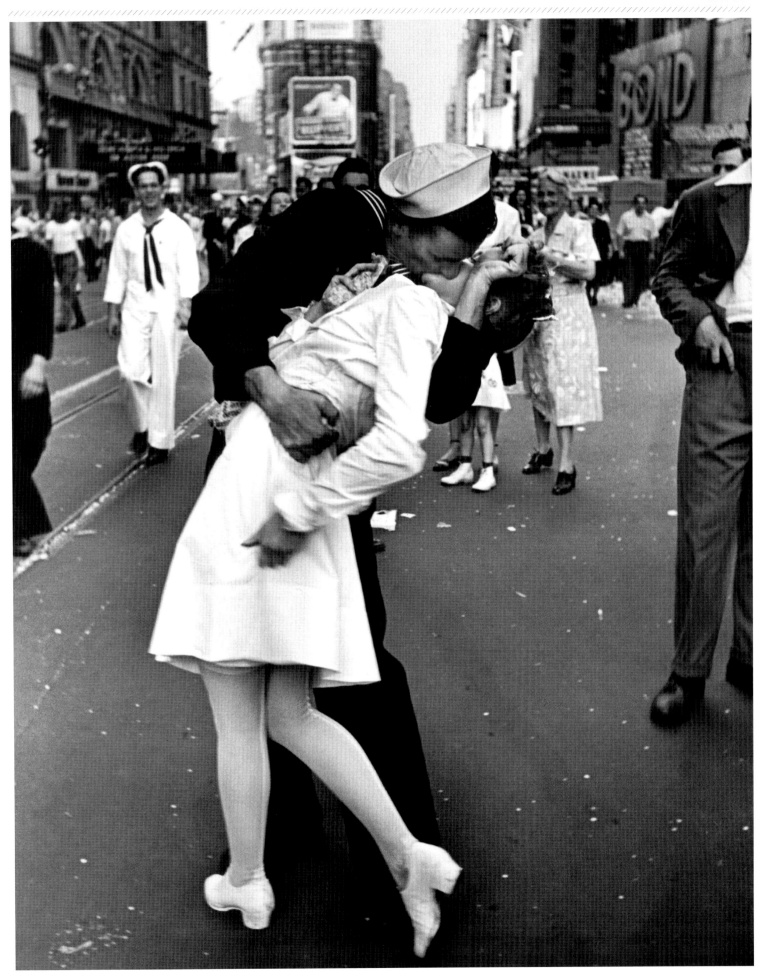

Lee Friedlander
Las Vegas

1970 Gelatin silver print 11×14 inches ©Lee Friedlander Courtesy Fraenkel Gallery, San Francisco, CA

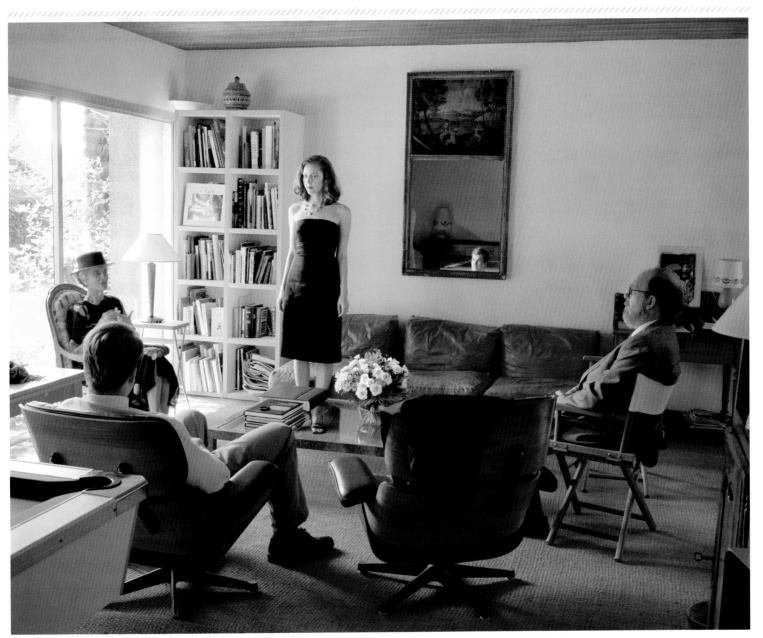

Jessica Todd Harper
"Self Portrait" with Christopher and My Future In-Laws

2001 Chromogenic print 32 × 40 inches ©Jessica Todd Harper Courtesy the Artist and Cohen Amador Gallery, New York, NY

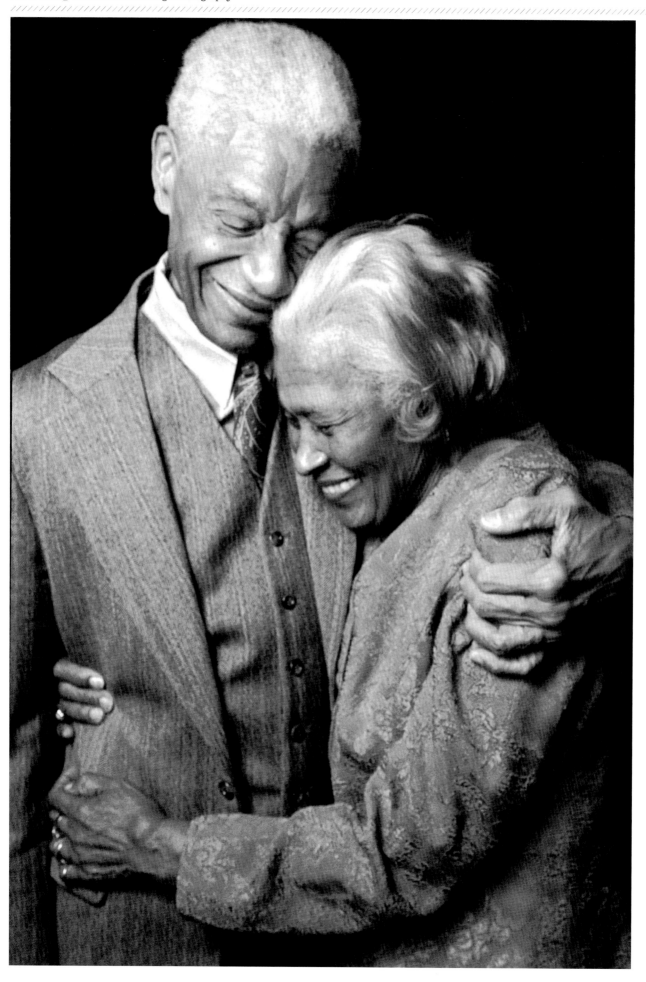

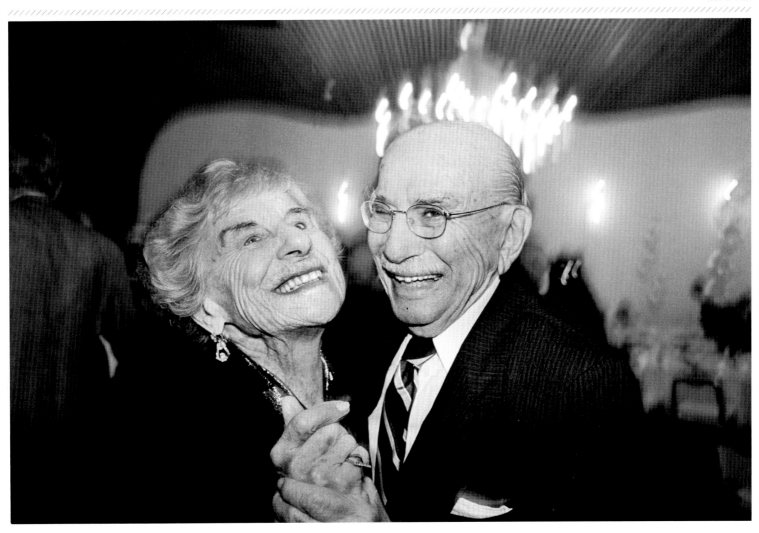

Ed Kashi
Florida, 2001
May 16, 2001 Archival Inkjet print 24 × 36 inches ©Ed Kashi Courtesy Ed Kashi Studio, Montclair, NJ

Chester Higgins Jr.
George Cecil Winsor and Lettice Edwards Winsor
1999 Duotone print 20 × 16 inches ©Chester Higgins Jr. Collection of the Artist

Dorothea Lange
Love in Berkley: University Ave.

1955 Gelatin silver print 8×10 inches ©Dorothea Lange Collection, Oakland Museum of California, City of Oakland Museum of Contemporary Photography, Columbia College Chicago, Chicago, IL

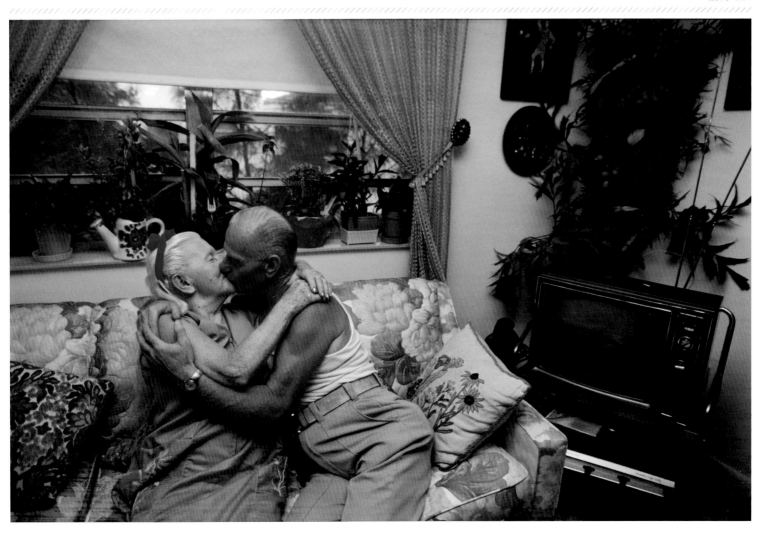

Mary Ellen Mark
South Beach, Miami, Florida, USA

1979 Cibachrome print 20 × 24 inches ©Mary Ellen Mark Courtesy Falkland Road, Inc., New York, NY

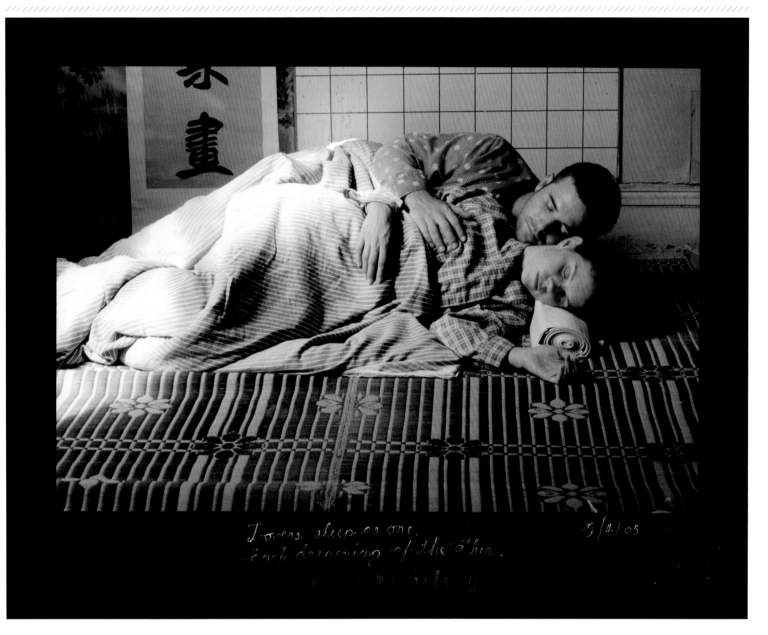

Duane Michals
Lovers Sleep as One, September 4, 2005
2005 Chromogenic print with hand applied text 11×14 inches ©Duane Michals Courtesy Pace/MacGill Gallery, New York, NY

Walter Martin and Paloma Muñoz
Traveler LXXVIII (78)
2003 Chromogenic print on Plexiglas 40×33 inches ©Walter Martin and Paloma Munõz Courtesy PPOW Gallery, New York, NY

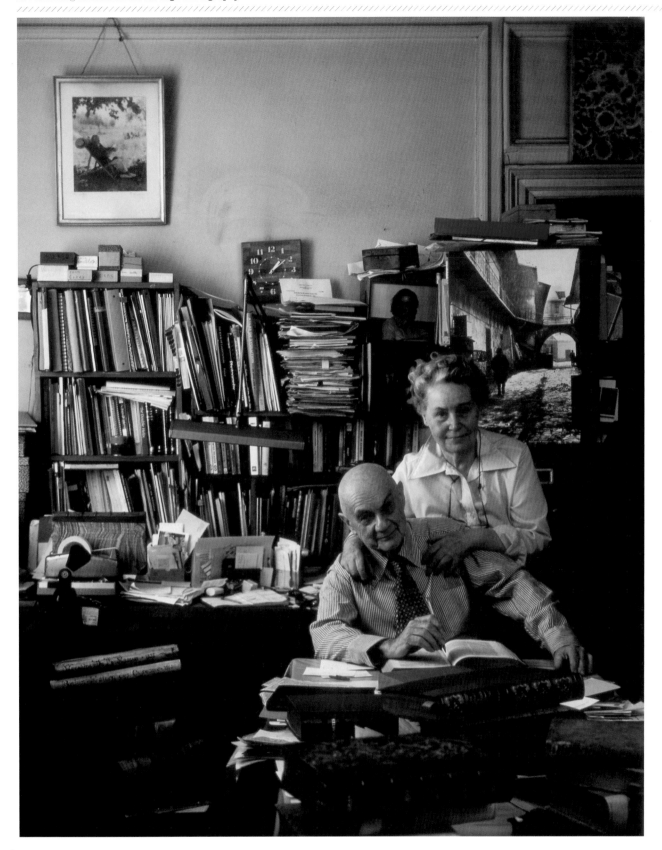

Arnold Newman
Roman Vishniac and His Wife Edith

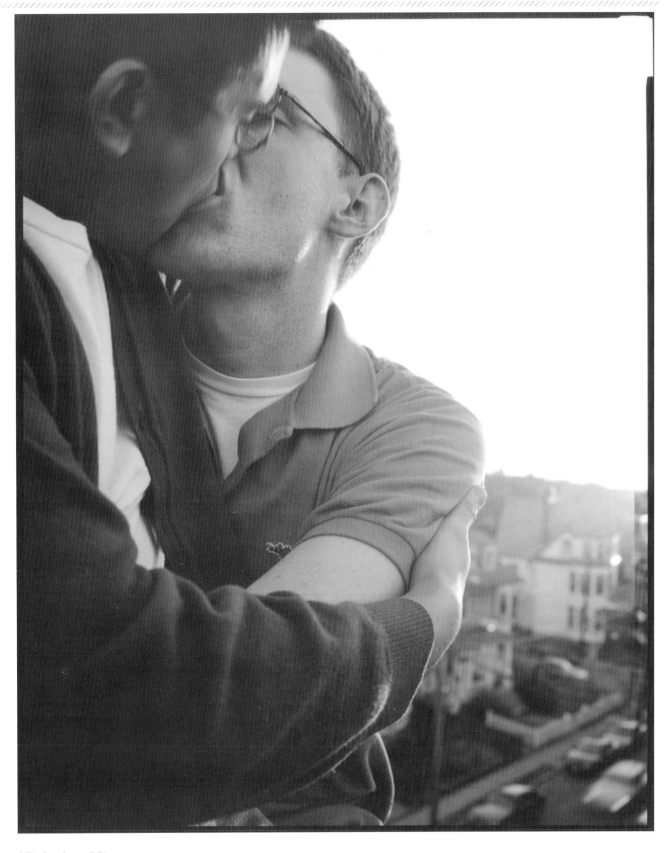

Nicholas Nixon
J.F., D.C., Boston

2000 Gelatin silver print 10 × 8 inches ©Nicholas Nixon Courtesy Fraenkel Gallery, San Francisco, CA and Yossi Milo Gallery, New York, NY
Cincinnati Art Museum, Cincinnati, OH, Museum Purchase with funds provided by Carl Jacobs, 2004.108

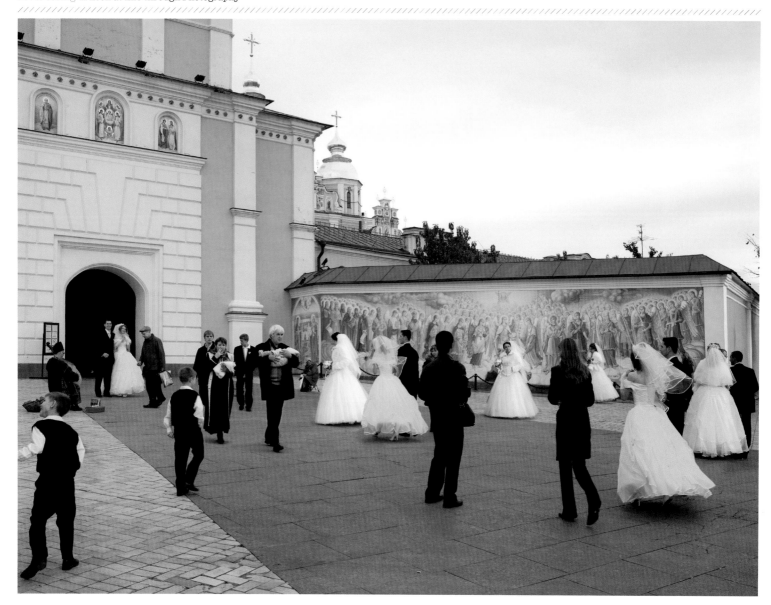

Karl O. Orud
The Brides of Sofiiska
2006 Digital chromogenic print mounted to Plexiglas 24 × 32 inches © Karl Orud Collection of the Artist

Bill Ray
Co-ed dorm, Oberlin College, Ohio
1970 Inkjet print 20 × 13½ inches © 2009 Time Inc. Used with permission. Time LIFE Collection

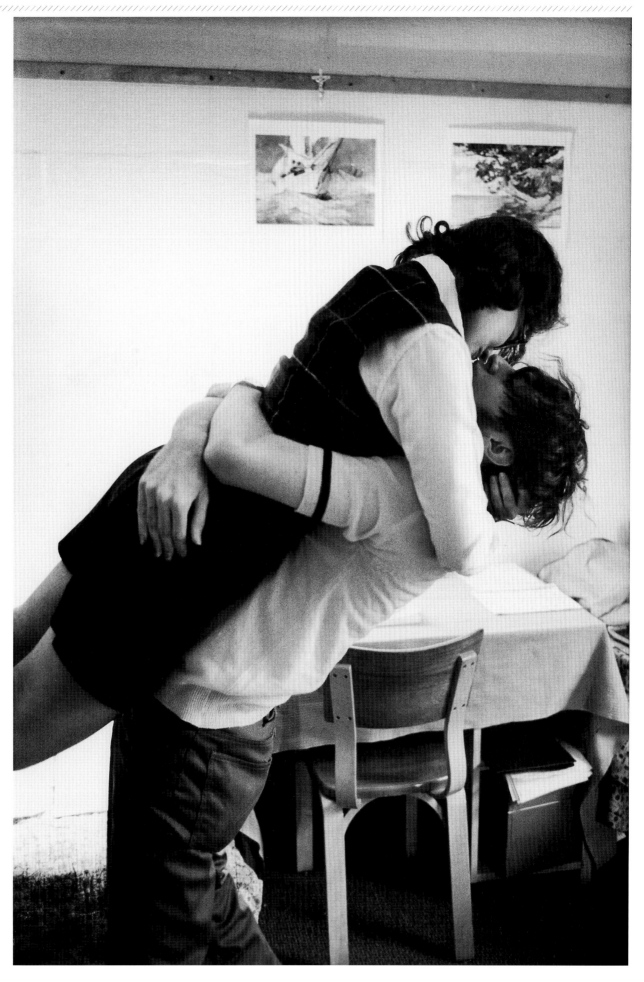

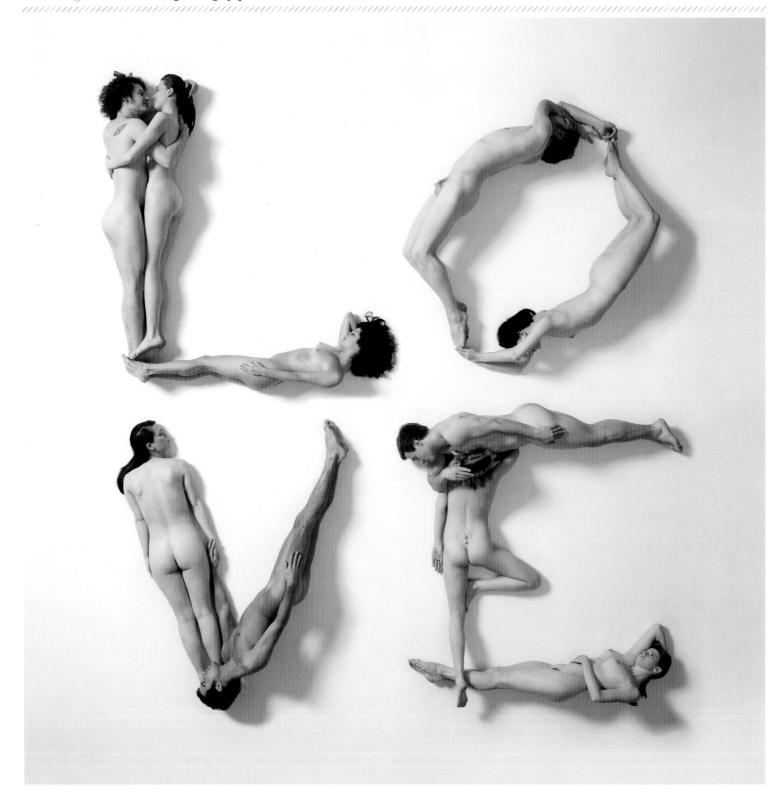

Silas Shabelewska
LOVE #7

2007 Chromogenic print mounted to diasec face 50 × 50 inches edition 1 of 6 © Silas Shabelewska Courtesy Soufer Gallery, New York, NY

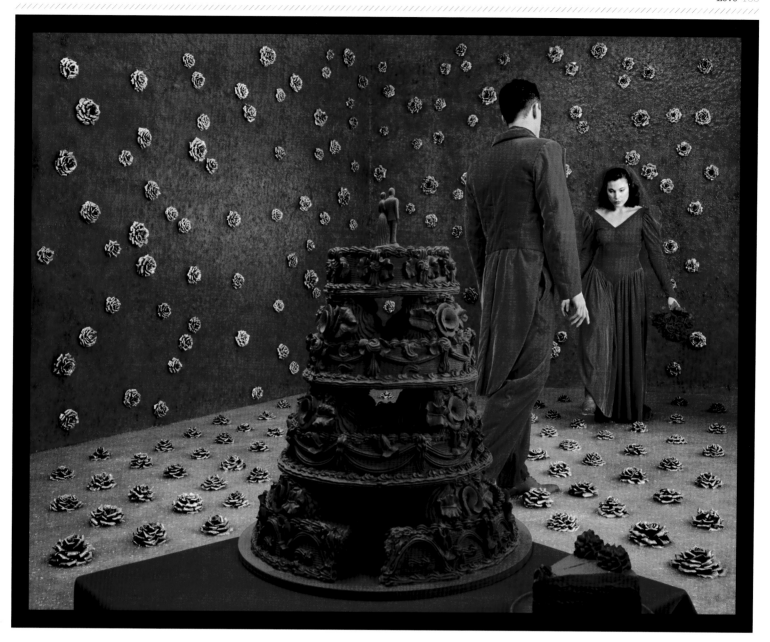

Sandy Skoglund
The Wedding

1994 Cibachrome print 38 × 48 inches © 1994 Sandy Skoglund Columbus Museum of Art, Columbus, OH: Museum Purchase, Howald Fund, 1994.003

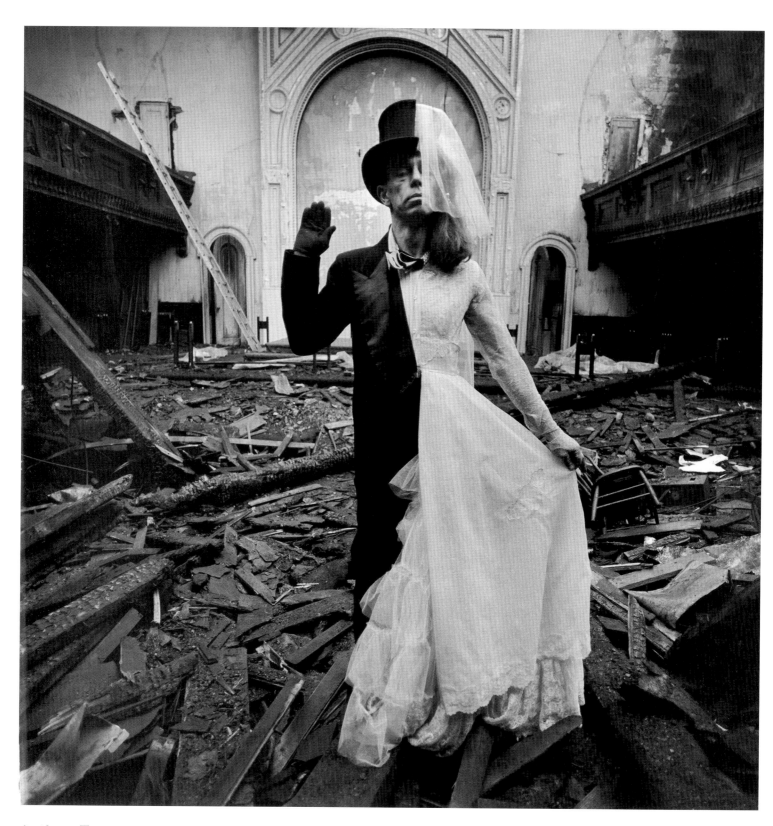

Arthur Tress
Stephen Brecht, Bride and Groom

1970 Gelatin silver print 20×16 inches © Arthur Tress Collection of Thomas R. Schiff, Cincinnati, OH

CANDI'S WEDDING WITH HER TWO FAVORITE CUSTOMERS
FROM HER JOB AT THE SIRLOIN STOCKADE.

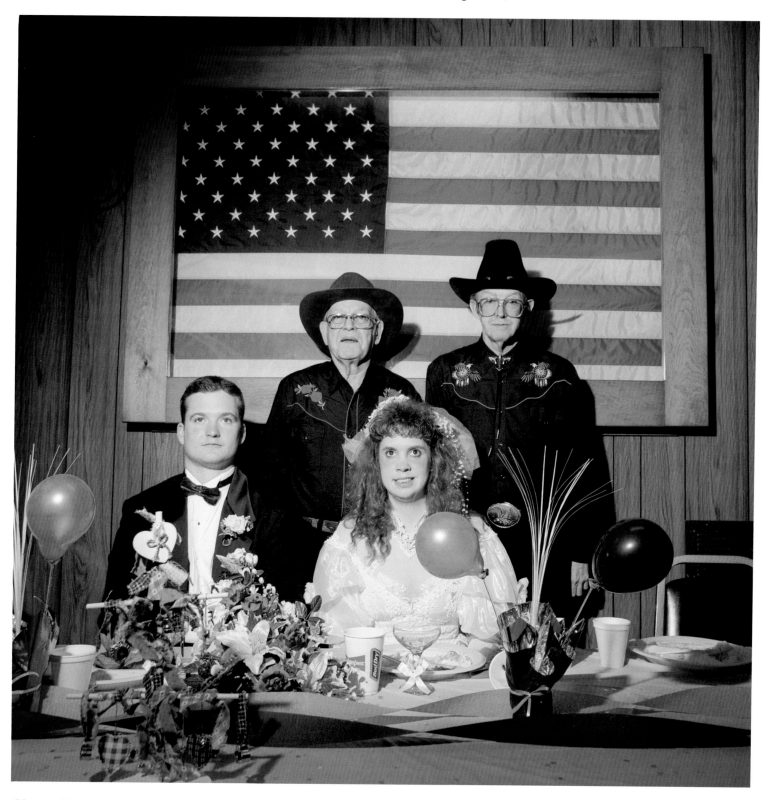

Chris Verene
My Cousin Candi's Wedding
1994 Chromogenic print with handwritten caption in oil paint 30 × 36 inches © Chris Verene Butler Family Collection

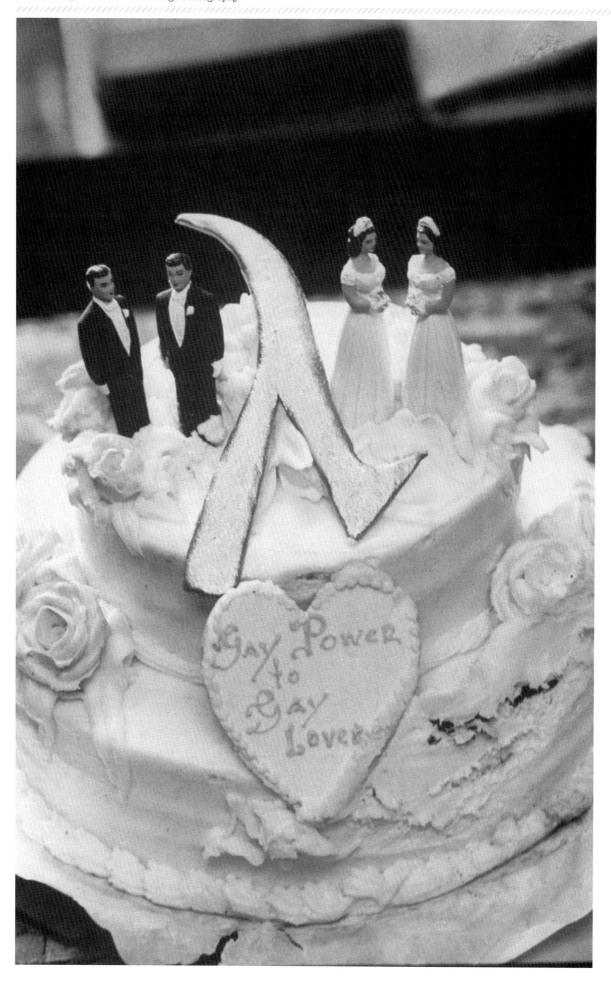

Nick Waplington
Wedding Party, from the Living Room Series

1995 Chromogenic print 39 × 50 inches © Nick Waplington New Orleans Museum of Art, New Orleans, LA: Gift of Diego Cortez, 2003.146

Grey Villet
Wedding cake adorned with homosexual couples to be used by activists to protest
New York City clerk's refusal to issue wedding licenses to homosexuals

1971 Inkjet print 12 × 7½ inches © 2009 Time Inc. Used with permission. Time LIFE Collection

Health is a state of complete physical, mental and social well-being, and not merely the absence of disease or infirmity.

World Health Organization, 1948

Wellness

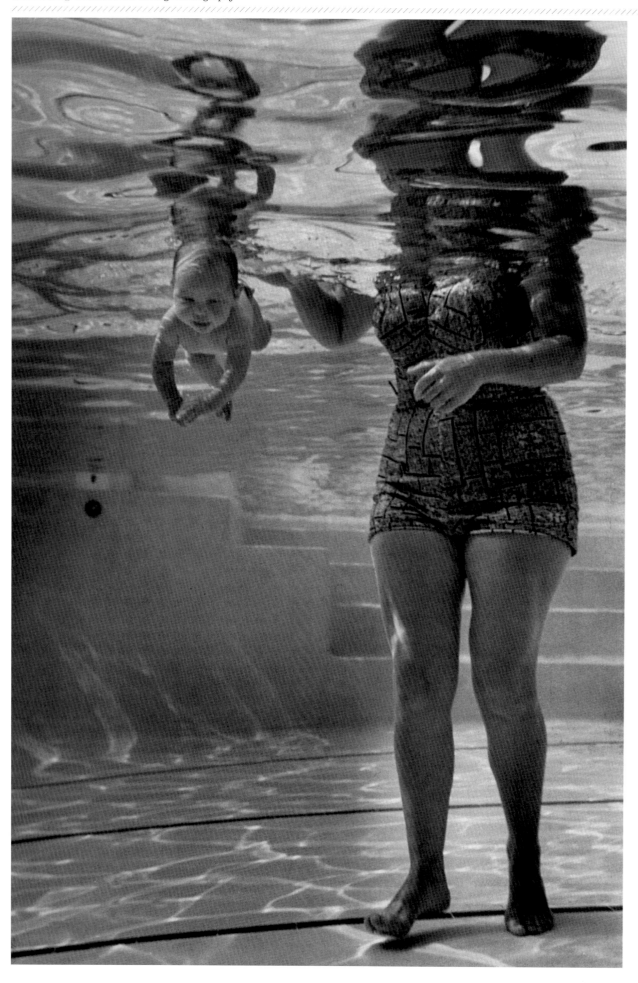

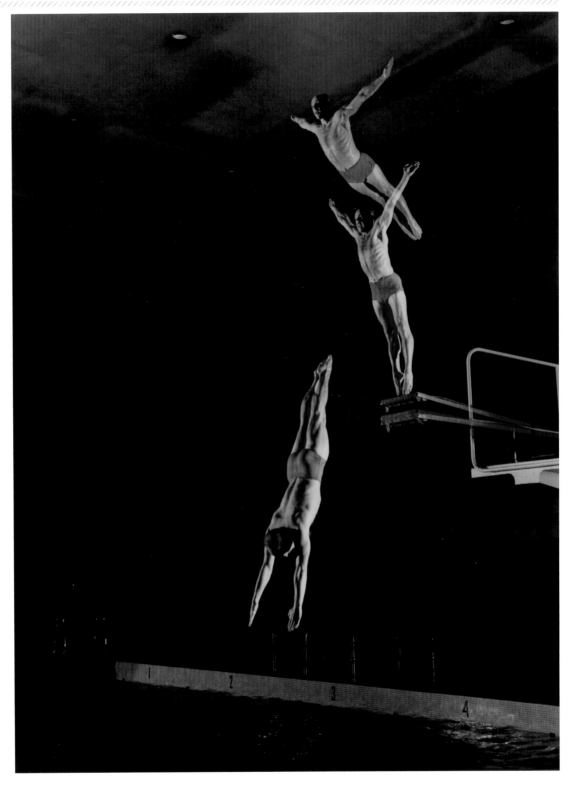

Harold Eugene Edgerton
Diver

1955 Dye transfer print 20 × 16 inches © Harold Eugene Edgerton New Orleans Museum of Art,
New Orleans, LA: Gift of the Harold and Esther Edgerton Family Foundation, 96.172.8

Edward Clark
World's youngest swimmer, nine-week old Julie Sheldon, Los Angeles

1954 Inkjet print 18 × 12 inches © 2009 Time Inc. Used with permission. Time LIFE Collection

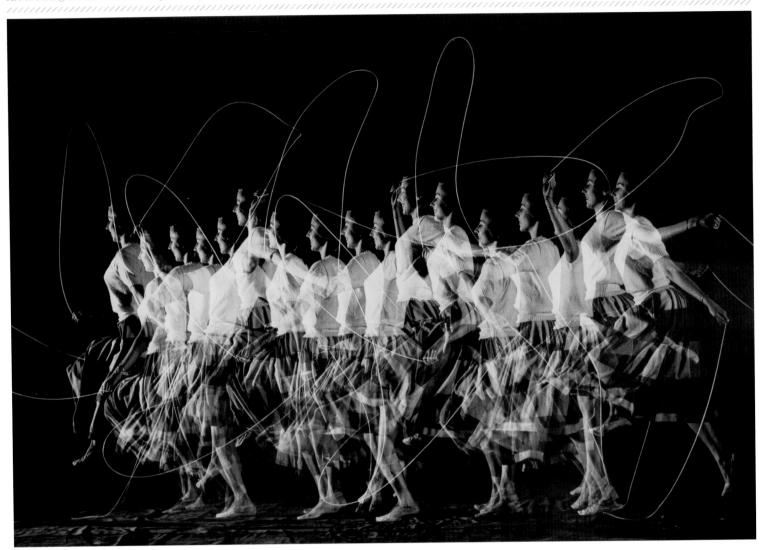

Harold Eugene Edgerton
Moving Skipping Rope

Circa 1960 Gelatin silver print edition 32 of 40 16 × 20 inches ©The Harold and Esther Edgerton Family Foundation New Orleans Museum of Art, New Orleans, LA:
Gift of the Harold and Esther Edgerton Family Foundation, 96.159

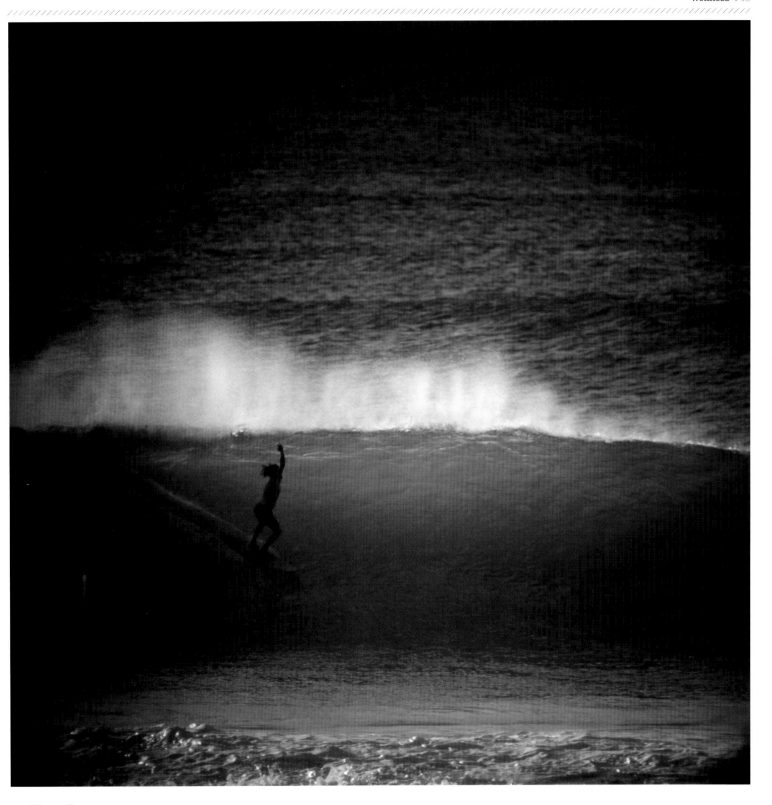

LeRoy Grannis
John Boozer, Pipeline No. 65

1966 Chromogenic print 36 × 36 inches edition of 18 ©LeRoy Grannis Courtesy Bonni Benrubi Gallery, New York, NY

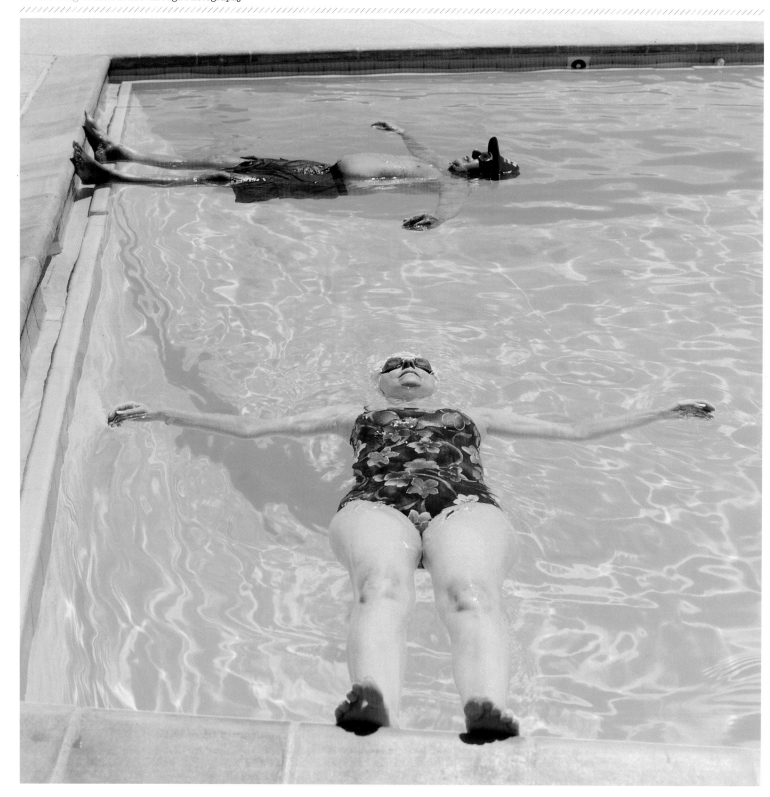

Peter Granser
Couple in a pool, from the Sun City Series
2000 Chromogenic print 23½ × 23½ inches ©Peter Granser Collection of the Artist

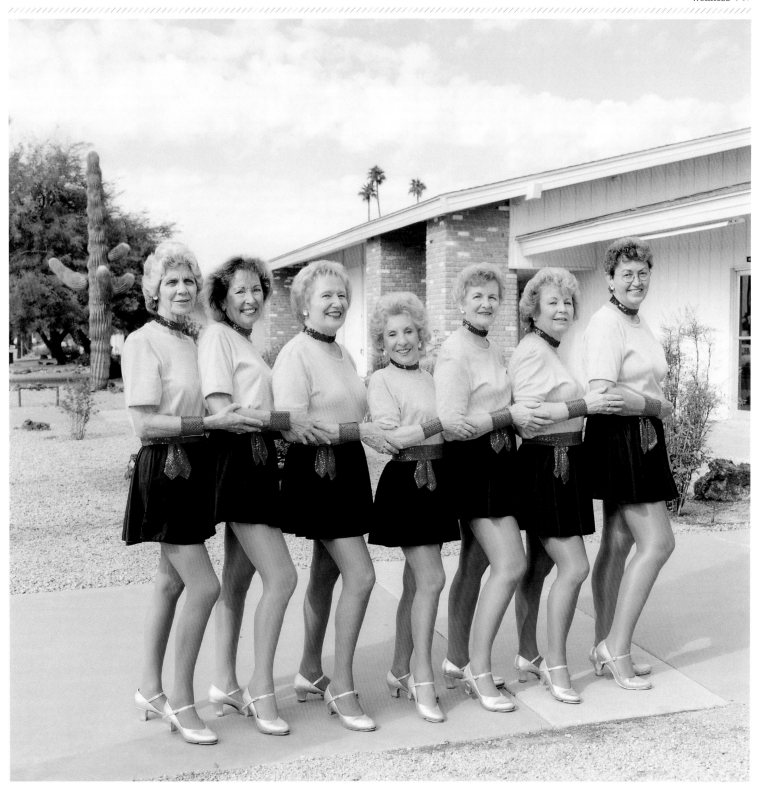

Peter Granser
Tip Top Dancers, from the Sun City Series
2000 Chromogenic print 23½ × 23½ inches © Peter Granser Collection of the Artist

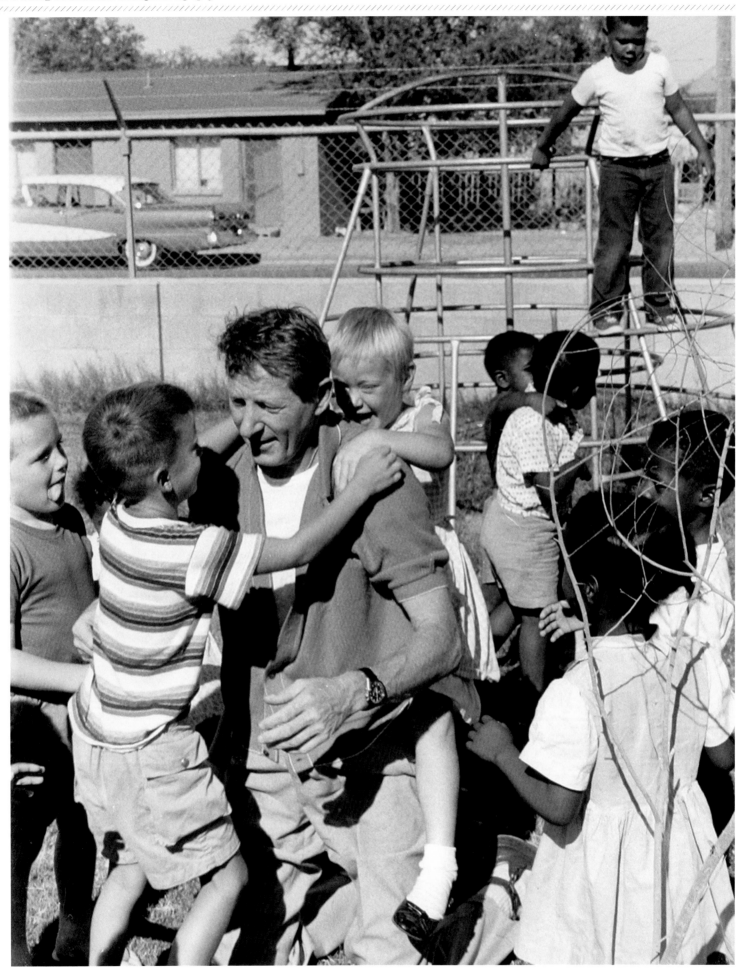

Chester Higgins Jr.
Ruth Williams

2000 Gelatin silver print 20 × 16 inches © Chester Higgins Jr. Collection of the Artist

Philippe Halsman
Danny Kaye

1960 Gelatin silver print 13¾ × 10⅞ © Halsman Archive Norton Museum of Art, West Palm Beach, FL, Gift of Mr. Thomas Lewyn through the Ackerman Foundation, 83.86

Ryan McGinley
Running Field

2007–2008 Chromogenic print 30 × 44 inches edition of 3 © Ryan McGinley Courtesy Team Gallery, New York, NY

Ryan McGinley
Roller Coley

2007–2008 Chromogenic print 20 × 16 inches edition of 3 © Ryan McGinley Courtesy Team Gallery, New York, NY

Catherine Opie
Dusty

2007 Chromogenic print 29½ × 22 inches edition of 5 ©Catherine Opie Courtesy Gladstone Gallery,
New York, NY and Regen Projects, Los Angeles, CA

Joel Meyerowitz
The Elements: Air/Water Part I, No. 6

2007 Chromogenic print mounted to Plexiglass 82 × 66 inches edition 2 of 6 ©Joel Meyerowitz Collection of Mary and David Solomon

Melissa Ann Pinney
Kanaha State Park, Maui

2002 Chromogenic print 20 × 24 inches ©Melissa Ann Pinney Courtesy Catherine Edelman Gallery, Chicago, IL

Gordon Parks
Muhammad Ali, Hyde Park, London

1970 Gelatin silver print 14 × 11 inches ©Gordon Parks The Gordon Parks Foundation, Pleasantville, NY

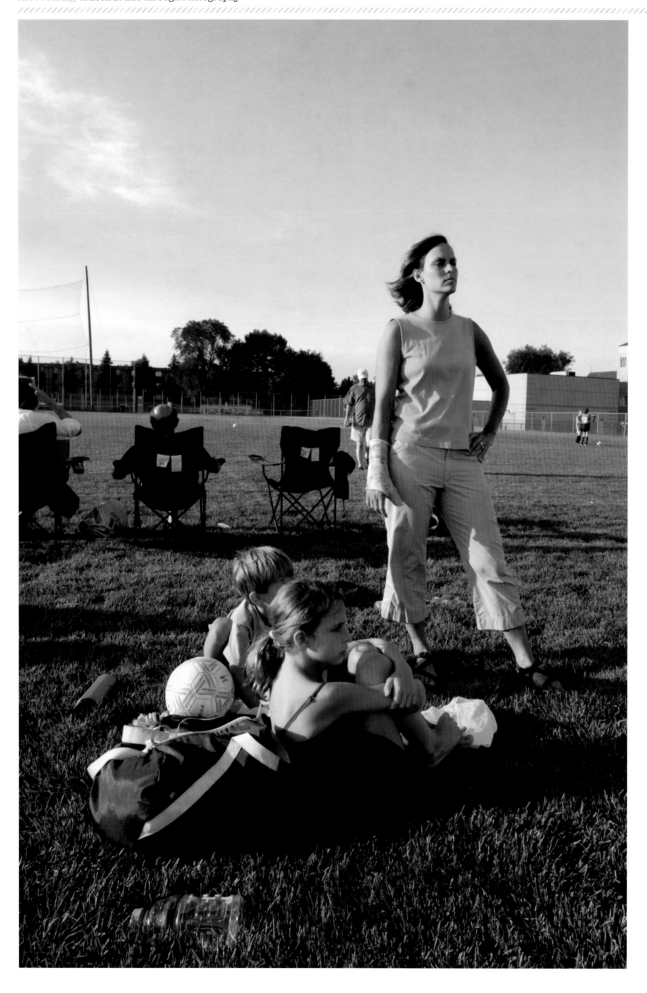

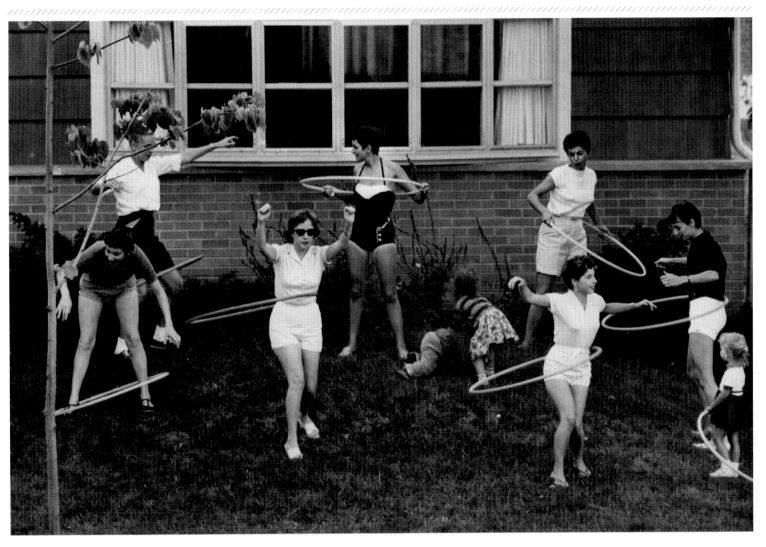

Art Shay
Hula Hoop Fun for the Whole Family
Circa 1960, printed 1990s Gelatin silver print 11×14 inches ©Art Shay Courtesy Steven Daiter Gallery, Chicago, IL

Dona Schwartz
Fractured Coach
2006 Chromogenic print 42×30 inches ©Dona Schwartz Courtesy Steven Bulger Gallery, Toronto, Ontario, Canada

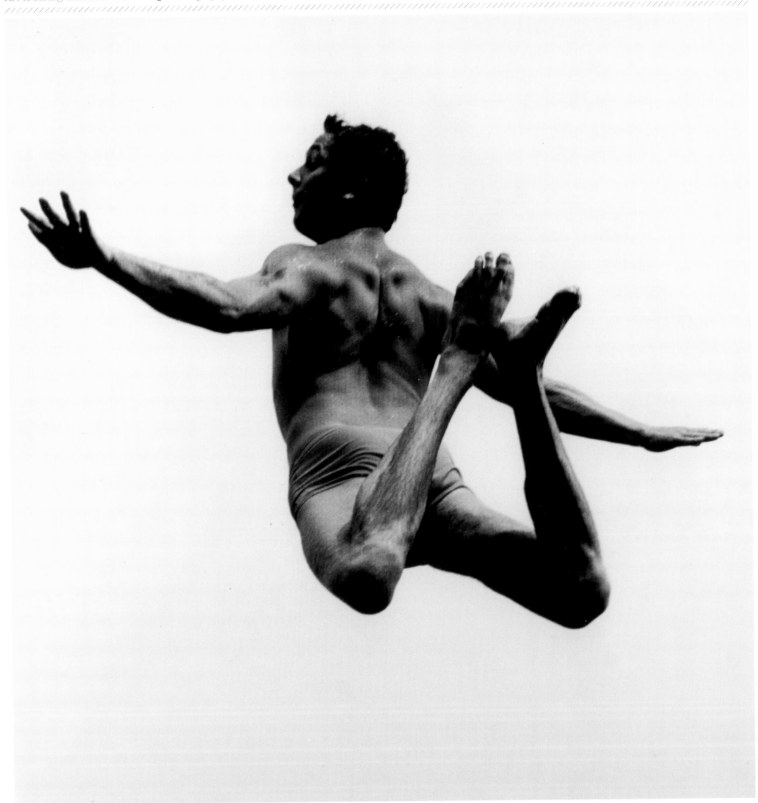

Aaron Siskind
Pleasures and Terrors of Levitation #99, 1961

1961 Gelatin silver print 18¼ × 17¼ inches ©Aaron Siskind Foundation Courtesy Bruce Silverstein Gallery, New York, NY Museum of Contemporary Photography, Columbia College Chicago, Chicago, IL

Neal Slavin
Channel Swimmers Association

1986 Polaroid print 63 × 44 inches ©Neal Slavin Courtesy Neal Slavin Studio, New York, NY

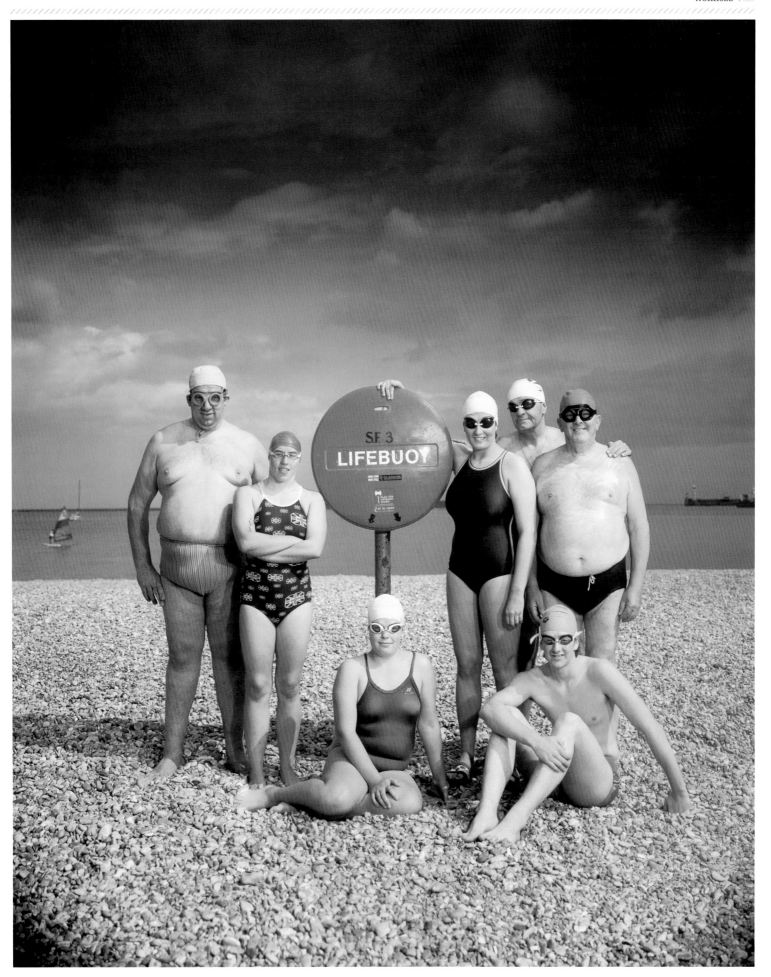

Neal Slavin
Great Britain Paraplegic Weight Lifting Team
July 2, 1984 Polaroid print 24 × 20 inches ©Neal Slavin Courtesy Neal Slavin Studio, New York, NY

Peter Stackpole
Black and white children playing in school playground
May 1, 1945 Inkjet print 36 × 36 inches ©2009 Time Inc. Used with permission. Time LIFE Collection

Massimo Vitali
Untitled (beach scene)
2000–2007 Chromogenic print 60 × 72 inches ©Massimo Vitali Courtesy Bonni Benrubi Gallery, New York, NY

Marco van Duyvendijk
Contortionist girl in action at the State Circus, Ulaanbaatar, Mongolia
2004 Chromogenic print mounted on aluminum 28 × 27½ inches edition 4 of 10 ©Marco van Duyvendijk The Grinnell College Art Collection, Faulconer Gallery, Grinnel, IA: Gift of the Artist, 2006

For those who take on the challenge of caregiving, the rewards are immense…These are the people who have the fortitude to journey into life's most fearsome destinations, and who survive the experience greatly enriched.

Julie Winokur

Caregiving
& Healing

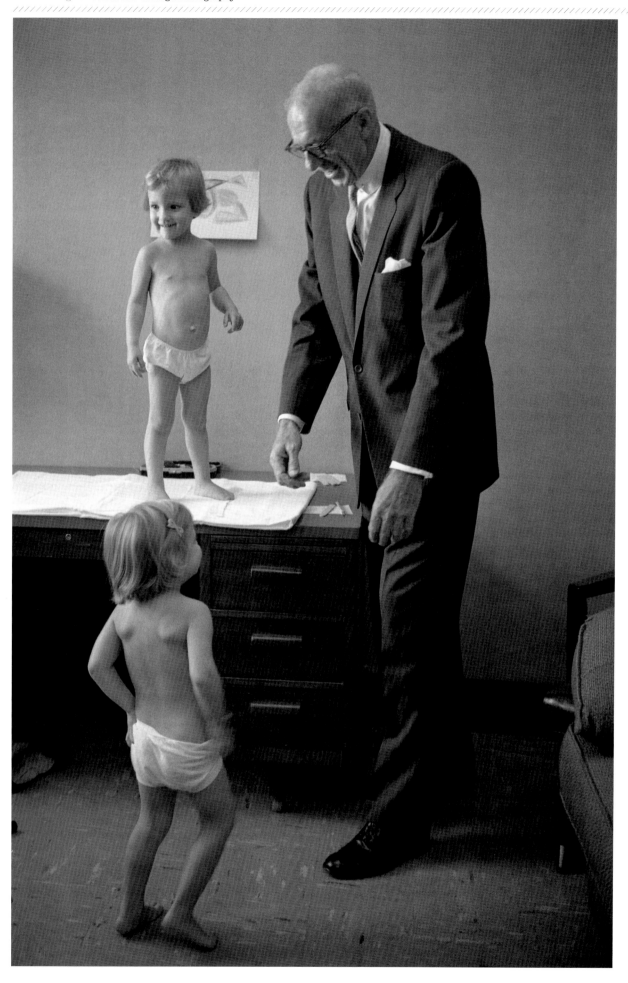

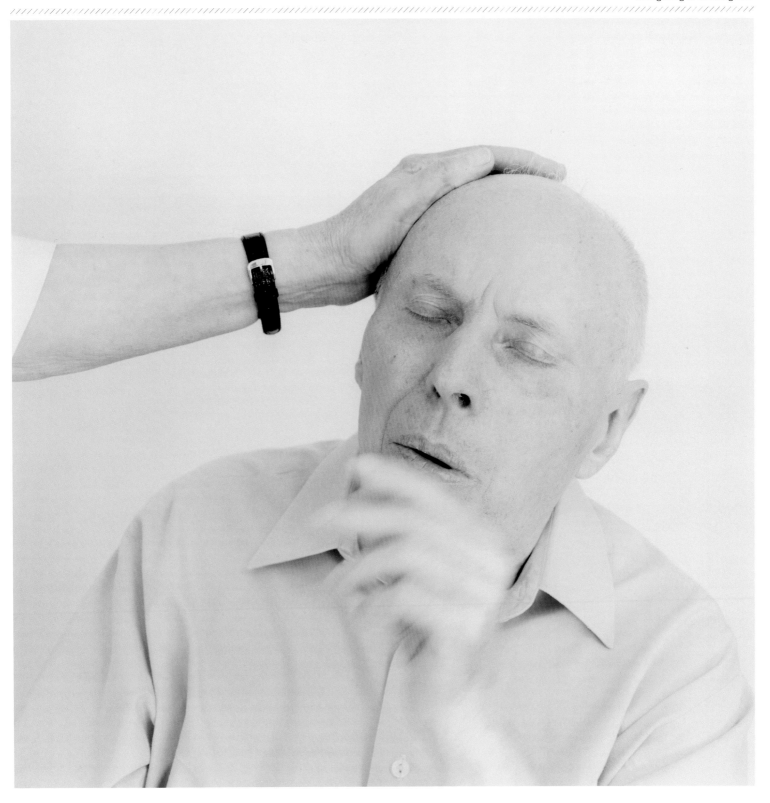

Peter Granser
Portrait 6, from the Alzheimer's Series
2001 Chromogenic print 39 × 30 inches © Peter Granser Collection of the Artist

Bob Gomel
Noted pediatrician Dr. Benjamin Spock looking amused by two
young patients during examination
1962 Giclee print 20 × 10 inches © 1962 Bob Gomel Collection of the Artist

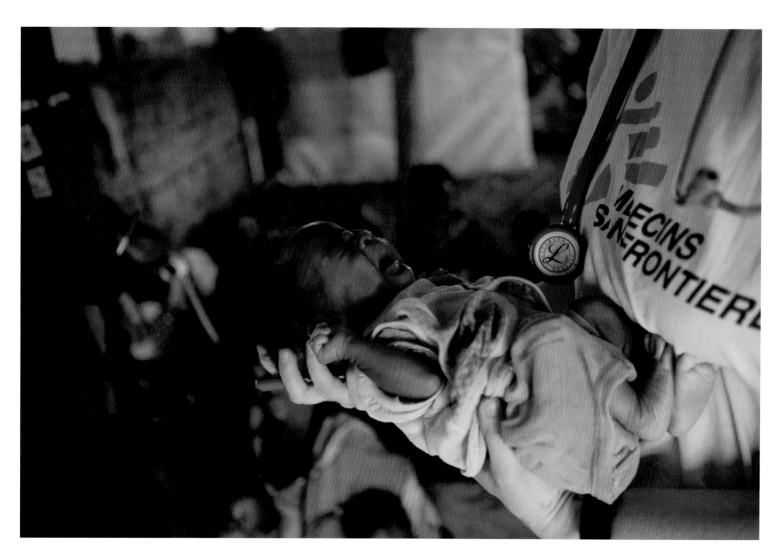

Ron Haviv
Tche camp for internally displaced persons, Ituri province, DR Congo
2005 Inkjet print 20 × 24 inches © Ron Haviv/VII Courtesy VII Photo Agency LLC, Brooklyn, NY

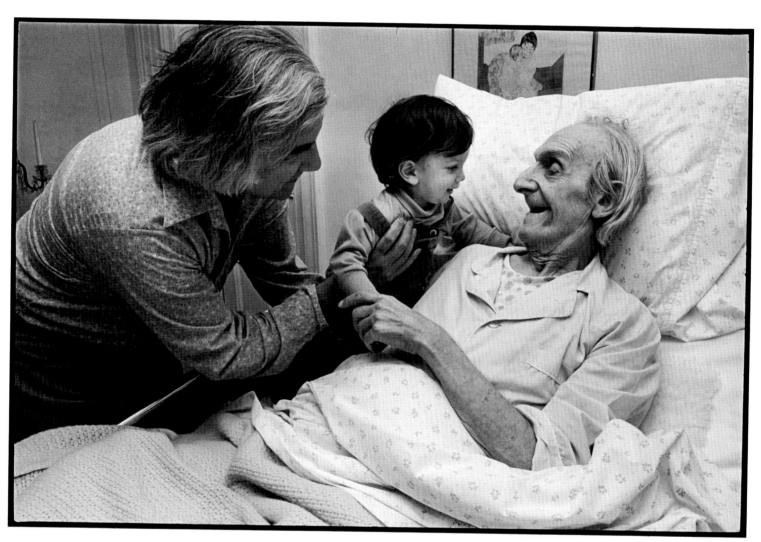

Abigail Heyman
Don and Lazar Visiting Abe

1978 Gelatin silver print 16 × 20 inches © Abigail Heyman Collection of the Artist

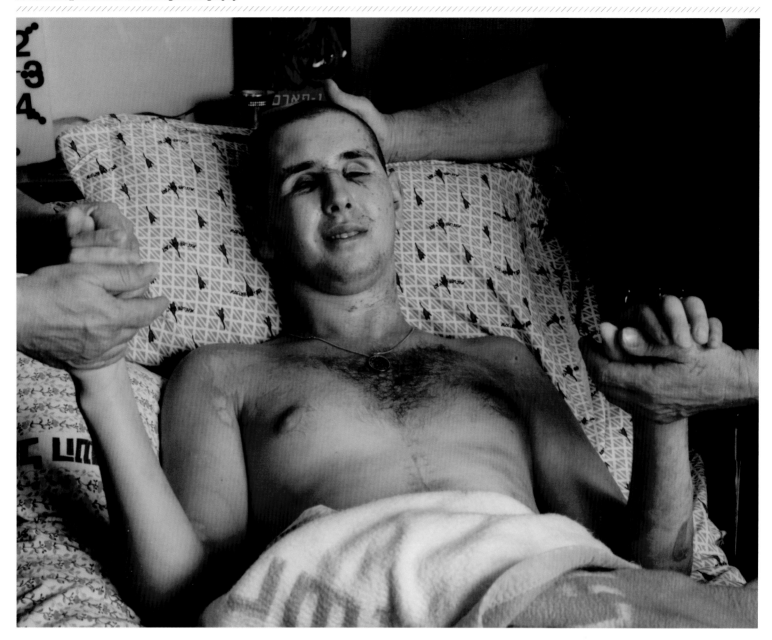

Gillian Laub
Ayal with his Mom and Dad on his Birthday, Tel Aviv, Israel, 2002
2002 Chromogenic print Dibond to Plexiglas 20 × 24 inches © Gillian Laub Courtesy Bonni Benrubi Gallery, New York, NY

Mary Ellen Mark
Hydrocephalic Girl
1990 Gelatin silver print 20 × 16 inches © Mary Ellen Mark Courtesy Falkland Road, Inc., New York, NY

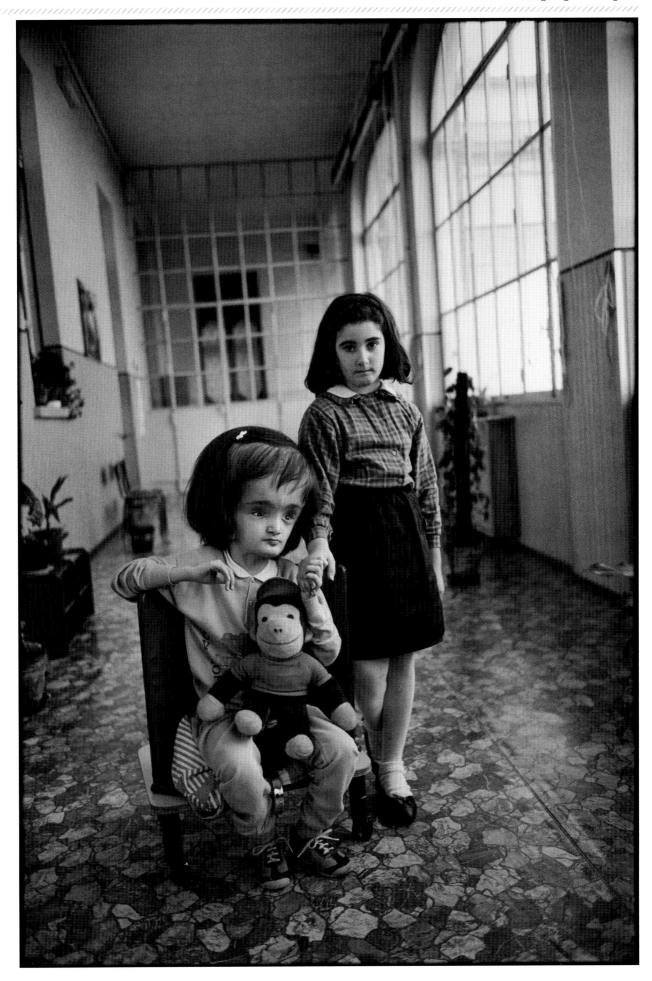

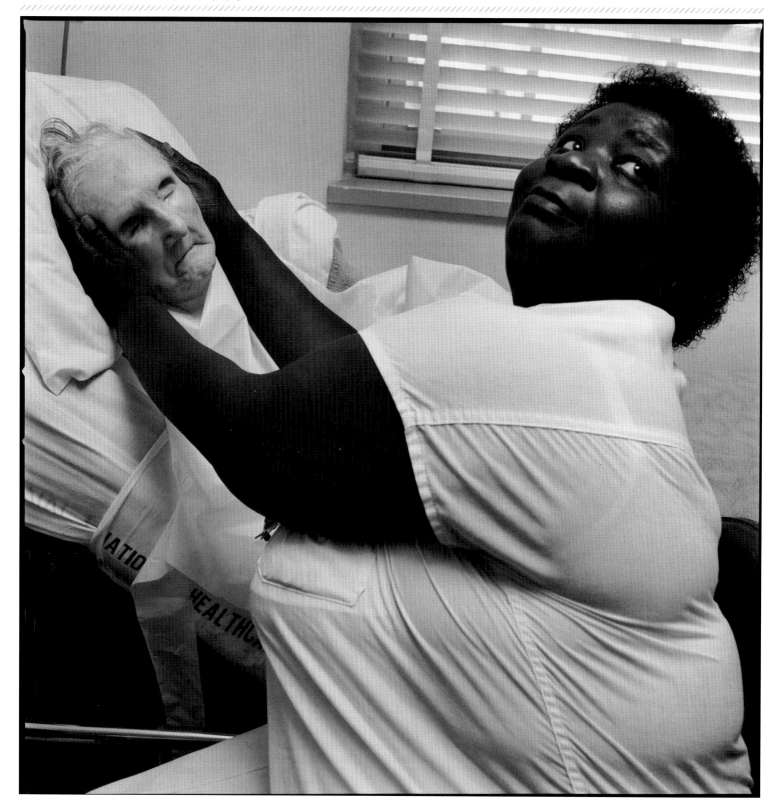

Mary Ellen Mark
Leprosy Patient

1990 Gelatin silver print 20×16 inches ©Mary Ellen Mark Courtesy Falkland Road, Inc., New York, NY

Thomas McAvoy
Blind doctor Albert-André Nast using his ear instead of a stethoscope, Chelles, France

1953 Inkjet print 18×13 inches ©2009 Time Inc. Used with permission. Time LIFE Collection

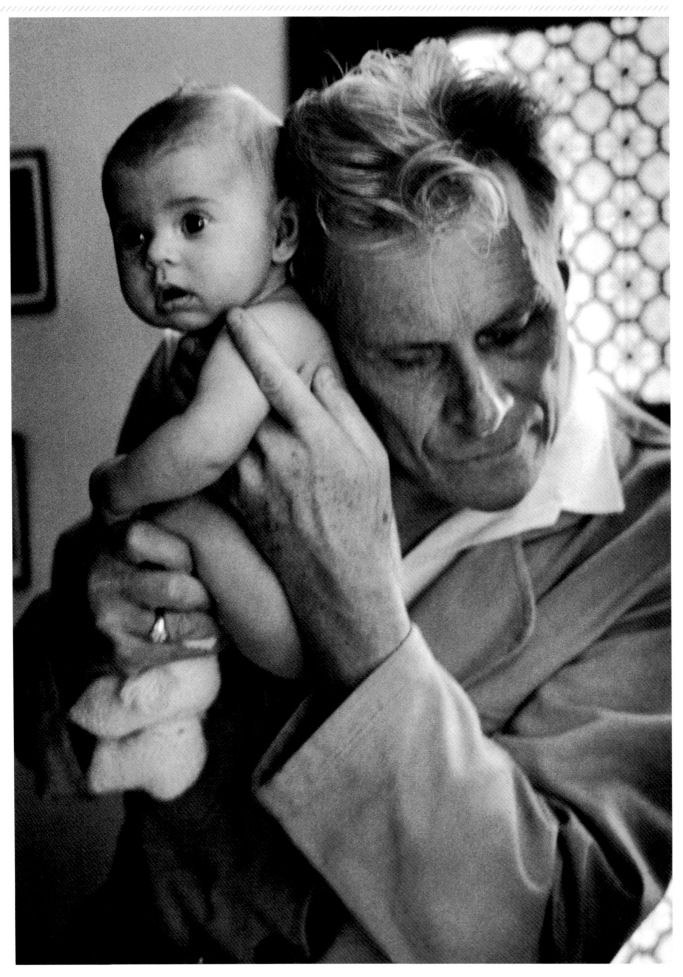

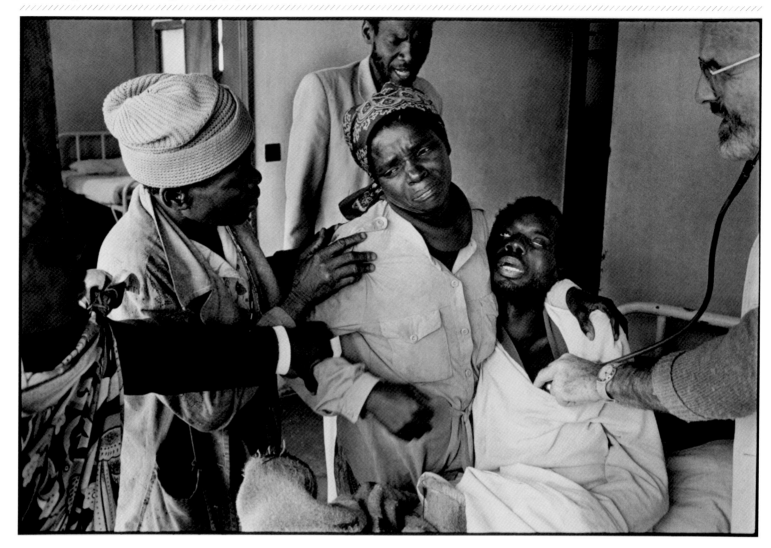

Gideon Mendel
Mission Hospital in Zimbabwe

July 1993 Gelatin silver print 11¾ × 17⁵⁄₁₆ ©Gideon Mendel International Center of Photography, New York, NY, Gift of the Photographer to the W. Eugene Smith Legacy Collection, 1996 (359.1996)

Gideon Mendel
Mission Hospital in Zimbabwe

July 1993 Gelatin silver print 17⁵⁄₁₆ × 11¾ inches ©Gideon Mendel International Center of Photography, New York, NY, Gift of the Photographer to the W. Eugene Smith Legacy Collection, 1996 (357.1996)

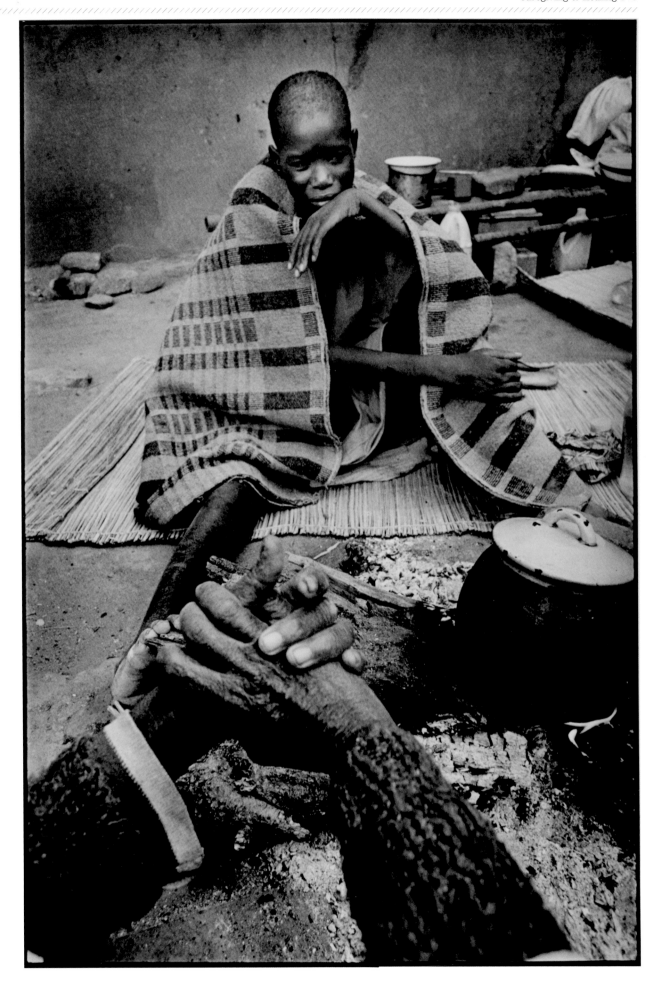

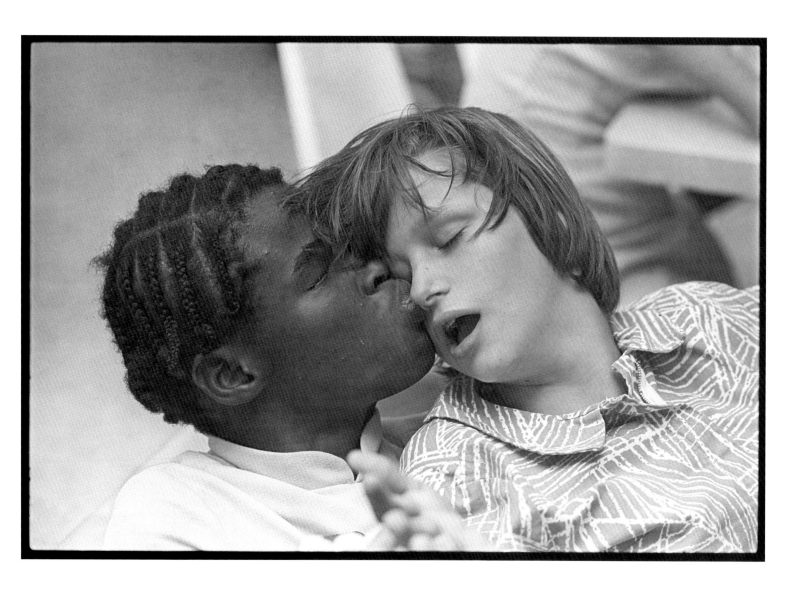

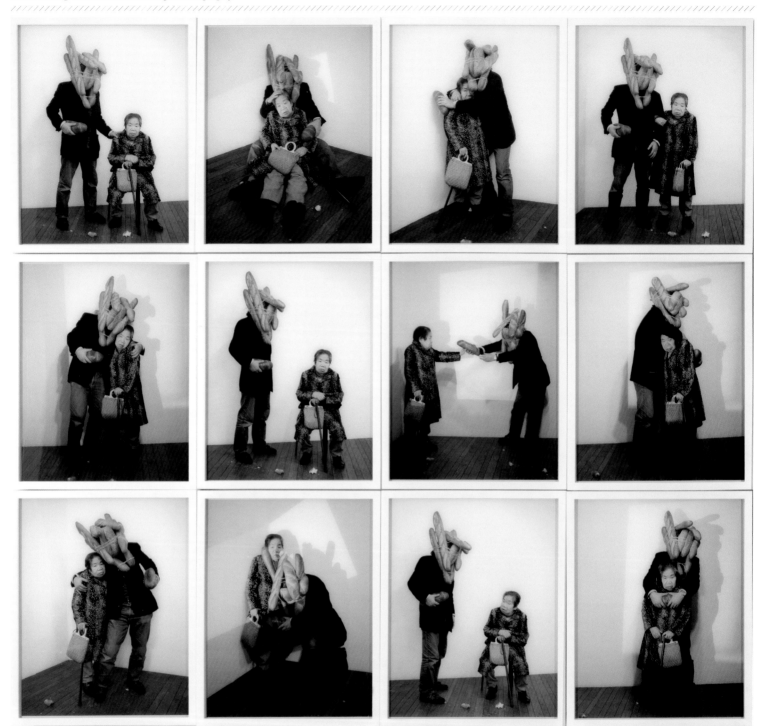

Tatsumi Orimoto
Breadman Son + Alzheimer Mama
1996–2007 21 Cibachrome prints each: 21⅕ × 17⅖ inches edition 2 of 5 ©Tatsumi Orimoto Courtesy DNA Gallery, Berlin, Germany

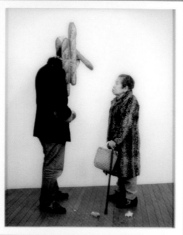
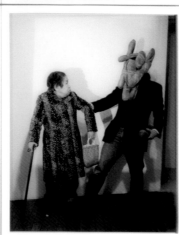
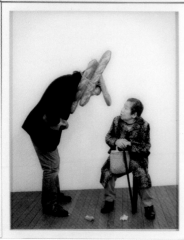
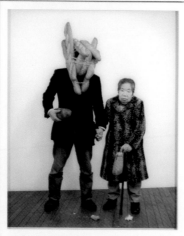

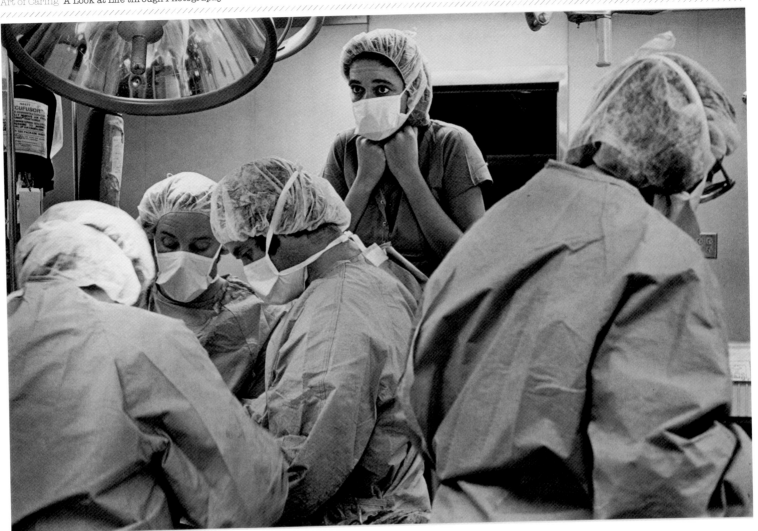

Eugene Richards
Exhausted Nurse in the Operating Room

1989 Gelatin silver print 12⅜ × 18⅝ inches © Eugene Richards International Center of Photography, New York, NY, Gift of the Photographer to the W. Eugene Smith Legacy Collection, 1995 (24.1995)

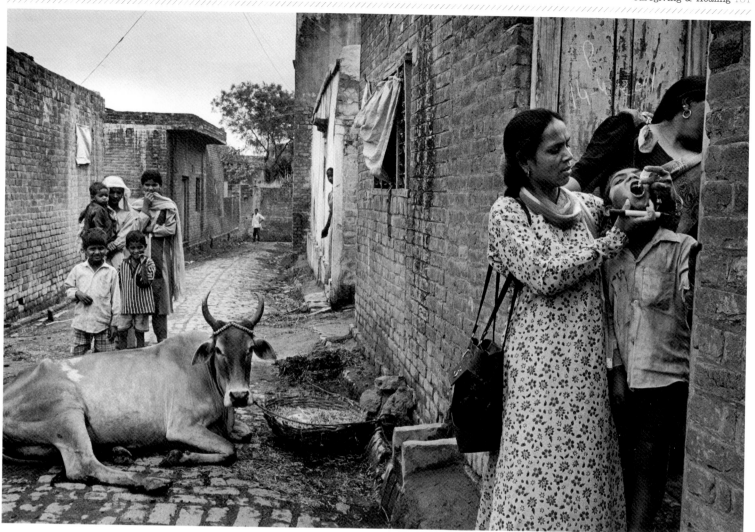

Sebastião Salgado
Moradabad District, India

2001 Gelatin silver print 13½ × 20 inches ©Sebastião Salgado Courtesy the Artist and Amazonas Press, Paris, France

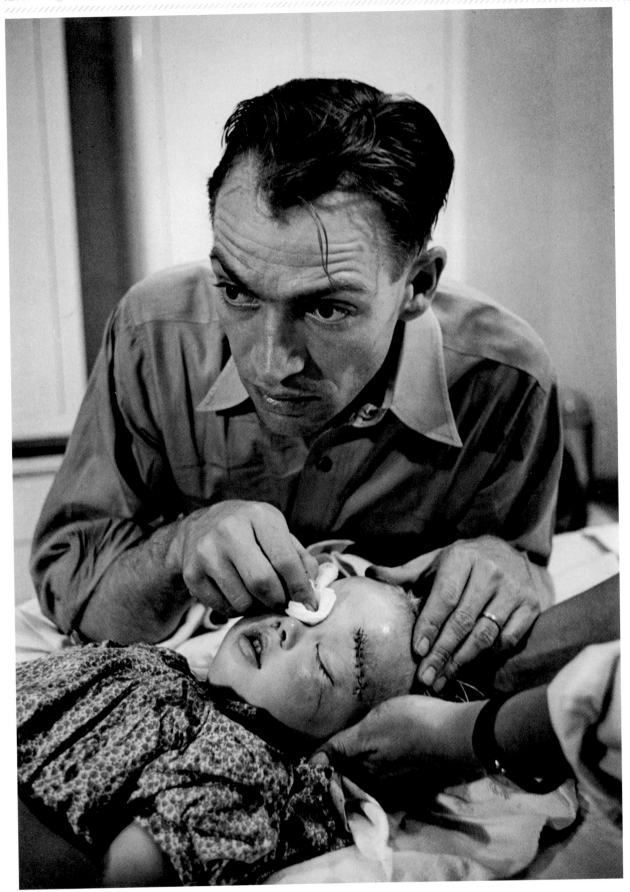

W. Eugene Smith
Country Doctor Ernest Ceriani, Kremmling, CO

1948 Inkjet print 25¼ ×18 inches ©2009 Time Inc. Used with permission. Time LIFE Collection

W. Eugene Smith
Erna Spohrhanssen, nurse, at Eugenia's Funeral

1954 Gelatin silver print 13½ × 10 inches © W. Eugene Smith/Black Star International Center of Photography, New York, NY,
The LIFE Magazine Collection, 2005 (1550.2005)

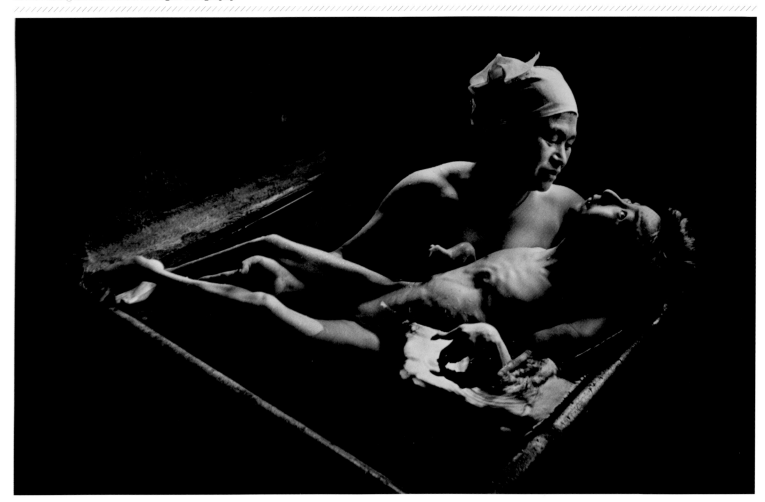

W. Eugene Smith
Tomoko in Her Bath

1972 Gelatin silver print 11½ × 18½ inches ©W. Eugene Smith New Orleans Museum of Art, New Orleans, LA: Museum Purchase through the National Endowment for the Arts, 75.347

Maggie Steber
Madje at Lunch

2006 Inkjet print 20 × 16 inches ©Maggie Steber Collection of the Artist

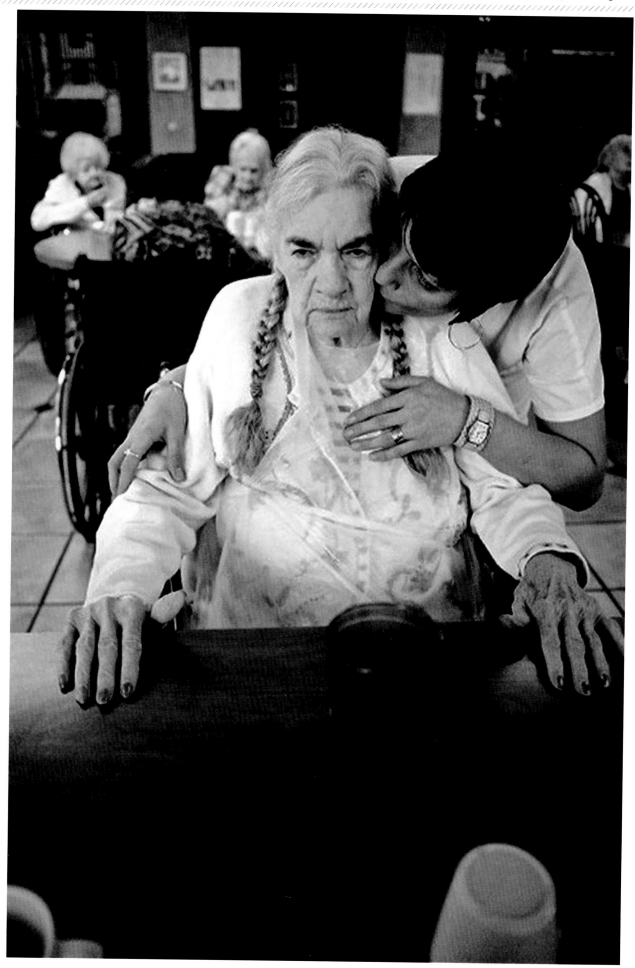

Deborah Willis
Sing and Chemo

2001 Gelatin silver print 20 × 16 inches © Deborah Willis Collection of the Artist

Bruce Weber
NYC Studio

1986, printed 1990 Gelatin silver print 23¼ × 18 inches © Bruce Weber International Center of Photography, New York, NY
Gift of the Photographers + Friends United Against AIDS, 1998 (1.1998.i)

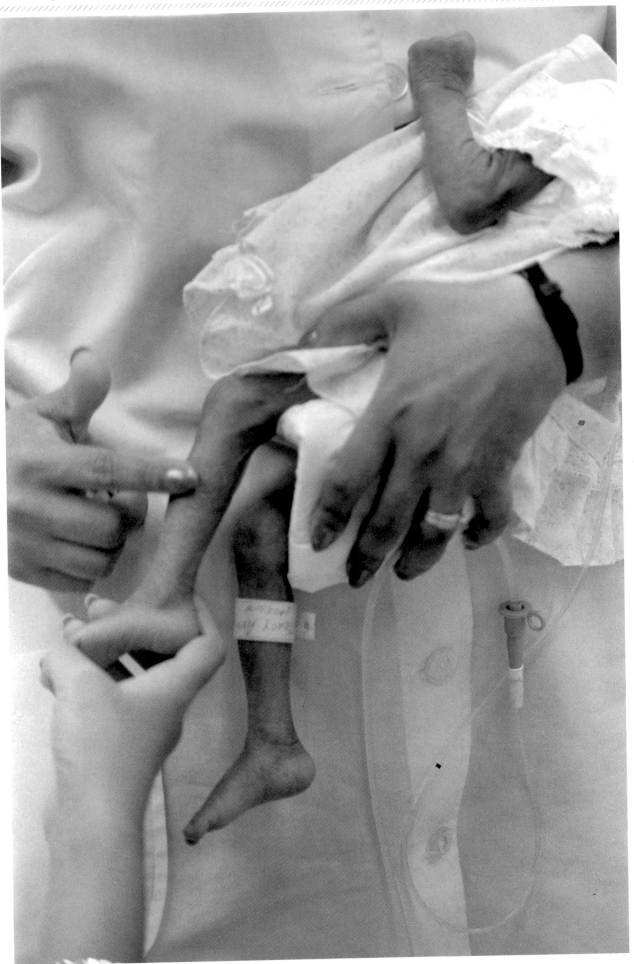

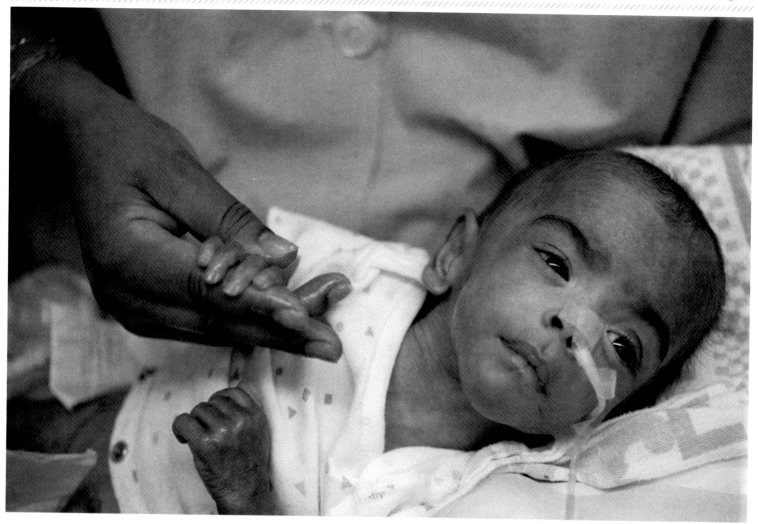

Claire Yaffa
A Dying Child is Born 2
1990 Gelatin silver print 20 × 24 inches © Claire Yaffa Collection of the Artist

Claire Yaffa
A Dying Child is Born 1
1990 Gelatin silver print 20 × 24 inches © Claire Yaffa Collection of the Artist

Aging is a blessing... aging gracefully
can become a work of art.

Chester Higgins

Aging

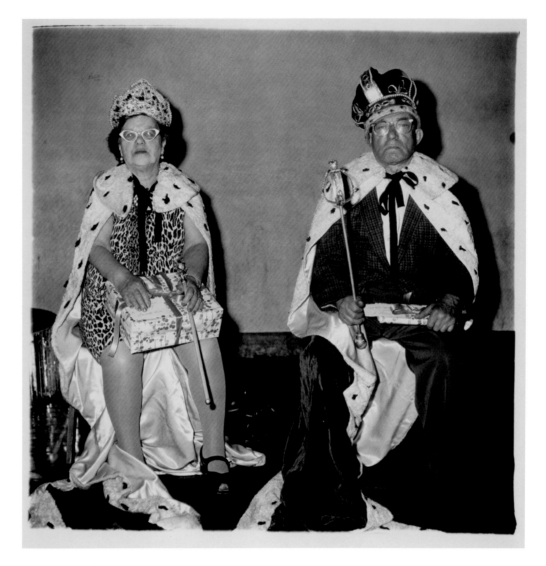

Diane Arbus
The King and Queen of a Senior Citizens' Dance, New York City

1970, printed 1973 Gelatin silver print 14 9/16 × 14 5/8 inches © Diane Arbus New Orleans Museum of Art, New Orleans, LA:
Museum Purchase, Ella West Freeman Foundation Fund, 73.29.3

Cornell Capa
Grandma Moses on her 100th birthday, Eagle Bridge, New York

1960 2 Gelatin silver prints each: 8¾ × 13 inches © Cornell Capa/Magnum Photos International Center of Photography, New York, NY,
The Robert Capa and Cornell Capa Archive, Promised Gift of Cornell and Edith Capa

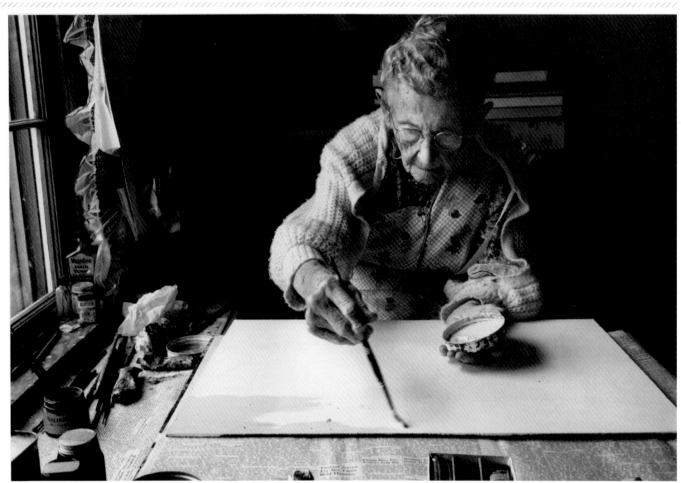

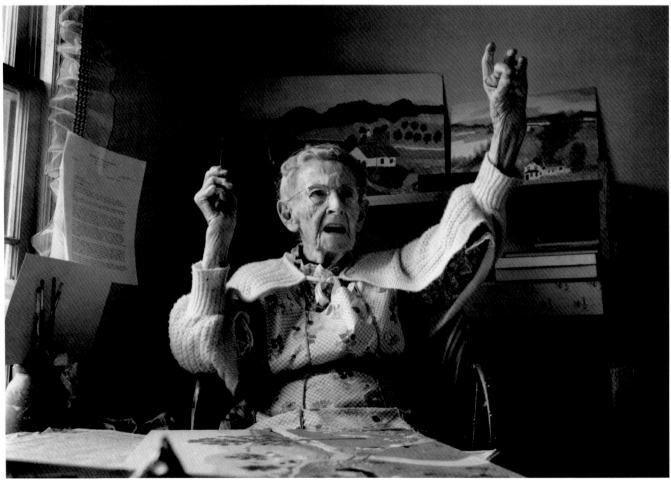

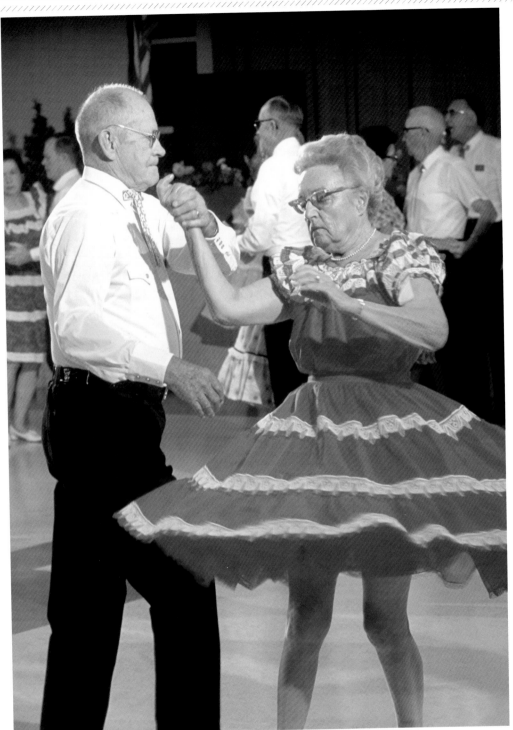

Ralph Crane
Elderly couple dancing, woman's red skirt swirling,
in retirement community

1970 Inkjet print 11 × 8 inches ©2009 Time Inc. Used with permission. Time LIFE Collection

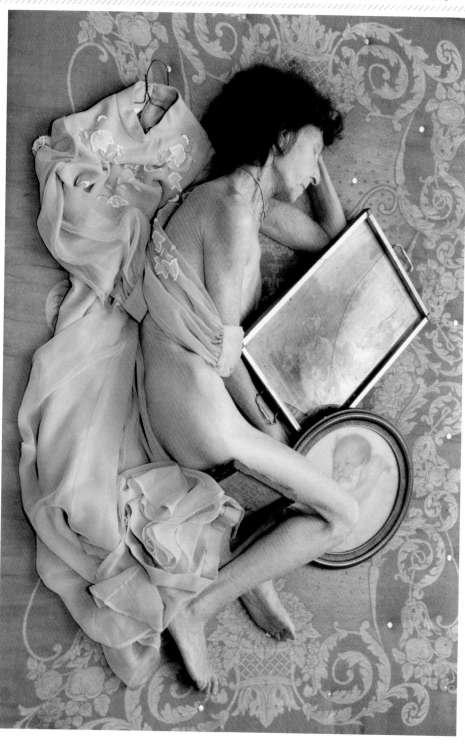

 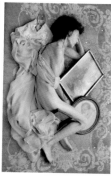

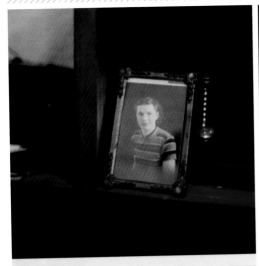

A photo of my wife aged 18. B. Jun 1915 D. Jan 1958

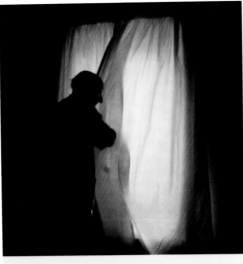

I'm not talking to a ghost I'm opening the curtains.

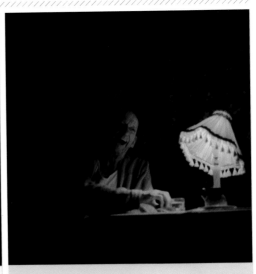

Enjoying my evening whiskey

My little bit of comfort.

P. Jays drying

Receiving pension

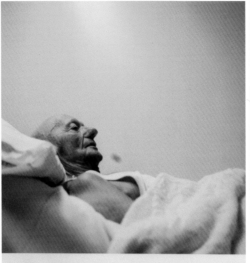

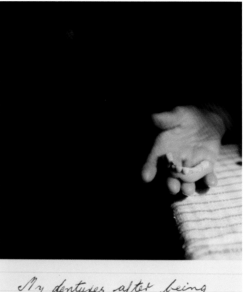

I think that roughness on my lower left rib cage is where I broke 5 ribs 40 yrs ago.

In Royal Gwent Hospital Bay, waiting for a bed in the ward. A stroke on my left arm and hand.

My dentures after being mugged by mugger, in '97, it cost me £120 for new set.

Watching the world (Rat Race) hustling by.

KayLynn Deveney
L to R: A photo of my wife, Curtain, Enjoying my Evening Whiskey, I think that roughness,
In royal hospital, My dentures, My little bit of comfort, P. Jays drying, Receiving pension,
Watching the world

2001–2006 10 Chromogenic prints mounted to aluminum each: 8¾ x 6 inches ©KayLynn Deveney Museum of Contemporary Photography, Columbia College Chicago, Chicago, IL

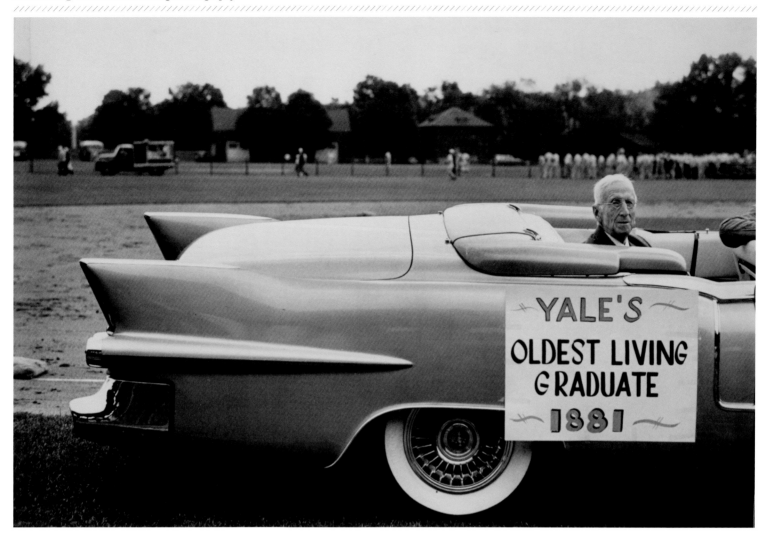

Elliott Erwitt
Yale/New Haven

1955 Gelatin silver print 6½ × 9½ inches edition 6 of 100 © Elliott Erwitt New Orleans Museum of Art, New Orleans, LA: Gift of Dr. Barry Leon, 78.304

David Finn
Rabbi Louis Finkelstein

1966 Silver gelatin print 14 × 11 inches © David Finn Courtesy Ruder Finn Inc., New York, NY

I Look young—I Feel
Great! I don't Think of
Myself as old. I'm Lucky!
BUT—

The condition of elderly people is sad.
There are times I Talk To and see people here—
and Then Cry.
They ache so bad! Old people need help!
They get The Feeling That They are a burden—
A stone around The Neck.
THEY ARE SO LONELY
IF only people would visit here—but
Young people Turn Their backs—They're Afraid!

I'd like to hit Them with my cane—

THEY'LL LEARN—EVERYBODY GETS OLD
—Mary E. H.
Neville Manor

Chester Higgins Jr.
Renee Chin

July 18, 1998 Duotone print 20 × 16 inches © Chester Higgins Jr. Collection of the Artist

Jim Goldberg
Mary E.H., Neville Manor, from the Nursing Home Series

1982 Gelatin silver print from Polaroid Positive/Negative film type 665 19¼ × 15¼ inches © Jim Goldberg/ Magnum Photos Courtesy The Polaroid Collections, Somerville, MA

Nic Nicosia
Domestic Drama #1

1982 Cibachrome print 40 × 60 inches edition 1 of 15 ©Nic Nicosia New Orleans Museum of Art, New Orleans, LA:
Museum Purchase B. M. Harrod Fund and Kate P. Jourdan Memorial Fund, 83.28

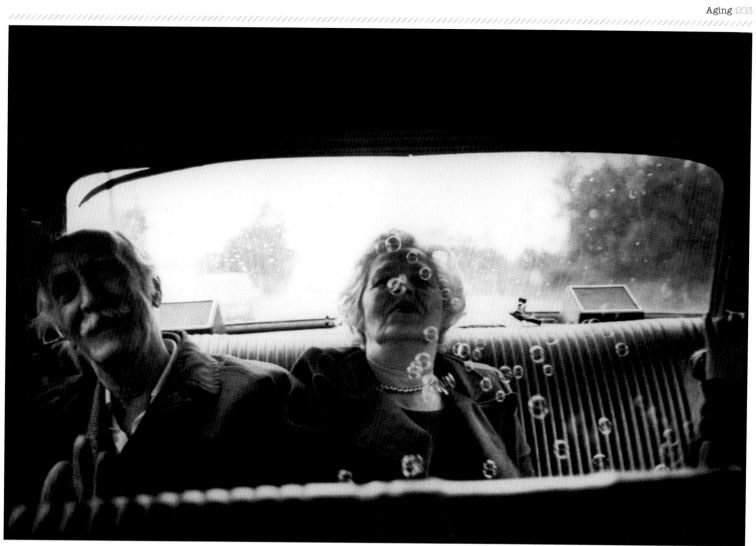

Sylvia Plachy
Grandpa and Grandma
1979 Gelatin silver print 20 × 24 inches © Sylvia Plachy Collection of the Artist

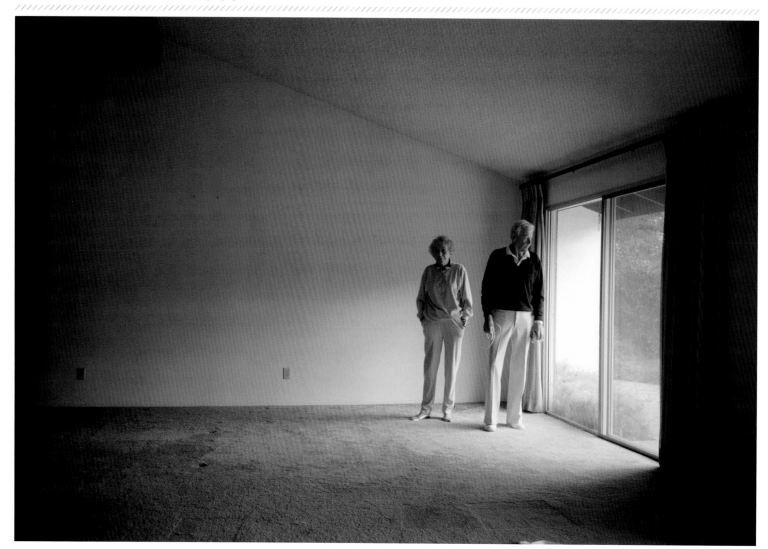

Larry Sultan
Moving Out

1988 Chromogenic print 24 × 34 inches ©Larry Sultan From the Artist Courtesy Janet Borden Gallery, New York, NY

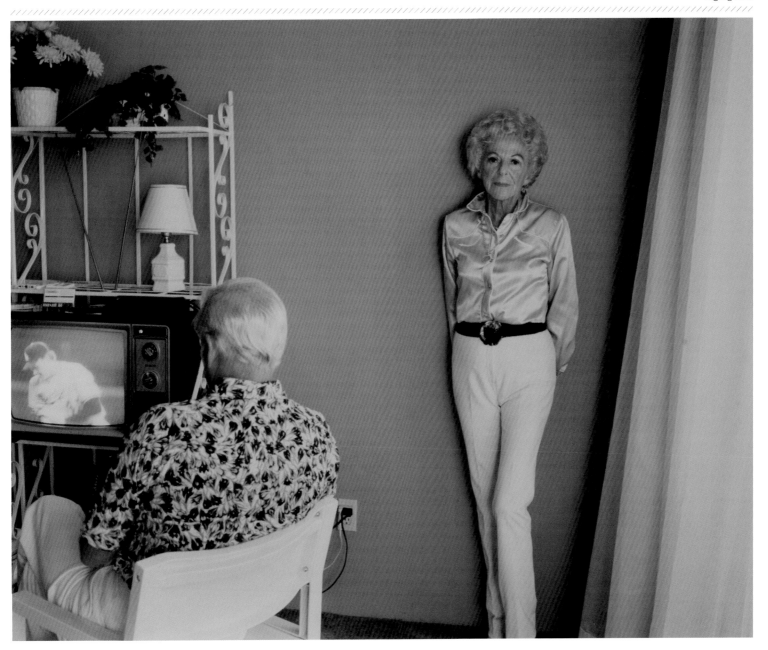

Larry Sultan
Untitled (My Mom Posing for Me, Palm Springs), from the Pictures from Home Series
1989 Chromogenic print 17¾ × 21½ inches edition of 25 ©Larry Sultan New Orleans Museum of Art, New Orleans, LA: On Loan from H. Russell Albright, M.D., EL.2001.129

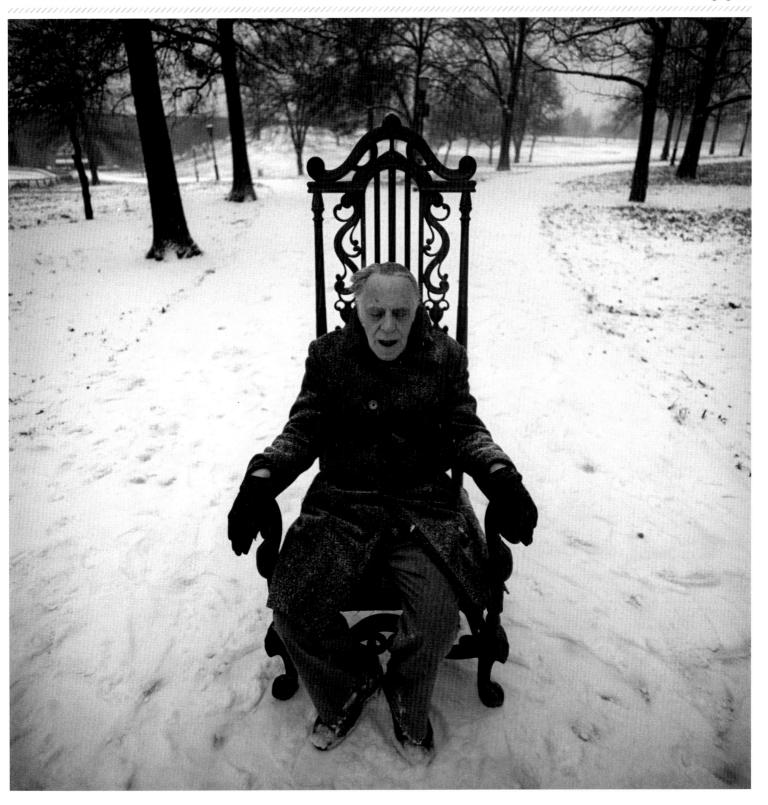

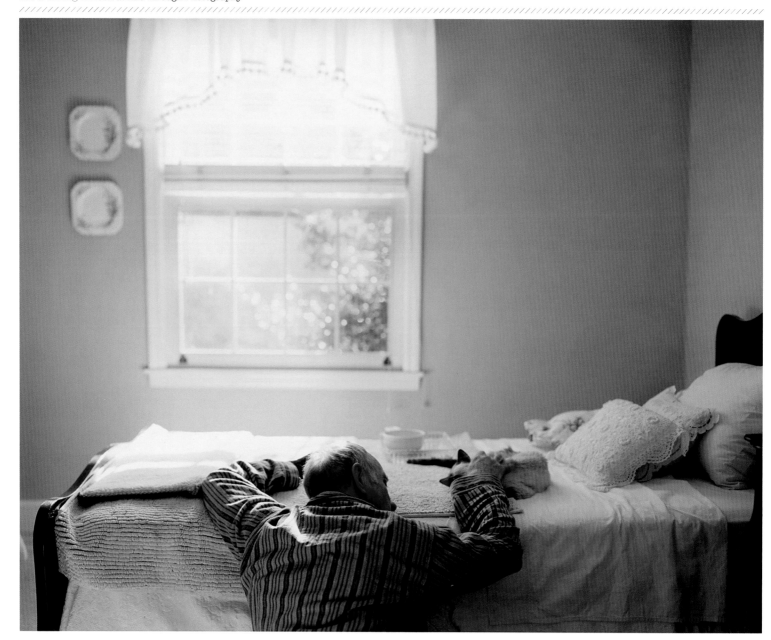

Angela West
Gracie #1

2006 Cibachrome print mounted to Plexiglas 40 × 50 inches © Angela West Courtesy Jackson Fine Art, Atlanta, GA

Angela West
Gracie #2

2006 Cibachrome print mounted to Plexiglas 40 × 50 inches © Angela West Courtesy Jackson Fine Art, Atlanta, GA

Ever since cameras were invented, photography
has kept company with death.

Susan Sontag

Disaster

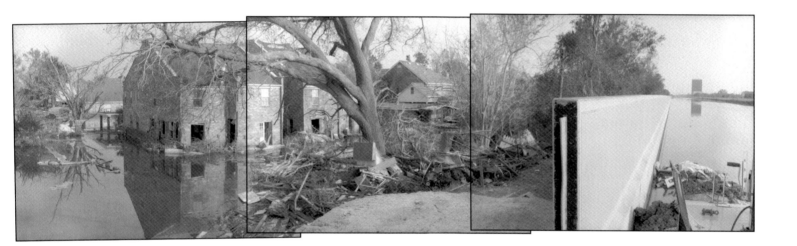

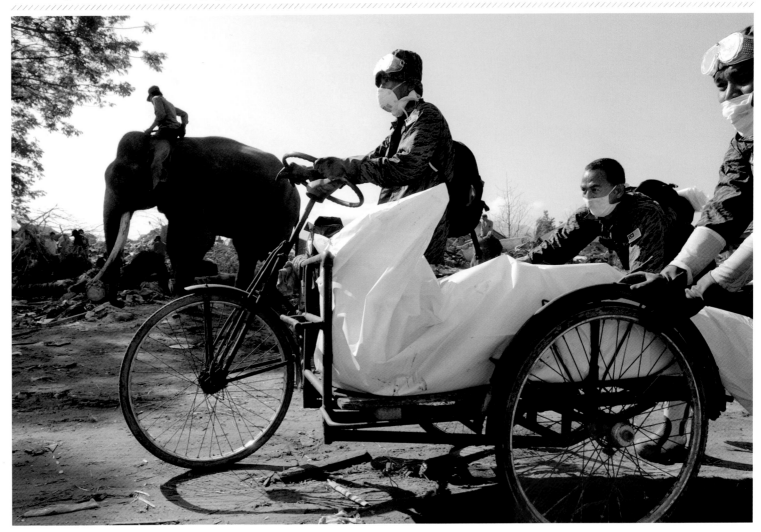

James Balog
Body Recovery Team, Banda Aceh, January 31, 2005
2005 Chromogenic print 20 × 24 inches ©James Balog Collection of the Artist

James Balog
Woman at Indonesian Red Cross Headquarters, Banda Aceh, January 28, 2005
2005 Chromogenic print 20 × 24 inches ©James Balog Collection of the Artist

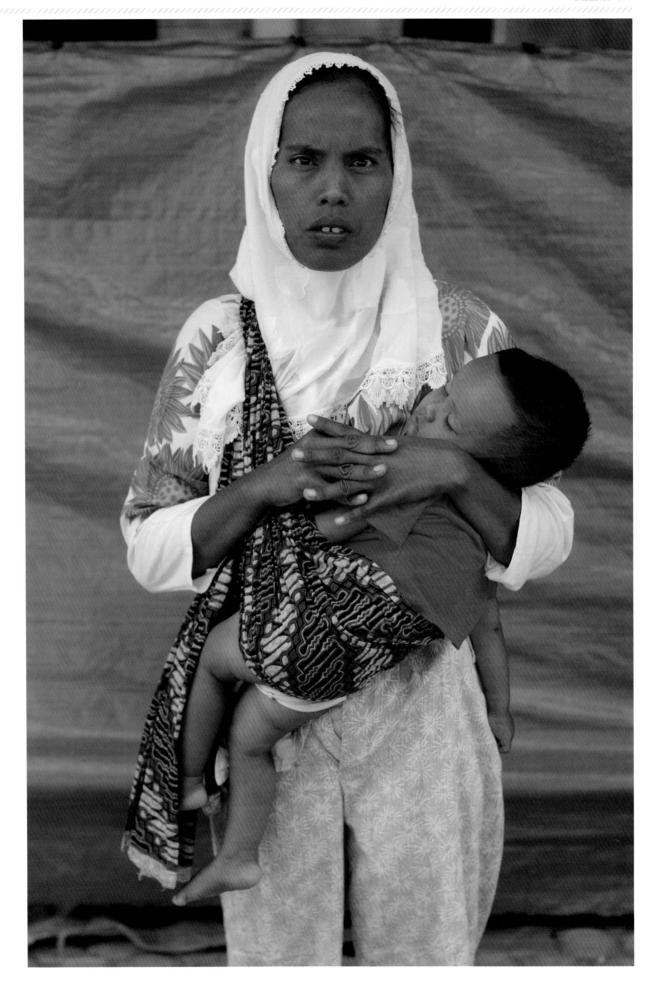

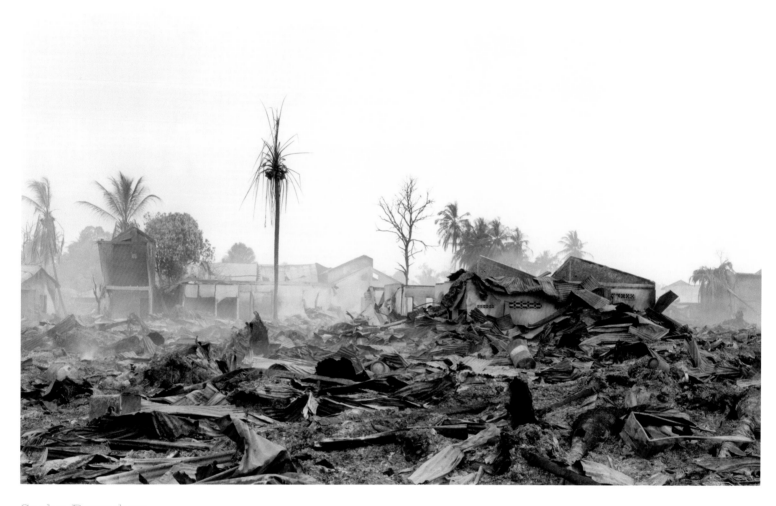

Sasha Bezzubov
Tsunami # 3, Indonesia, from the Things Fall Apart Series
2005 2 Chromogenic prints mounted to Dibond each: 40 × 50 inches ©Sasha Bezzubov Courtesy James Francis Trezza Fine Art, New York, NY

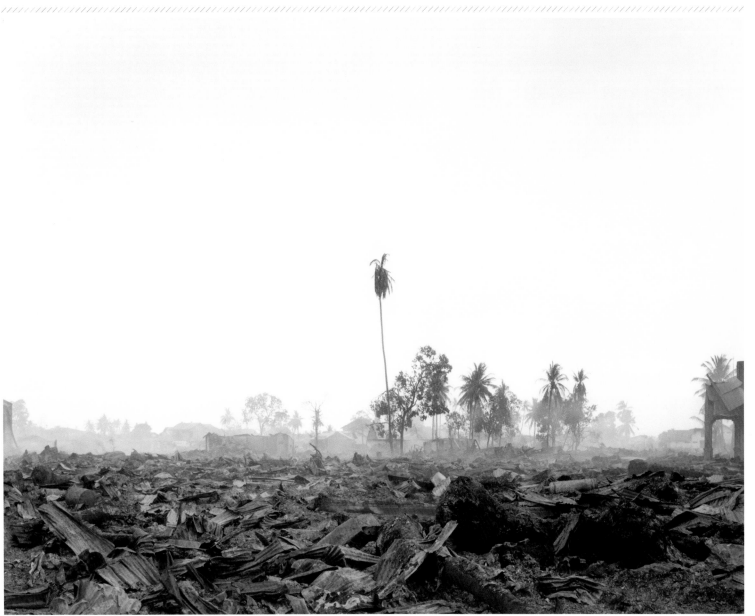

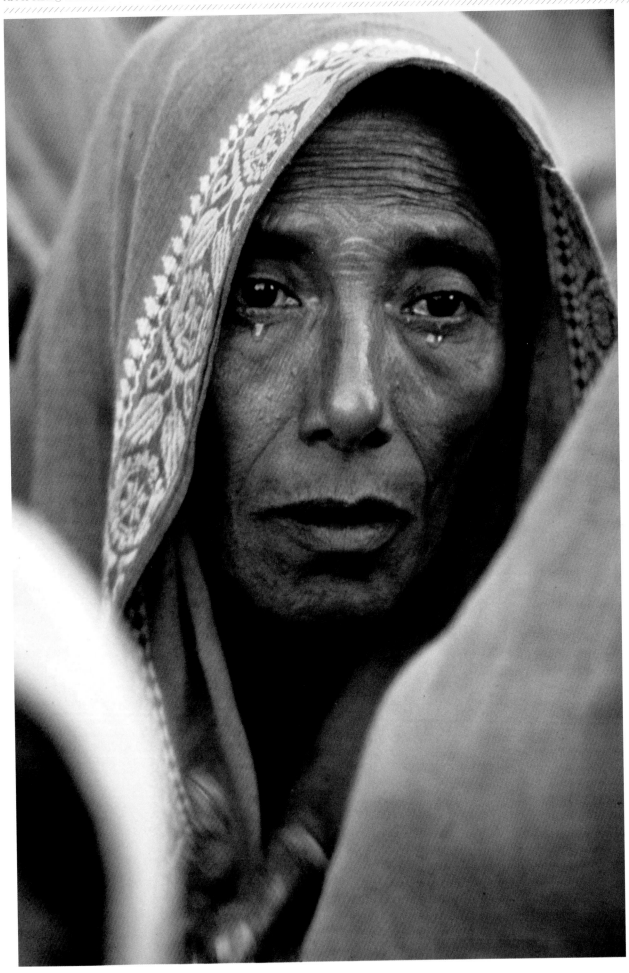

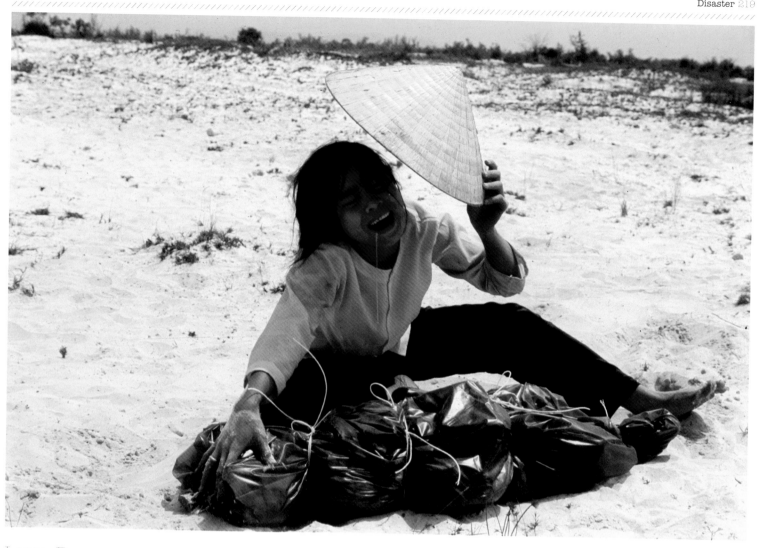

Larry Burrows

Grieving widow crying over plastic bag containing remains of husband recently found in mass grave of civilians killed by the Viet Cong during the Tet offensive, February 1968

April 1, 1969 Inkjet print 7 × 10 inches © 2009 Time Inc. Used with permission. Time LIFE Collection

Larry Burrows

Cyclone Survivor, East Pakistan

1970 Inkjet print 19¼ × 14 inches © 2009 Time Inc. Used with permission. Time LIFE Collection

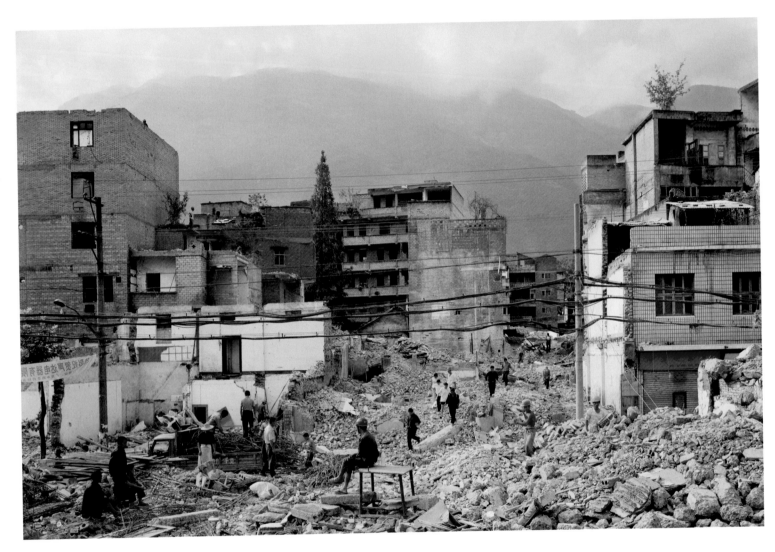

Edward Burtynsky
Wushan #4, Yangtze River, China, from the Three Gorges Dam Series

2002 Chromogenic print 29 × 50 inches edition 1 of 5 © Edward Burtynsky, Courtesy Charles Cowles Gallery, New York, NY

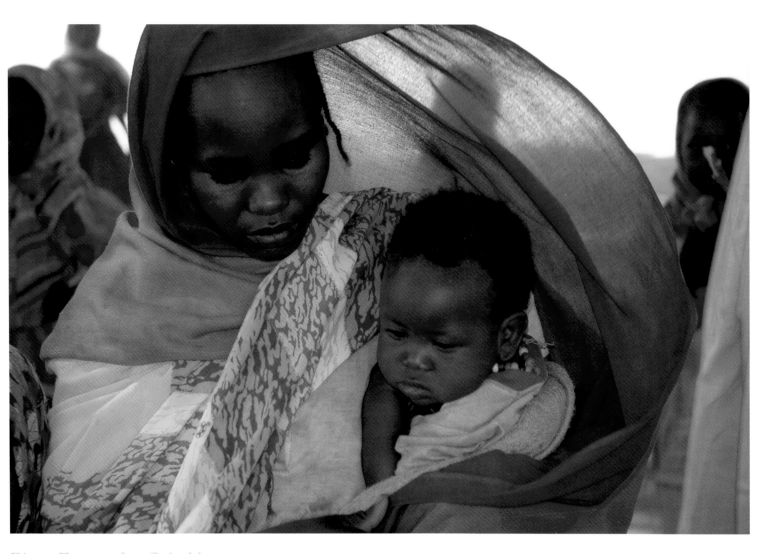

Diego Fernandez Gabaldon
Care

December, 2005 Chromogenic print 13¼ × 20 inches © Diego Fernandez Gabaldon Collection of the Artist

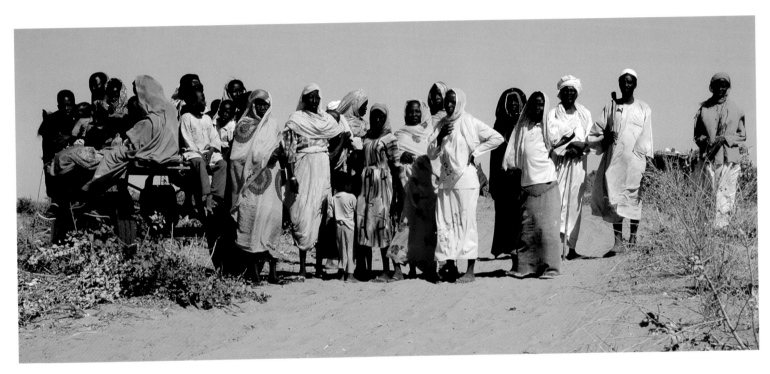

Diego Fernandez Gabaldon
Fleeing

November, 2006 Chromogenic print 8¾ × 20 inches ©Diego Fernandez Gabaldon Collection of the Artist

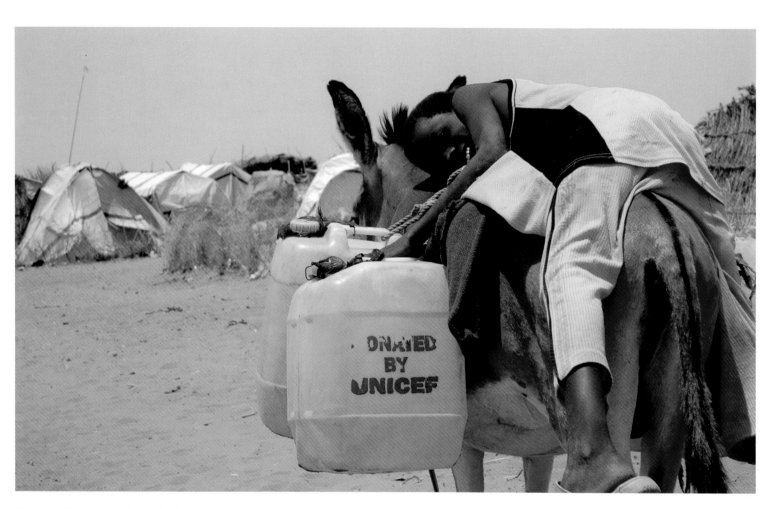

Diego Fernandez Gabaldon
IDP Camp

May, 2006 Chromogenic print 13¼ × 20 inches ©Diego Fernandez Gabaldon Collection of the Artist

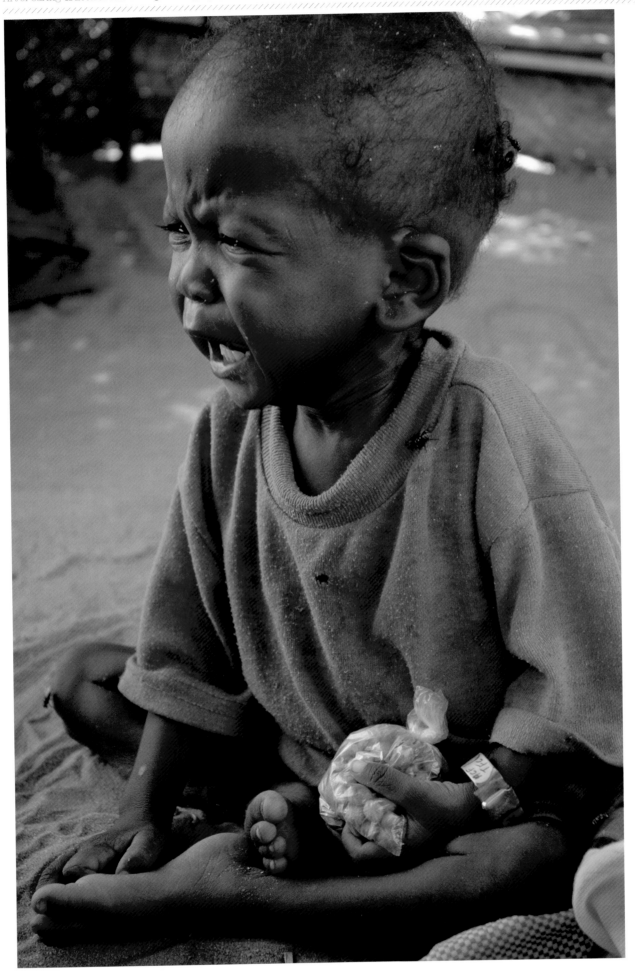

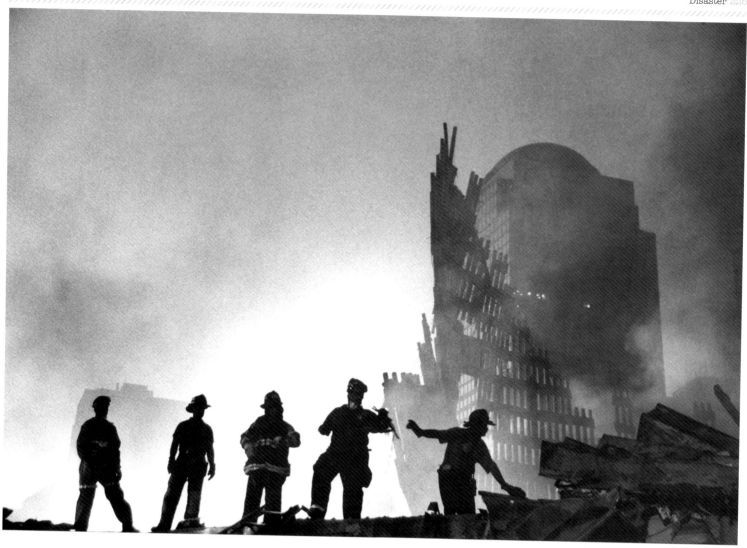

Fred George
Ash Wednesday, Dusk, 9/12/01

2001 Inkjet print 11×14 inches ©Fred George New-York Historical Society Library, New York, NY, Department of Prints, Photographs, and Architectural Collections

Diego Fernandez Gabaldon
Malnutrition

May, 2006 Chromogenic print 16×10½ inches ©Diego Fernandez Gabaldon Collection of the Artist

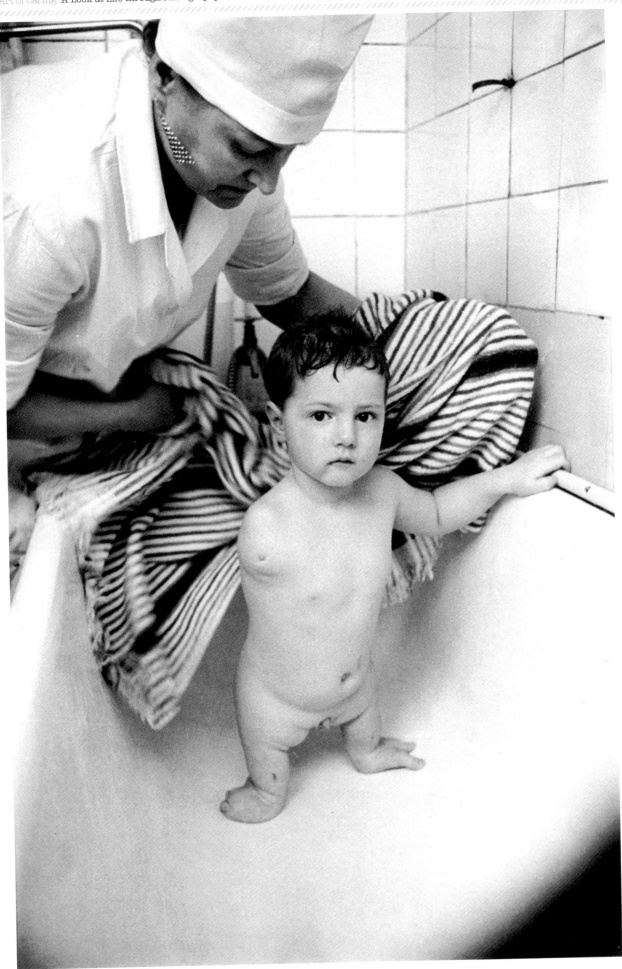

Sean Hemmerle
Minefield-Jalalabad, Afghanistan

2002 Chromogenic print 31 × 38 inches ©Sean Hemmerle Collection of Martin Z. Margulies, Miami, FL

Timur Grib
Chernobyl's Boy

1991 Gelatin silver print 24 × 20 inches ©Timur Grib Collection of the Artist

Robert Glenn Ketchum
Care for Earth

1991 Chromogenic print 48 × 65 inches ©Robert Glenn Ketchum Courtesy RGK Photography, Inc., Los Angeles, CA

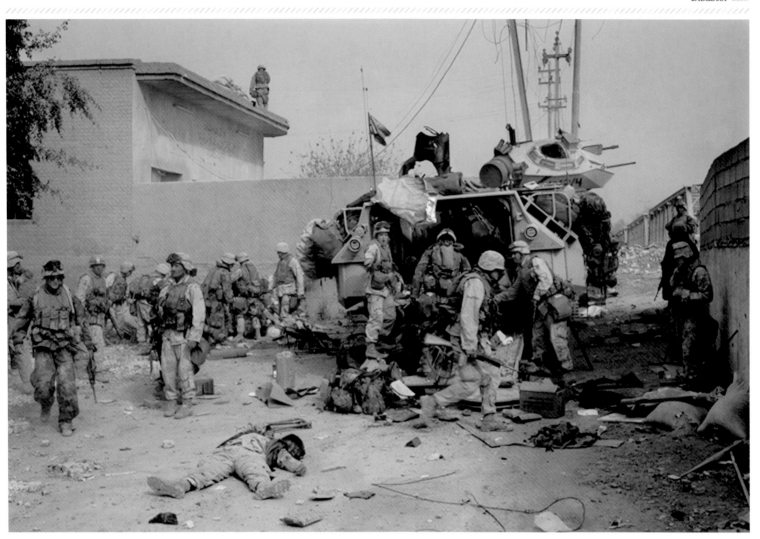

Gary Knight
U.S. Marines, Baghdad, from the Bridge Series

2003 Chromogenic print edition of 10 28 × 38 inches © Gary Knight Collection of Martin Z. Margulies, Miami, FL

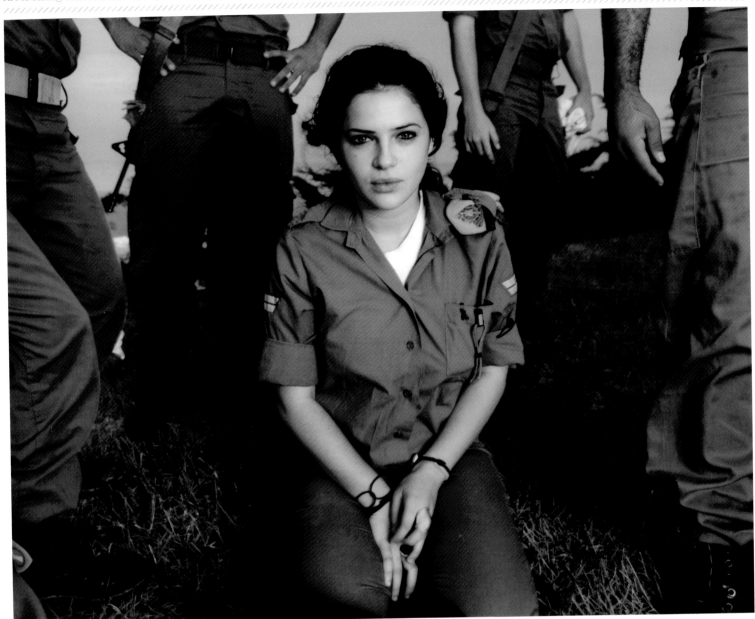

Gillian Laub
Aliza at Friends' Memorial, Tiberias, Israel, 2002

2002 Chromogenic print mounted to Plexiglas 20 × 24 inches ©Gillian Laub Courtesy Bonni Benrubi Gallery, New York, NY

David McMillan
Dormitory Room, Pioneer Camp, October 1997, from the Chernobyl and Villages Series

1997 Chromogenic print 14½ × 18 inches © David McMillan Canadian Museum of Contemporary Photography,
an affiliate of the National Gallery of Canada, Ottawa, Canada; Purchased 1999

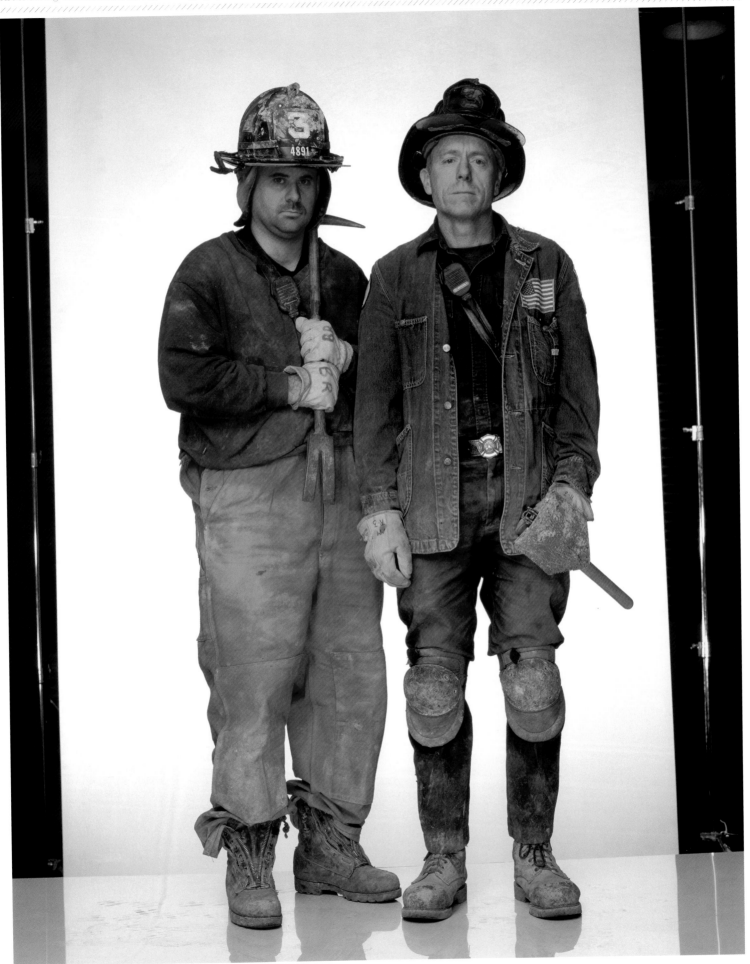

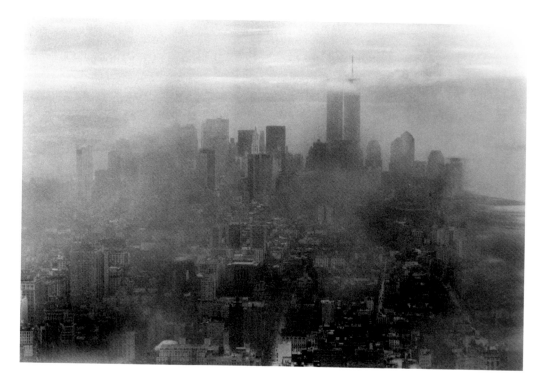

The savages have sacked the city's gate.
Its towers have fallen to their tragic fate.
A thief has brought the citizens to grief.
Grave talk of plague is in the street.
The people wait.
Angels cry and cannot sleep beneath.

Duane Michals
Untitled

2001 Gelatin silver print with hand applied text 11×14 inches ©Duane Michals Courtesy Pace/MacGill Gallery, New York, NY

Joe McNally
Bill Ryan & Mike Morrissey

September, 2001 6 × 7 Color inkjet print on archival paper 20 ×16 inches ©Joe McNally Collection of the Artist

Gilles Peress
Funeral of an IRA Man, Derry, from the Northern Ireland Series
1984 Gelatin silver print 30 × 40 inches © Gilles Peress Norton Museum of Art, West Palm Beach, FL, Gift of Carol Ann Merritt, The Carol & Raymond Merrit Collection, 2004.75

Robert Polidori
6328 North Miro St., New Orleans, LA
2005 Fujicolor crystal archive print mounted to Dibond 40 × 54 inches edition 1 of 10 ©Robert Polidori Collection of Dale and Doug Anderson

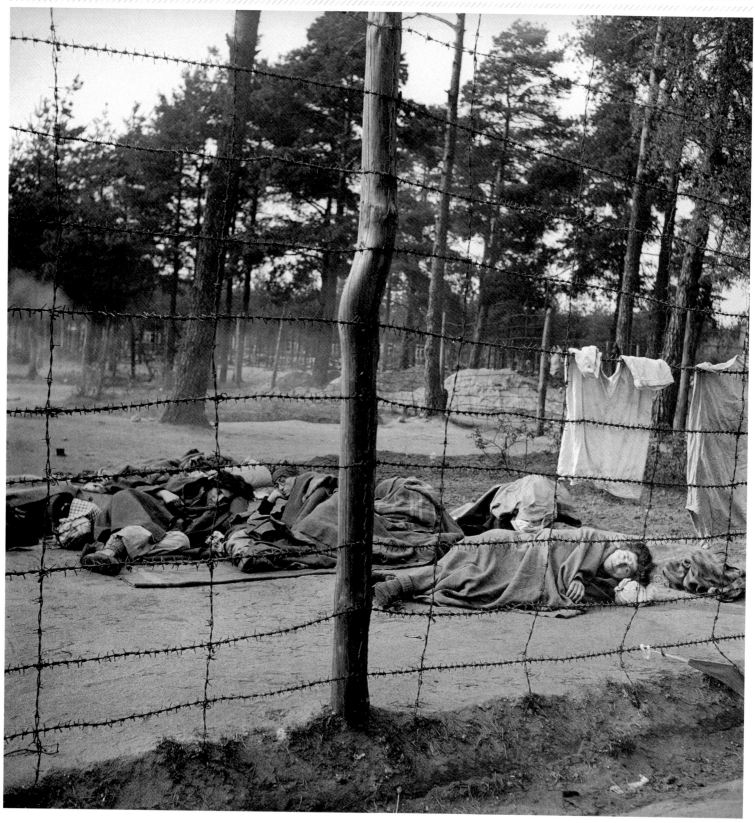

George Rodger
Behind the barbed wire fence at the recently liberated Bergen-Belsen concentration camp, female prisoners lie dying of typhus and starvation on the ground outside, Bergen-Belsen, Germany, mid-April 1945

1945 Inkjet print 30 × 28¾ inches ©2009 Time Inc. Used with permission. Time LIFE Collection

Chen Qiulin
Ellisis's Series #3

2002 Giclée print 49⅝ × 33⅞ inches ©Chen Qiulin Collection of Dale and Doug Anderson

Zoe Strauss
Mom We're OK, Gulfport, Mississippi

2005 Archival pigment print 34 × 22 inches ©Zoe Strauss Courtesy Silverstein Photography, New York, NY

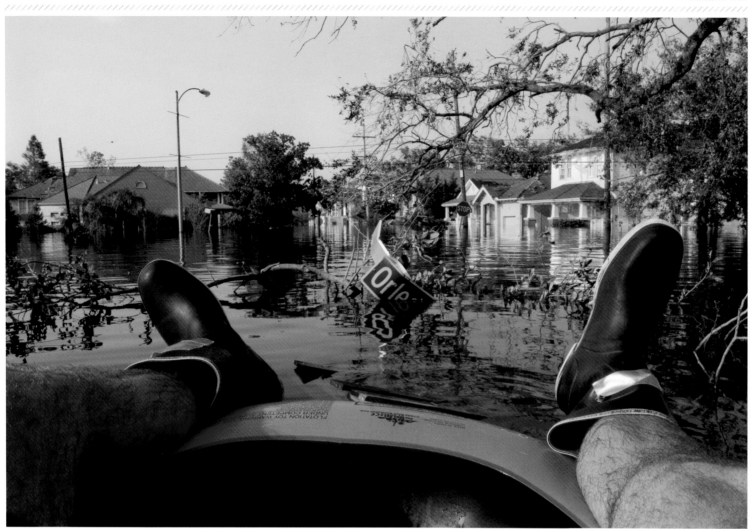

Jonathan Traviesa
Untitled

2005 Inkjet print 13 × 19¾ inches ©Jonathan Traviesa New Orleans Museum of Art, New Orleans, LA: Gift of the Artist, 2007.166.1

October 7th, 2005. When the power went out, the old man slipped and fell.
He never woke up. New Orleans.

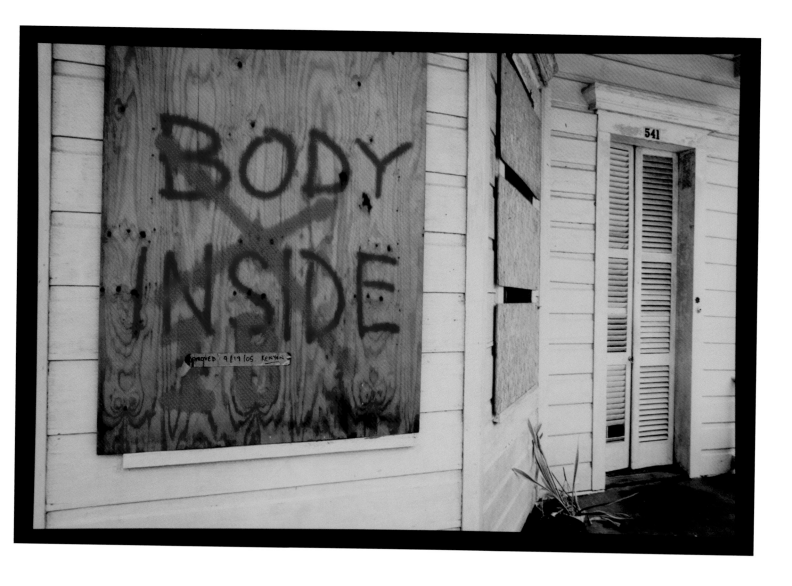

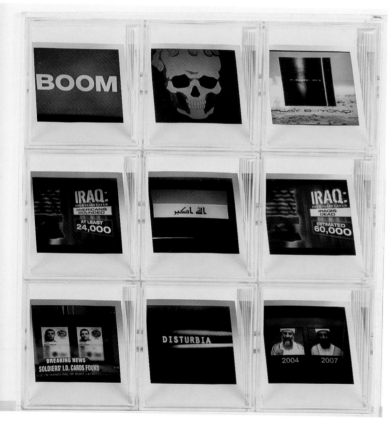

Cynthia E. Warwick
Wake Up People

2001–2008 Polaroid prints in Plexiglas boxes 3 boxes, each: 13¾ × 12¼ × 3¼ inches
© Cynthia E. Warwick Collection of the Artist

We are able to find everything in our memory, which is like a dispensary or chemical laboratory in which chance steers our hand sometimes to a soothing drug and sometimes to a dangerous poison.

Marcel Proust

Remembering

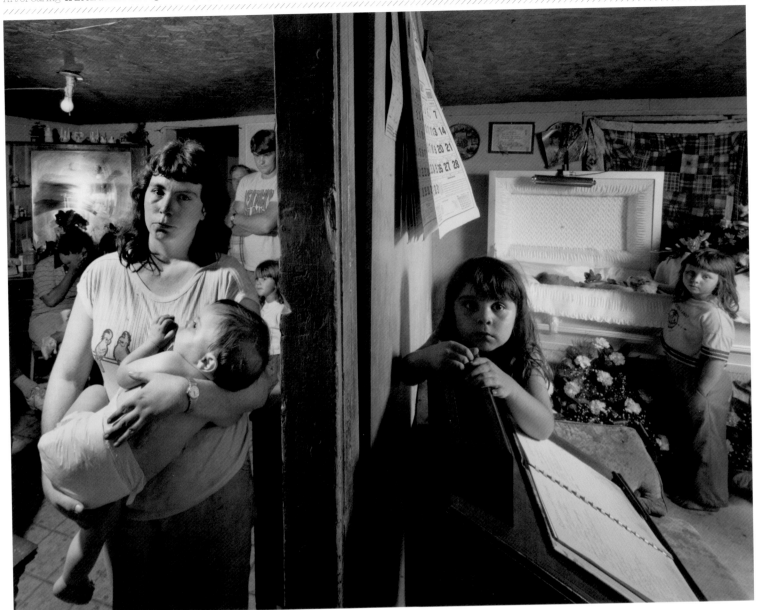

Shelby Lee Adams
The Home Funeral, Leatherwood, Kentucky

1990 Gelatin silver print 14¾×19 inches ©Shelby Lee Adams International Center of Photography, New York, NY, Gift of Alan Albert and Opsis Foundation, 1992 (107.1992)

Andrea Robbins and Max Becher
Dachau, Execution Range and Blood Ditch

1994 Chromogenic print 20 × 24 inches © Andrea Robbins and Max Becher Samuel P. Harn Museum of Art, University of Florida, Gainsville, FL: Museum Purchase, funds provided by the Caroline Julier G. Richardson Art Acquisition Fund

Christian Boltanski
Les Monuments I, II, III

1985 3 Polaroid Polacolor 20 × 24 photographs each: 30¾ × 24¾ inches
© Christian Boltanski Courtesy The Polaroid Collections, Somerville, MA

Keith Carter
Dog and Coffin
1992 Toned Gelatin silver print 15½ × 15½ inches ©Keith Carter Courtesy Keith Carter Photography, Inc., Beaumont, TX

Keith Carter
Goodbye to a Horse
1993 Toned Gelatin silver print 15½ × 15½ inches © Keith Carter Courtesy Keith Carter Photography, Inc., Beaumont, TX

Albert Chong
Rock Shrine For My Father

1990 Gelatin silver print, copper mat 26¾ × 34 inches © Albert Chong Collection of the Artist

Albert Chong
Aunt Winnie

1995 Inkjet on canvas 53 × 36 inches © Albert Chong Collection of the Artist

Edward Clark
Navy CPO Graham Jackson
1945 Inkjet print 18 × 28 inches © 2009 Time Inc. Used with permission. Time LIFE Collection

Linda Connor
Ceremony, Sri Lanka

1979 Gold toned gelatin silver print 8 × 10 inches © Linda Connor Museum of Contemporary Photography, Columbia College Chicago, Chicago, IL

only those of us who have left know what it is like

Fred Cray
Untitled (Only Those of Us Who Have Left Know What It Is Like)
2006 Lightjet print 20 × 40 inches © Fred Cray Courtesy Janet Borden Gallery, New York, NY

Sylvia de Swaan
The Site of Our Heritage

2008 Archival inkjet print 20 × 40 inches © Sylvia de Swaan Collection of the Artist

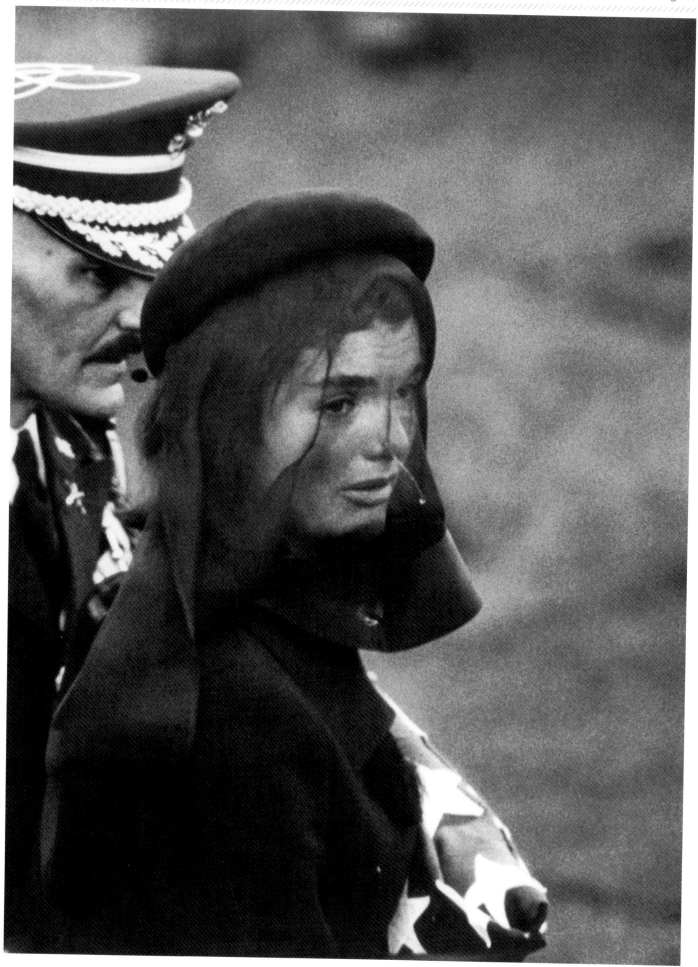

Donna Ferrato
Fanny and Her Kindergarten Class Mourn the Death of the Class Gerbil
1988 Gelatin silver print 16 × 20 inches ©Donna Ferrato The Buhl Collection

Tom Fields
Cherokee History Lesson

1984 Gelatin silver print 11×14 inches ©Tom Fields Courtesy Native Fields Web Gallery, Stillwater, OK

Jeff Charbonneau and Eliza French
Axis-Memoria

2007 Chromogenic print mounted to Dibond 29½ × 29½ inches ©Jeff Charbonneau and Eliza French Courtesy Robert Berman Gallery, Santa Monica, CA

Tom Fields
Hall of Fame Football Player

1984 Gelatin silver print 14 × 11 inches ©Tom Fields Courtesy Native Fields Web Gallery, Stillwater, OK

Nan Goldin
Amalia and Amanda, New York City

1994 Cibachrome print 19½×19½ inches ©Nan Goldin Courtesy Matthew Marks Gallery, New York, NY

Nan Goldin
Amalia's Dresser, New York City

1994 Cibachrome print 15½ × 23½ inches © Nan Goldin Courtesy Matthew Marks Gallery, New York, NY

Peter Granser
Cemetery, from the Sun City Series

2000 Chromogenic print 23½ × 23½ inches © Peter Granser Collection of the Artist

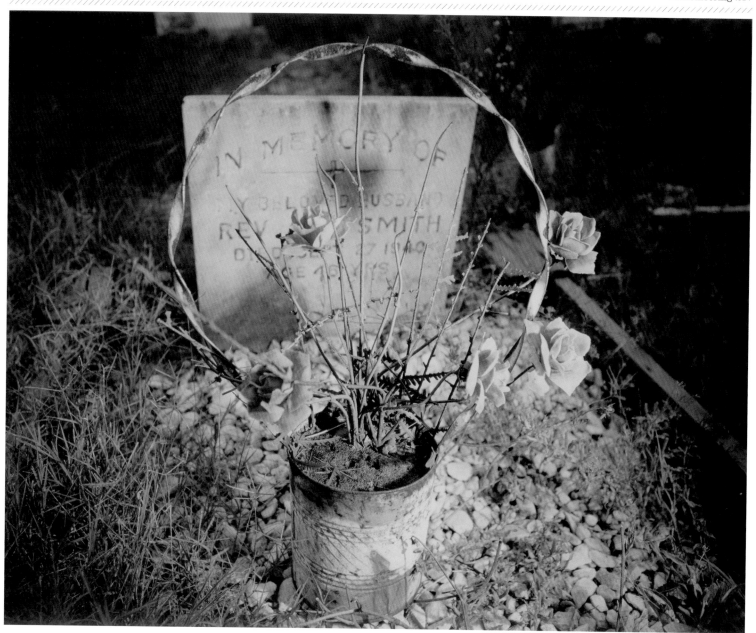

William K. Greiner
Coffee Can Wreath, New Orleans 1989

1989, printed 2009 Chromogenic print 25 × 30 inches © William K. Greiner Collection of the Artist

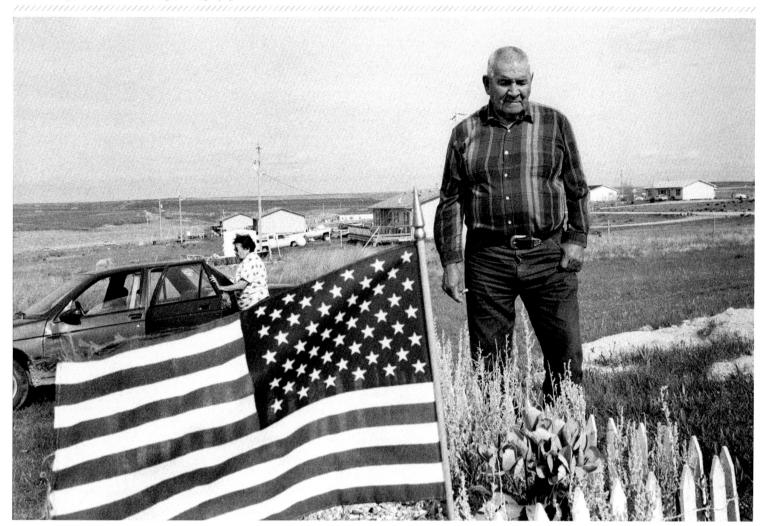

Ed Kashi
Pine Ridge, 2000

2000 Gelatin silver print 24 × 36 inches ©Ed Kashi Courtesy Ed Kashi Studio, Montclair, NJ

Sally Mann
Ashes

circa 1995 Gelatin silver print 20 × 24 inches © Sally Mann Courtesy Gagosian Gallery, New York, NY

Sally Mann
Windows
circa 1995 Gelatin silver print 20 × 24 inches © Sally Mann Courtesy Gagosian Gallery, New York, NY

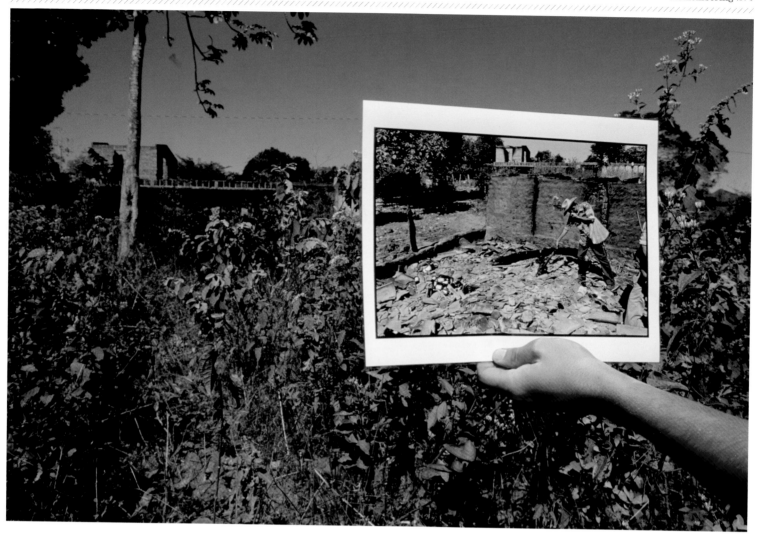

Susan Meiselas
Return to Site, El Mozote Massacre, El Salvador, 2001

2001 Chromogenic print 20 × 24 inches ©Susan Meiselas/ Magnum Photos Courtesy Meiselas Studio, New York, NY

GRANDPA GOES TO HEAVEN

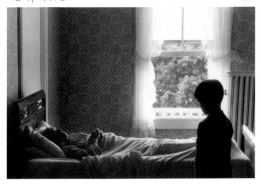

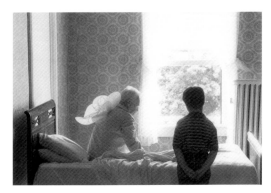

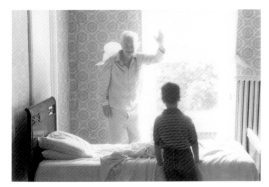

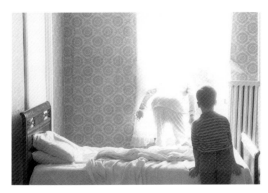

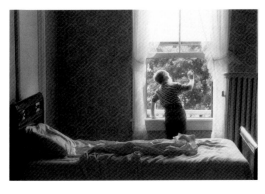

Duane Michals
Grandpa Goes to Heaven
1985 5 Gelatin silver prints each: 4 × 5 inches ©Duane Michals Collection of Dale and Doug Anderson

Jonathan Moller
Three women, themselves survivors of the violence, watch as the remains of relatives and friends who were killed in the early 1980s are exhumed. Nebaj, Guatemala

2000 Carbon pigment print 18½ × 18½ inches ©Jonathan Moller Collection of the Artist

James Nakagawa
Kai, Ninomiya, Japan, Autumn

1998 Gelatin silver print 14 × 14 inches ©James Nakagawa Courtesy the Artist and Sepia International, New York, NY

Sylvia Plachy
Dachau

1985 Gelatin silver print 20 × 24 inches © Sylvia Plachy Collection of the Artist

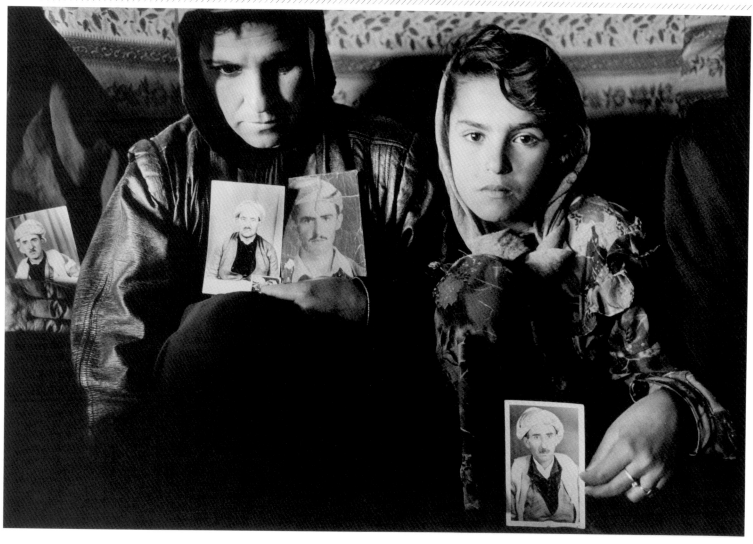

Sebastião Salgado
Beharke, Iraqi Kurdistan: On July 31, 1981, Iraqi soldiers arrived unexpectedly and took away all the men in every family; they were never seen again. Under Muslim law, women cannot remarry, so they are left waiting

1997 Gelatin silver print 11¹¹⁄₁₆ × 17⅛ inches © Sebastião Salgado International Center of Photography, New York, NY, Gift of Cornell Capa, 2007 (2007. 6.4)

Sheng Qi
Memories (Me)

2000 Chromogenic print 48⅜ × 33⅛ inches © Sheng Qi International Center of Photography, New York, NY, Purchase, with funds provided by Anne and Joel Ehrenkranz, 2004 (7.2004)

Neal Slavin
Cemetery Workers and Greens Attendants Union Local 365 S.E.I.U., A.F.L. - C.I.O, Ridgewood, N.Y.

1979 Chromogenic print 10½ × 10⁹⁄₁₆ ©Neal Slavin Cincinnati Art Museum, Cincinnati, OH, Gift of Mr. and Mrs. David C. Ruttenberg, 1983.479

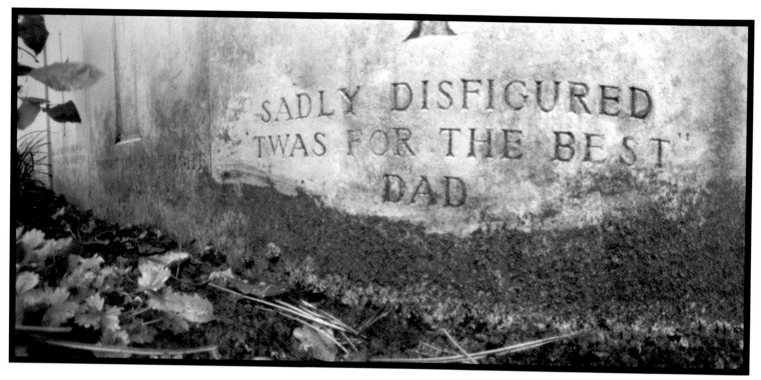

Jane Alden Stevens
Epitaph, Brookwood Military Cemetery (British), England
2001 Inkjet print 22 × 48 inches ©Jane Alden Stevens Collection of the Artist

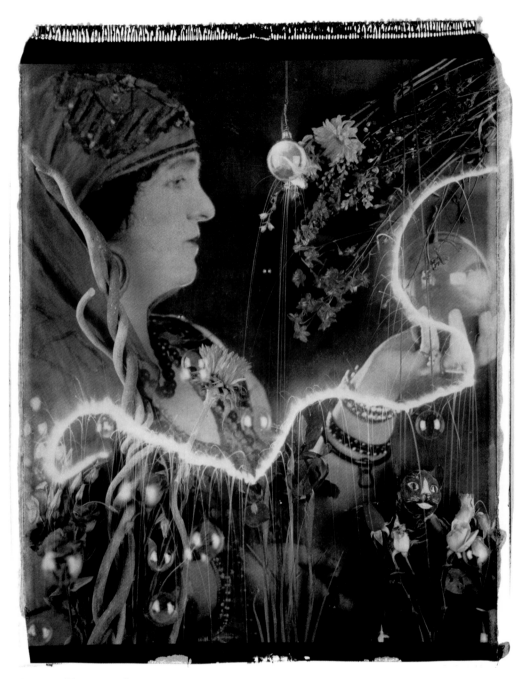

Anna Tomczak
Zazelle II

1999 Polaroid image transfer on Arches 300# hot press paper 30 × 22 inches ©Anna Tomczak Collection of the Artist

Leo Touchet
Leaving the Church, from the New Orleans Jazz Funeral Series
1973 Gelatin silver print 19½ × 13 inches ©Leo Touchet New Orleans Museum of Art, New Orleans, LA: Museum Purchase from Exhibitions Fund, 75.357

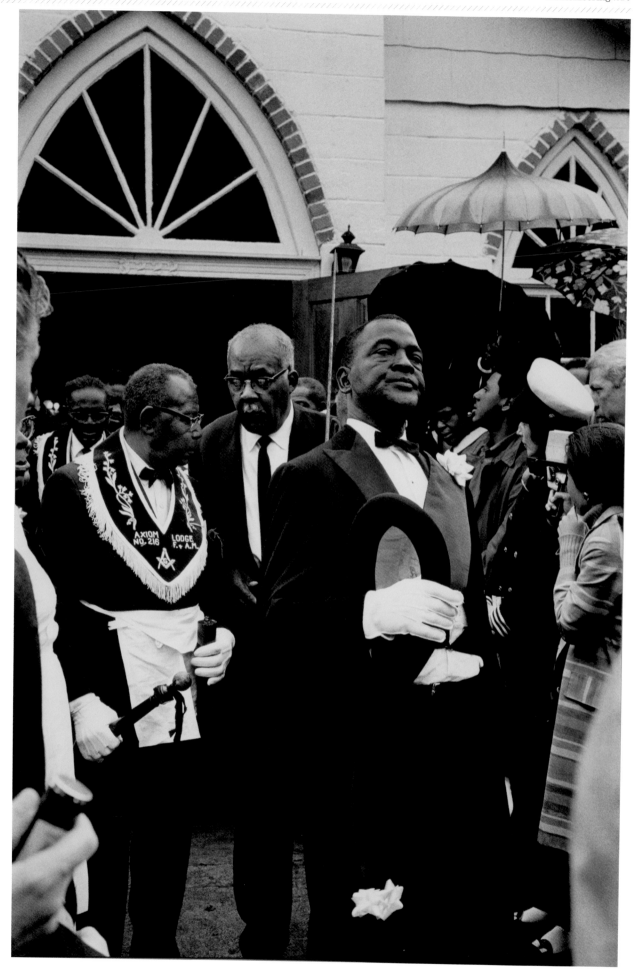

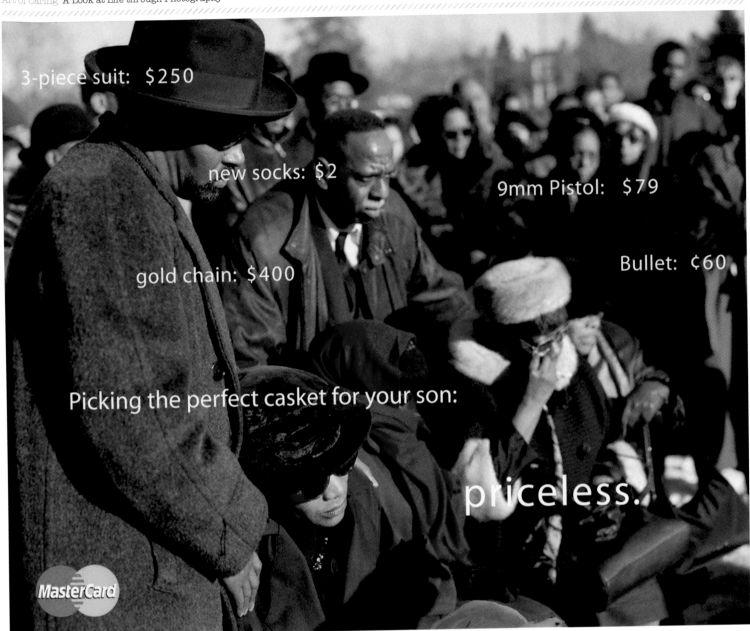

3-piece suit: $250

new socks: $2

9mm Pistol: $79

gold chain: $400

Bullet: ¢60

Picking the perfect casket for your son:

priceless.

MasterCard

Hank Willis Thomas
Priceless #1, from the B®ANDED Series
2004 Chromogenic print 48 × 60 inches © Hank Willis Thomas International Center of Photography, Purchase, with funds provided by Anne and Joel Ehrenkranz, 2006 (2006.5.1)

Hank Willis Thomas
Lageisha Remembers Dirt
2006 Lightjet print 30 × 24 inches edition of 2 © Hank Willis Thomas Courtesy Jack Shainman Gallery, New York, NY

The Art of Caring

The Art of Caring
Pulls at my heart
to write – to stage
to color – compose
Any feelings

The Flow of Giving
The Art of Caring
The Joy of Creating
The Hope of healing
open feelings

Given in Love
Smiling Rhymes
Embraces
Symphonies
of feelings

The Colors of Health
The Bolt of Disaster
Cacophony
Rainbow
our feelings

The Autumn of Living
the Curtain
Remembering
The Finale
with feeling

Bravo
Applause

Reaching
Yes – Caring
Celebrating
The Gift –
Expanding
His Love –
The Beginning
The Journey
The Dream
The Ending
The Art of Caring

Because – I Feel

- Zachary Morfogen, Founding Chairman
 Emeritus, the National Hospice Foundation

Index